HOTEL
KITSCH

HOTEL KITSCH

A Pretty Cool Tour of America's Fantasy Getaways

MARGARET & COREY BIENERT

CREATORS OF **A PRETTY COOL HOTEL TOUR**

ARTISAN | NEW YORK

Library of Congress Cataloging-in-Publication Data is on file.

ISBN 978-1-64829-204-0

Design by Nina Simoneaux
Case illustration by Corey Bienert

Artisan books are available at special discounts when purchased in bulk for
premiums and sales promotions as well as for fundraising or educational use.
Special editions or book excerpts can also be created to specification.
For details, please contact special.markets@hbgusa.com.

The publisher is not responsible for websites (or their content)
that are not owned by the publisher.

The Hachette Speakers Bureau provides a wide range of authors for speaking
events. To find out more, go to hachettespeakersbureau.com or email
HachetteSpeakers@hbgusa.com.

Published by Artisan,
an imprint of Workman Publishing Co., Inc.,
a subsidiary of Hachette Book Group, Inc.
1290 Avenue of the Americas
New York, NY 10104
artisanbooks.com

Artisan is a registered trademark of Workman Publishing Co., Inc.,
a subsidiary of Hachette Book Group, Inc.

Printed in China on responsibly sourced paper
First printing, October 2023

1 3 5 7 9 10 8 6 4 2

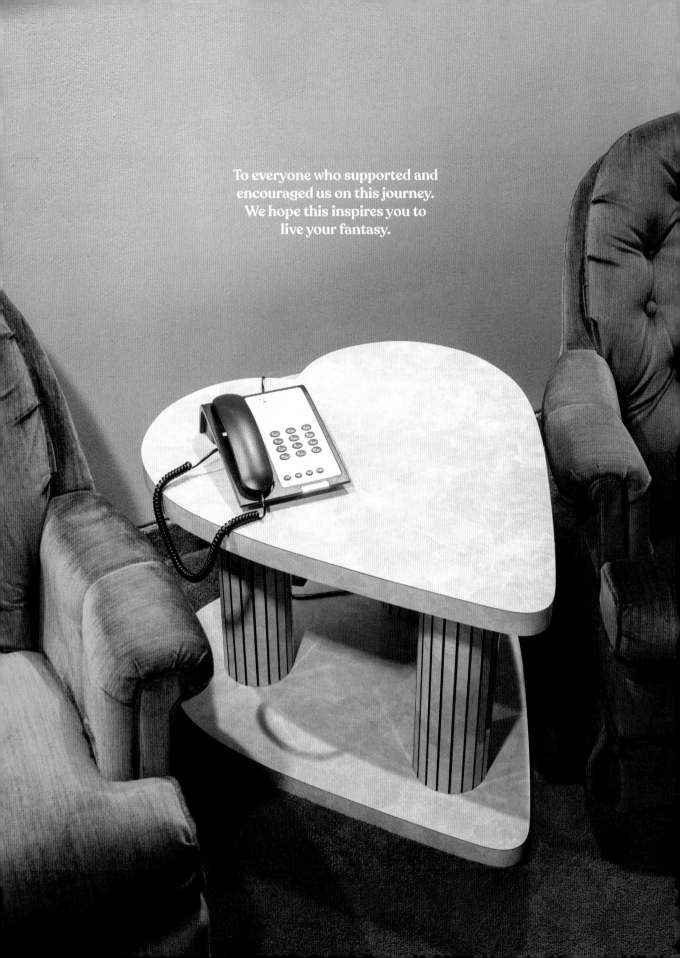

Contents

9 INTRODUCTION

THE HOTELS

15 **Cove Pocono Resorts**
East Stroudsburg, Lakeville, and
Mount Pocono, Pennsylvania

28 THE POCONOS AND THE
HONEYMOON ERA

37 **Gallery Holiday Motel**
South Amboy, New Jersey

45 **Adventure Suites**
North Conway, New Hampshire

53 **The Roxbury**
Roxbury, New York

62 **Grand Hotel**
Mackinac Island, Michigan

70 **Sybaris Pool Suites**
Locations throughout the Midwest

74 THE ANATOMY OF A PRETTY
COOL HOTEL ROOM

79 **Best Western**
Galena, Illinois

84 **Sunset Inn & Suites**
Clinton, Illinois

88 **Don Q Inn**
Dodgeville, Wisconsin

95 **Designer Inn & Suites**
Toledo, Iowa

100 FANTASUITES AND THE RISE OF
THE AMERICAN THEME HOTEL

107 **Grandpa's Pool House**
Stanchfield, Minnesota

111 **Wildwood Inn**
Florence, Kentucky

117 **Urban Cowboy Hotels**
Big Indian, New York;
Nashville, Tennessee

122 **The Dive Motel**
Nashville, Tennessee

129 **Magnolia Inn & Suites**
Southaven, Mississippi

132 HIDDEN ROADSIDE GEMS

136 **Jules' Undersea Lodge**
Key Largo, Florida

141 **7F Lodge**
College Station, Texas

145 **The Bloomhouse**
Austin, Texas

151 **Cliff House Lodge**
Morrison, Colorado

154 **Mon Chalet**
Aurora, Colorado

158 SO YOU WANT TO OPEN A
PRETTY COOL HOTEL

162 **Anniversary Inn**
Boise, Idaho;
Logan and Salt Lake City, Utah

171 **Black Swan Inn**
Pocatello, Idaho

178 **Destinations Inn**
Idaho Falls, Idaho

184 **Olympic Railway Inn**
Sequim, Washington

188 **Love Cloud**
Las Vegas, Nevada;
Los Angeles, California

193 **Madonna Inn**
San Luis Obispo, California

200 **Victorian Mansion**
Los Alamos, California

208 **Trixie Motel**
Palm Springs, California

216 ROOMS INSPIRED BY POP
CULTURE

220 **Castle Wood Cottages**
Big Bear Lake, California

226 **Hicksville Pines Chalets
& Motel**
Idyllwild–Pine Cove, California

234 **Best Western Fireside Inn**
Kingston, Ontario, Canada

239 **Shell House**
Isla Mujeres, Mexico

243 **Margate Suites**
Margate, England

246 **Romeo's Motel & Diner**
Ibiza, Spain

256 THE FUTURE OF THE BOUTIQUE
THEME HOTEL

263 **AFTERWORD**

267 **HOTEL DIRECTORY**

270 **ACKNOWLEDGMENTS**

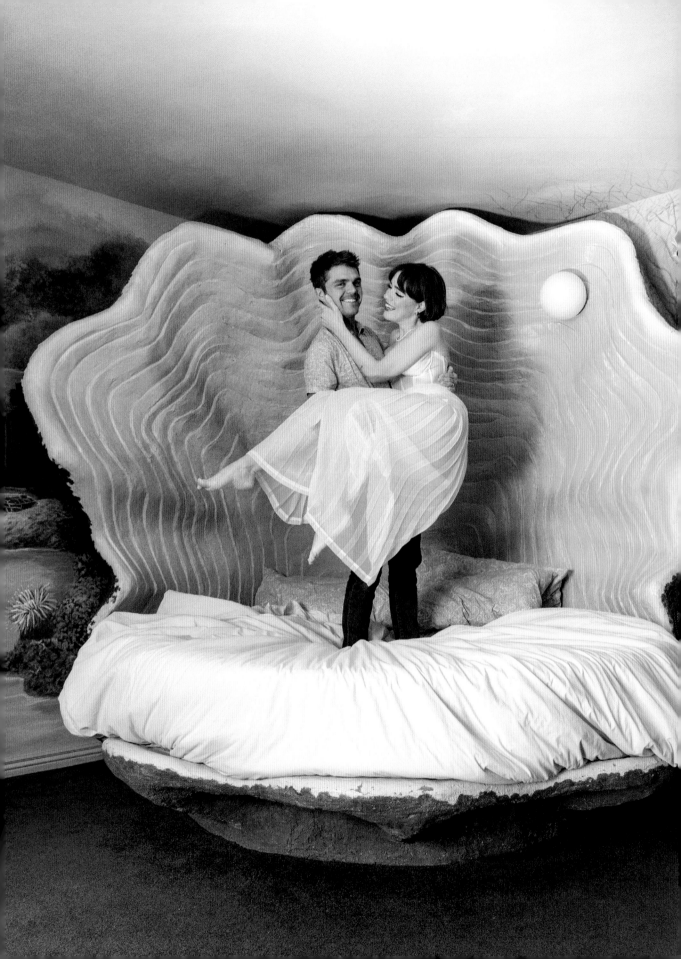

Introduction

Kitsch is a pink flamingo lawn ornament, a heart-shaped tub, and fuzzy dice hanging from the rearview mirror. It's leopard-print fabric and colorful floral carpeting. "Kitschy" can be interpreted to mean tacky, tasteless, or excessive, and full of sentimentality, like the souvenirs lining the shelves of a gift shop. It's the blatant and often unironic re-creation of something well-known and beloved—easily digestible art that doesn't take itself too seriously.

Hotel Kitsch is a collection of destinations that fully embrace this polarizing style. Included here are theme hotels that offer fantastical imitations of familiar settings—like a jungle room with fake trees and foliage surrounding the bed, or a cave suite that has carved rock walls and not a window to be seen—as well as imaginative interiors with a shameless abundance of pattern, color, and personality. The properties range from honeymoon hotels built in the Poconos in the 1970s to a newly renovated maximalist's paradise in Palm Springs. There are "hidden gem" roadside motels throughout the Midwest, Americana-inspired hotels in Ibiza, and so much more in between.

So how did we come to discover these hotels and fall in love with them? Our passion for photography connected us in college, and we started a production company together as newlyweds. While on a work trip in 2018, we decided to stay at Cove Haven Resort in the Poconos. We'd become aware of it thanks to the eerie, dreamlike photo series called *The Honeymoon* by Juno Calypso, which showcased one of the hotel's pink heart-shaped bathtubs. Once we arrived, we couldn't believe what a perfect time capsule the entire resort turned out to be. We were completely taken by the romantic atmosphere and couples-only summer camp feeling. The rooms were nostalgic, sexy, and reminiscent of the Doris Day movies Margaret had been aesthetically drawn to since childhood.

After that trip, we dove into researching where to find other hotels that had a vintage or fantastical style and stumbled into the world of theme hotels. We had been wanting to embark on a personal project whereby we could join forces and create

something together, and these rooms were the perfect subject. We started road-tripping as often as we could, cataloging our favorite designs along the way.

When we began seeking out these unique experiences, we consulted the internet. We got a few leads when we entered phrases like "theme hotel" or "fantasy suites," but because many of the hotels themselves didn't focus on building SEO (search engine optimization, which is what aids in searchability) or a social media presence, the results were incredibly limited. After some time, we honed our research skills—looking for the word "outdated" in reviews proved effective—and found enough promising information to start planning the trips.

The getaways we discovered were often overlooked and widely misunderstood, both a little sleazy and hopelessly romantic—something we could relate to. We'd always felt like eccentric artists who weren't sure where we fit in society, but as we embarked on this project, we began finding our people and hearing their stories of shameless self-expression. We were theater lovers who finally had somewhere to wear our costumes again.

As we traveled, we shared our adventures online under the name A Pretty Cool Hotel Tour, and our photos and videos began garnering attention. We visited hundreds of rooms from coast to coast, often unsure of what we would find when we unlocked the door. There was a thrill to uncovering properties that had thrived before the digital age but hadn't yet made their internet debuts. (A large part of the motivation for this series was because there was no resource for unique, kitschy hotels explicitly for adults. The handful of family-friendly hotels profiled here are noted as such in the Hotel Directory, beginning on page 267.) The rooms themselves were imaginative, silly, and sexy, and gave the visitor permission to lean into fantasy and self-expression. And people loved them!

This book is a visual journey through the most immersive, creative, and kitschy rooms we've visited. Whether the destination is a seventies-themed hotel (page 122) or one that actually requires you to scuba dive to the entrance (page 136), we're taking you along on an adventure that's all about fun. We'll explore the rich history behind American theme hotels and honeymoon escapes, and while this is not explicitly meant as a travel guide, we hope to inspire you to dig deeper into fantasy, romance, and self-expression—and maybe even plan your own road trip.

It's time to check into *Hotel Kitsch*.

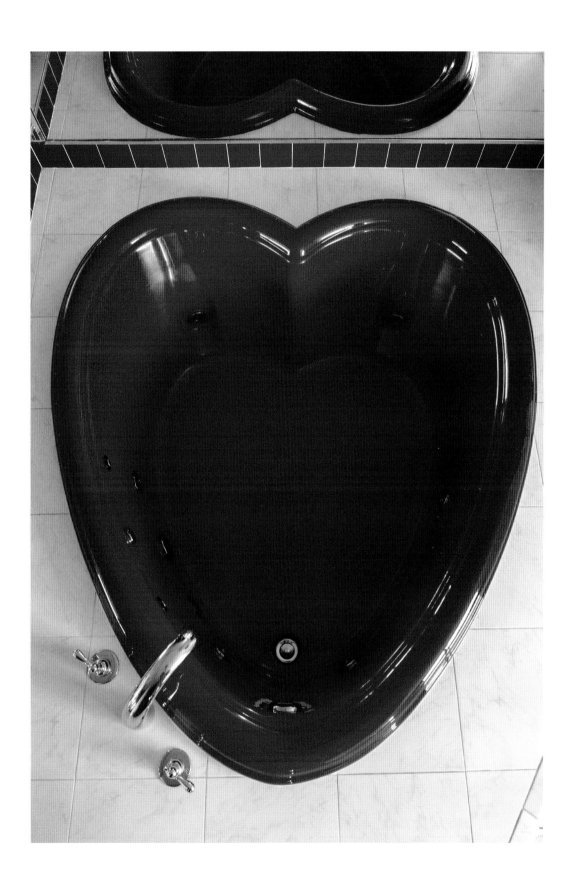

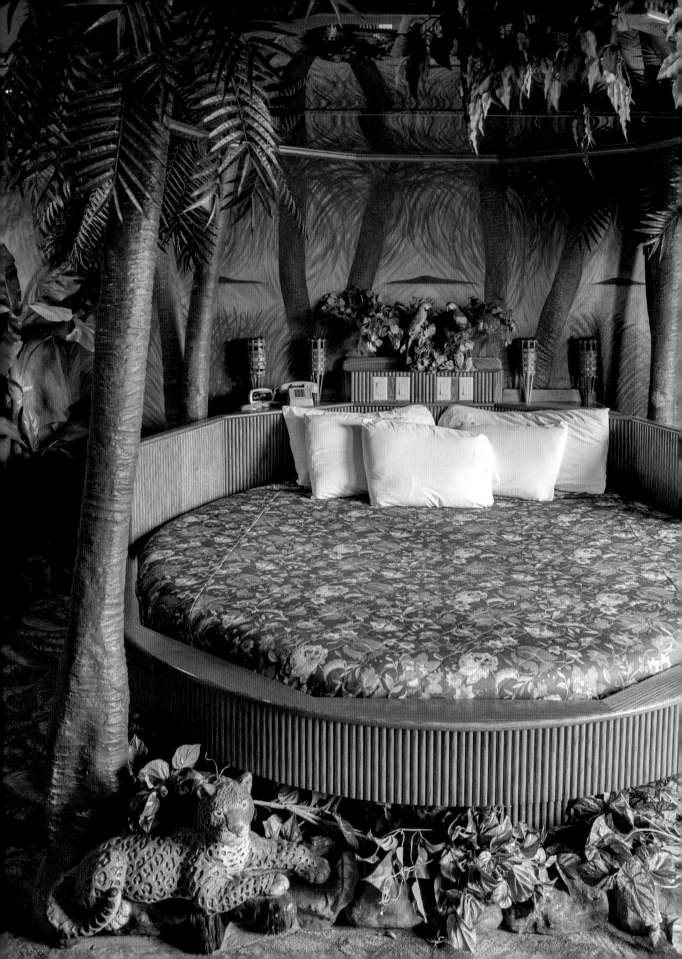

The

H
O
T
E
L
S

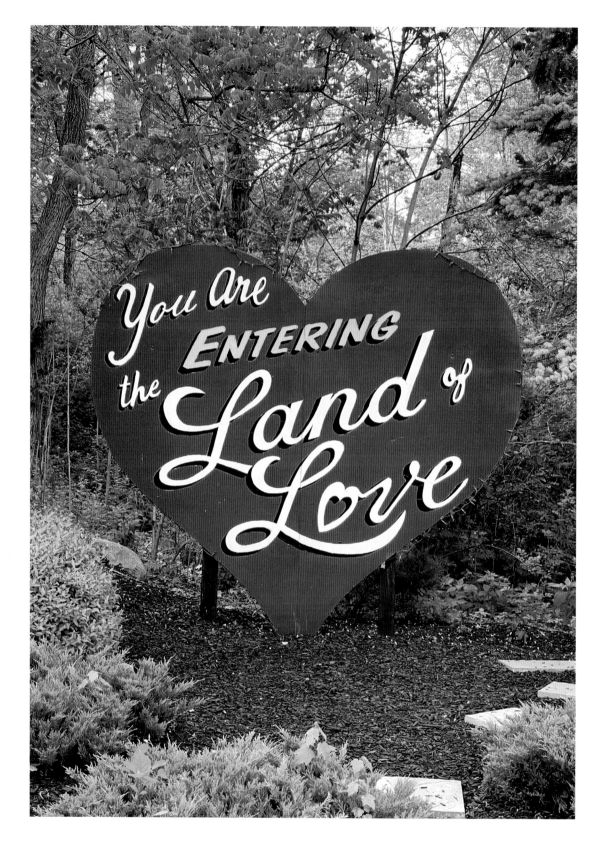

Cove Pocono Resorts

EAST STROUDSBURG, LAKEVILLE, AND MOUNT POCONO, PENNSYLVANIA

An abundance of hearts and other romantic decor can be found throughout these vintage resorts.

The Cove Pocono Resorts (Cove Haven, Paradise Stream, and Pocono Palace) are three remaining sister properties in what was once known as the "Honeymoon Capital of the World." Their rich history is an important piece of not only the Poconos story but Americana as a whole. In 1963, owner Morris Wilkins designed a heart-shaped tub for his first resort, Cove Haven. He aimed to create a welcoming atmosphere for couples looking to have a serene getaway by offering unique and romantic amenities.

In 1971, *Life* magazine ran a photo of the tub in an article about the opening of Interstate 80 that created quite the buzz for the Poconos and quickly solidified its reputation as the Land of Love. During the boom that followed, Cove Pocono Resorts expanded with more hotels, newly designed suites, and additional activities throughout their properties.

Interest in the heart-shaped tub exploded, and hotels across the country started copying Wilkins's design. As the story goes, Wilkins was frustrated with himself for not having secured a patent for his now unbelievably popular attraction and set out to create another masterpiece. In 1984, Cove Haven debuted his second grand innovation: the champagne-glass whirlpool. This 7-foot-tall (2 m) bathtub for two perfectly mimicked a giant stemmed glass and was a structural and visual work of art. By the time suites featuring this new tub became available, the wait

to stay in one was over a year long. Due to high demand, the design was introduced to Pocono Palace and Paradise Stream as well.

Although the Cove Pocono Resorts have slowly been modernized throughout the decades, there is plenty for fans of the original kitsch to enjoy. The suites (with names like Fantasy Apple, Diana's Oasis, Roman Tower, and Juliette) still feature heart-shaped tubs, private pools, champagne-glass whirlpools, and round beds. The properties themselves are expansive, too, and offer a variety of activities like archery, tennis, boating, mini golf, and duckpin bowling (which is similar to classic tenpin bowling but with slightly smaller pins). Live performances and group events are hosted at each resort, and Cove Haven can even arrange in-room photo shoots with their on-site photographer. If you're anything like us, you'll return year after year to continue making the Cove Pocono Resorts a lasting part of your love story.

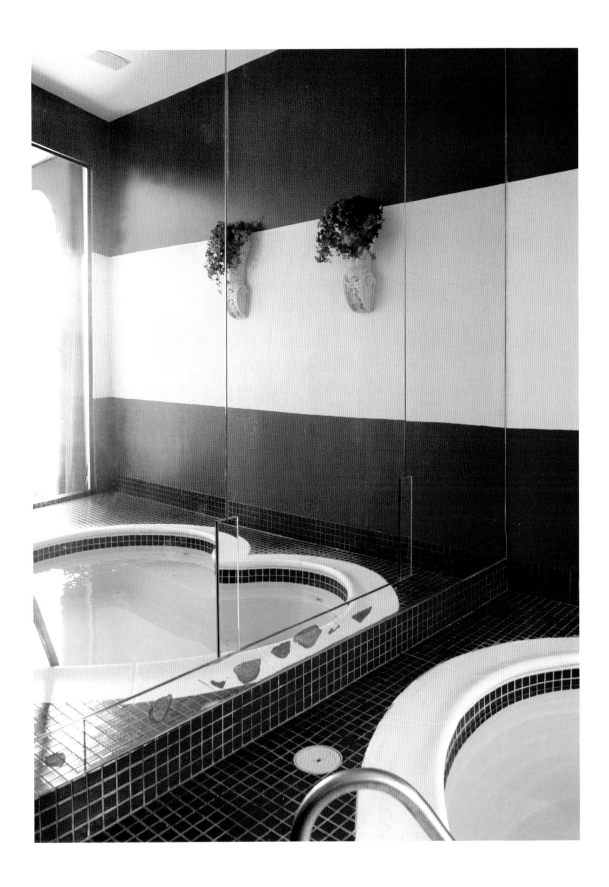

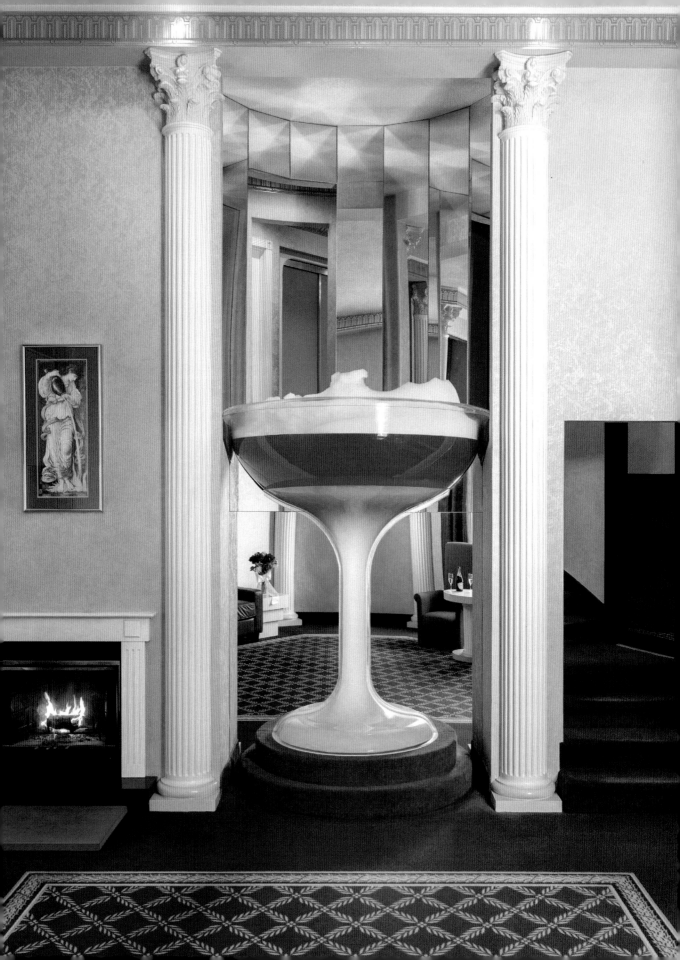

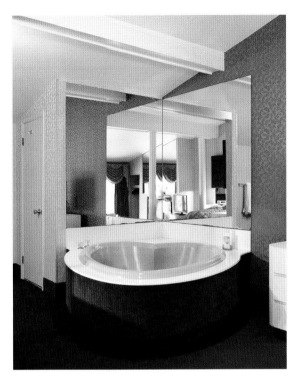
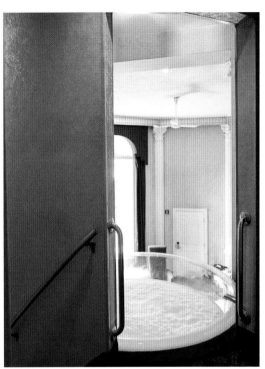
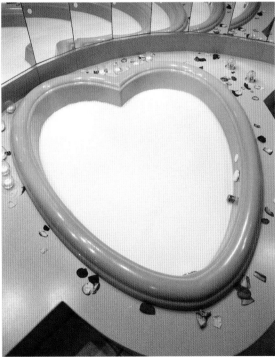
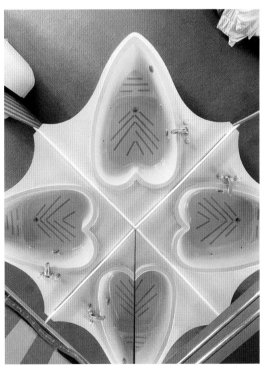

Roman-inspired architecture can be found throughout the resorts and is a common feature of theme hotels.

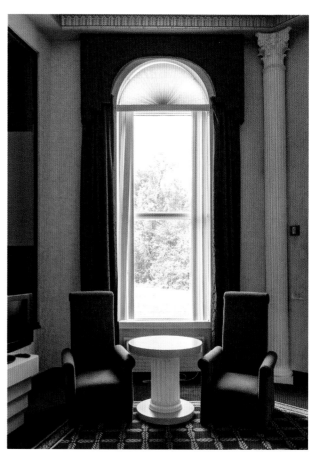

Fiber-optic star ceilings create a romantic ambience as they twinkle above the circular beds.

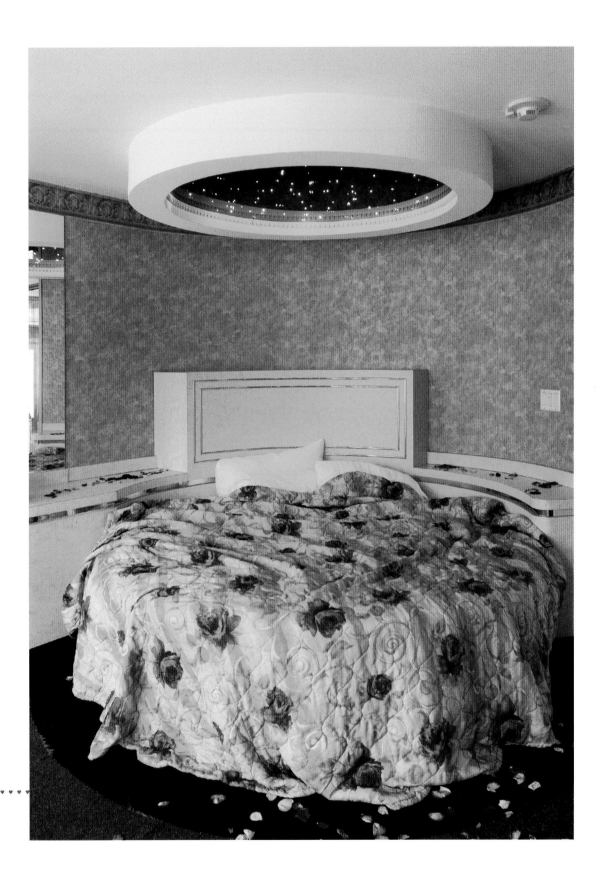

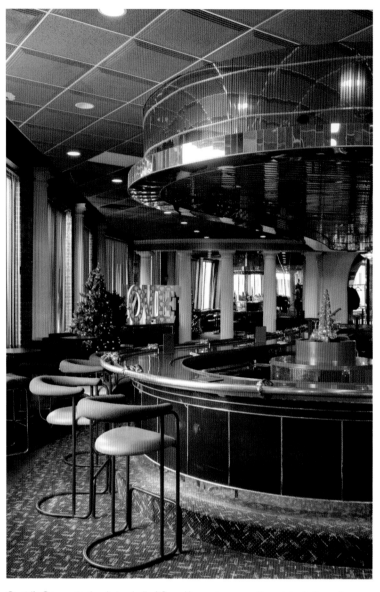

Cupid's Corner, in the dining hall of Cove Haven, is among the original pieces from the resort still in use today.

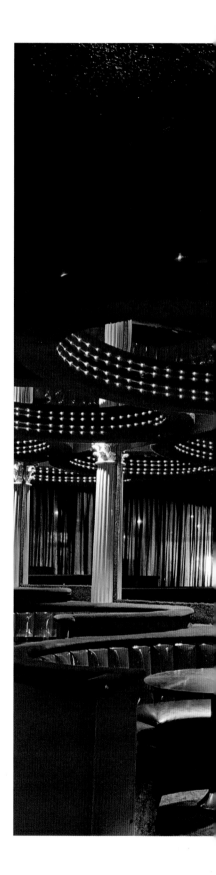

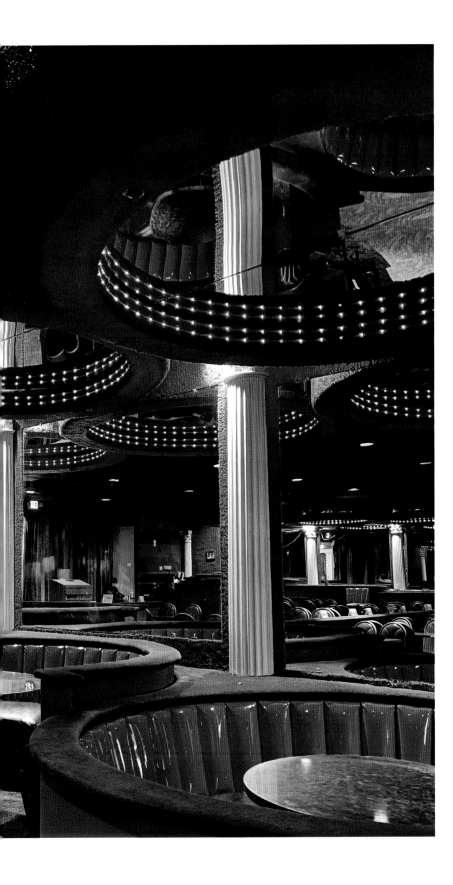

The nightclub at Pocono Palace mimics the resort's glamorous bedroom designs, with circular ceiling mirrors framed in red carpeting.

The gift shop at Cove Haven sells a variety of adult products and cheeky souvenirs specifically curated to spice up a romantic trip.

Dedicated gaming facilities help provide a memorable getaway in any season.

The Poconos AND THE Honeymoon Era

Vintage brochures from the Poconos advertise a colorful wonderland that catered exclusively to newlyweds.

When diving into the world of retro, kitschy hotels, there's one place you're bound to end up: the Poconos. Known as the birthplace of the heart-shaped tub, this mountainous region of eastern Pennsylvania has a rich history of welcoming couples with its cheesy, lighthearted approach to romance, as well as influencing the decor of hotels around the world.

Tourists started coming to the Poconos as early as 1829, drawn by the region's diverse natural beauty and the fact that it was just a short trip from major metropolitan areas (90 miles/145 kilometers from New York City and Philadelphia and roughly 300 miles/483 kilometers from Boston and Washington, DC). The very first honeymoon resort in the area, the Farm on the Hill, opened in 1945. (Not located on a hill at all, this hotel started the long-lasting Poconos tradition of advertising a fantasy to its patrons.) The end of World War II saw a sudden rise in marriages, and therefore honeymooners. The Farm on the Hill was quickly joined by other hotels attracting young couples. The designs of these first honeymoon hotels were wholesome and rustic and had Early American interiors that mimicked the cozy countryside, as if to give newlyweds a homey feel while they became better acquainted and embarked on their lives together. Activities from volleyball and hayrides to evening performances and parties were offered throughout the properties, so visitors had a chance to go out and meet other couples in a similar stage of life.

In 1958, two new hotel developers entered the scene and changed the course of couples hospitality throughout the region and, soon, the

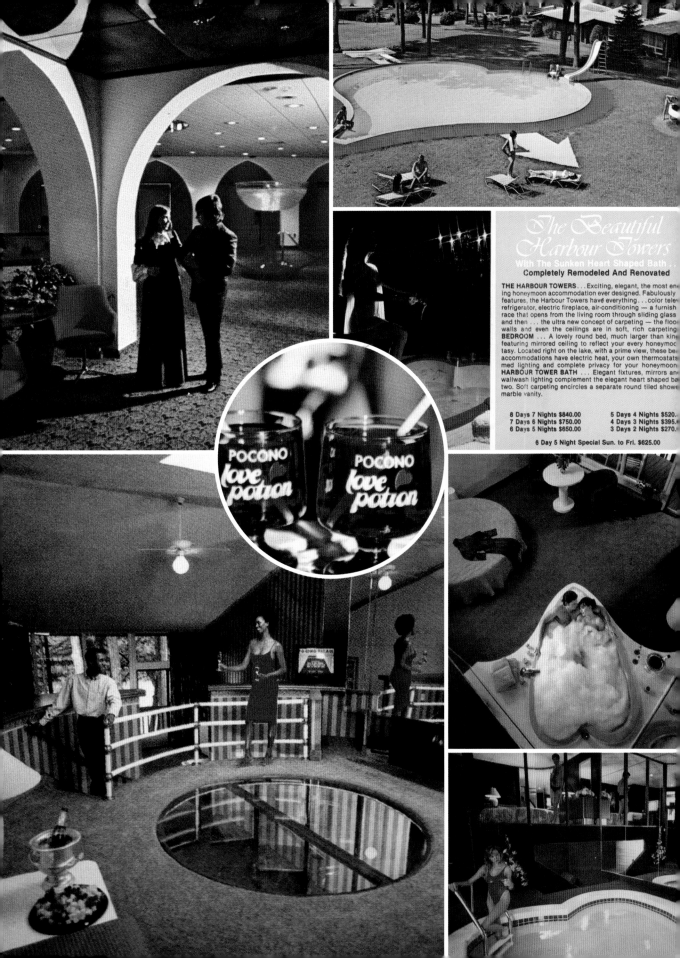

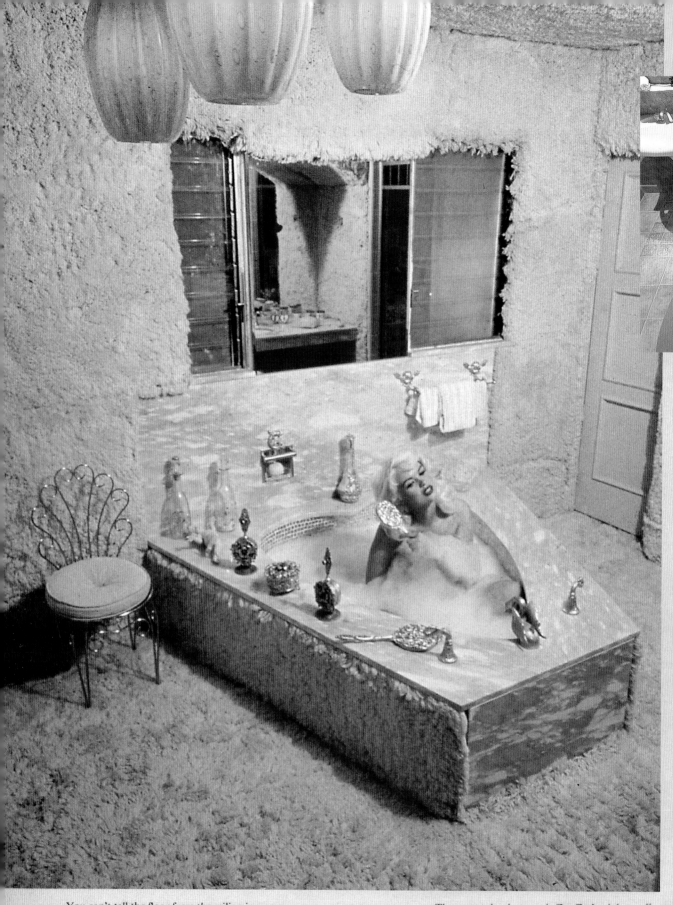

You can't tell the floor from the ceiling in Jayne Mansfield's furry pink bathroom. The main difference is that the heart-shaped bathtub is on floor.

The gayest dog in town is Zsa Zsa's pink poodle snuggling up with a don't-you-wish-you-were-here grin on his puss. He seems to adore being near Gabor.

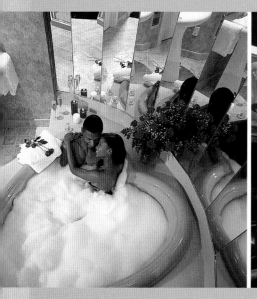

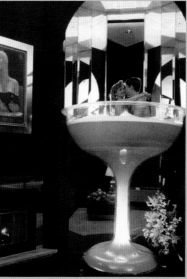

entire country. When Morris Wilkins and Harold O'Brien purchased Hotel Pocopaupac, they changed the name to Cove Haven and immediately got to work on improvements. This was the era that ushered in the sexual revolution, the launch of *Playboy* magazine, and Elvis Presley gyrating on national television. America was ready for something risqué, even explicit, and Cove Haven would offer just that. Most notably, it was the site of Morris Wilkins's most famous creation: the heart-shaped bathtub. This iconic bathtub ignited a huge shift in the Poconos, and before long, every other resort in the region had one. Tubs were not the only common feature getting a heart-shaped makeover. Mattresses, sinks, windows, and even entire bars were being built in the symbolic shape. And that's not where the sexy face-lifts ended: Shag carpeting on every surface, mirrors on walls and ceilings, silky

drapes and sheets, multilevel suites, round beds, and crystal chandeliers replaced the once-rustic, suburban decor. Morris Wilkins was designing spaces people were used to seeing only at the cinema, offering lovers a chance to enter a fantasy world full of glamour and sex.

The 1971 *Life* magazine article that put the heart-shaped tub on the map included a two-page spread featuring a couple in one of Cove Haven's tubs surrounded by mirrors. Despite the article calling these Poconos resorts emblematic of a national "surfeit of affluent vulgarity," it helped the region gain even more popularity and earn the title of "Honeymoon Capital of the World." The Poconos were officially drawing more newlyweds than Niagara Falls, and before long, Cove Haven had expanded by opening several new properties that offered similar amenities to meet the demand. Every resort in the region

was competing to attract customers, promoting full-service, all-season vacation experiences that included live music and comedy, horseback riding, golfing, skiing, bowling, tennis, indoor and outdoor pools (often in the shape of a heart or wedding bells), spas, and more.

The 1980s saw even more developments in the Poconos, and the region continued to receive a steady stream of visitors. In 1981, an LGBTQ-friendly establishment called Rainbow Mountain Resort opened, and in 1982, Andy Griffith starred in a made-for-TV movie called *For Lovers Only* that was shot at Cove Haven. By the mid-nineties, however, these massive resorts were seeing smaller crowds. Air travel was becoming more affordable, and couples had more vacation options. Cruises to the Bahamas; resorts in Orlando, Florida; and even Las Vegas casinos that had taken on a similar decor style to that of the Poconos were getting a huge piece of the honeymoon market. With visitors dwindling, many of the resorts struggled to keep up with the huge cost of running such expansive properties, let alone update them. In order to survive, some Poconos resorts pivoted to cater to families instead of couples. Others started

to try to reach niche audiences; the Birchwood Resort hosted bondage weekends and spanking parties. Once the local paper, the *Pocono Record*, wrote about fetish events, there was an overwhelming amount of negative publicity, and Birchwood was pressured to cancel its alternative-lifestyle parties (the *Pocono Record* announced the decision in an article titled "Resort: Thanks but No Spanks"). Many in the community were relieved, but Birchwood could no longer stay afloat, and it soon closed its doors for good. Hotels in the region continued to struggle, and visitors began to complain that the resorts were not receiving any updates, and that some weren't even being maintained. By the early 2000s, nearly every resort had been rebranded or was completely abandoned. The honeymoon heyday was over.

And yet Cove Haven, along with its two sister properties, Paradise Stream and Pocono Palace, is still open and catering to honeymooners and couples. Unlike their nearby competition, they never rebranded or removed the elements that made them stand out. Visitors are still enjoying heart-shaped tubs and explicitly sexy suites along with

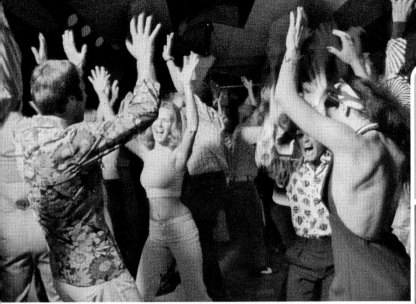

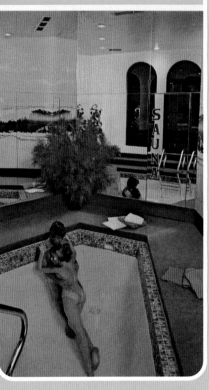

live performances and employee-led activities, from bingo to the Newlywed Game, which take place at their aptly named Spooner's Bar and Grille. And, of course, the "romantic kitsch" style that the Poconos popularized has gained a cult following and can be seen in contemporary hotel designs everywhere from California (page 208) to Ibiza (page 246).

Fueled by love, lust, and sheer curiosity, the Poconos effect is part of the rich American history of innovators and inventors. For some folks, it's more than enough to simply revisit the photos of a bygone era and delight in (or cringe at) the cheesiness through projects like Dead Motels USA, an online resource of retro hotels and motels throughout the United States that have shut down or otherwise rebranded. But there are still those—ourselves included—who love to fully immerse themselves in over-the-top romance and escape to the Poconos.

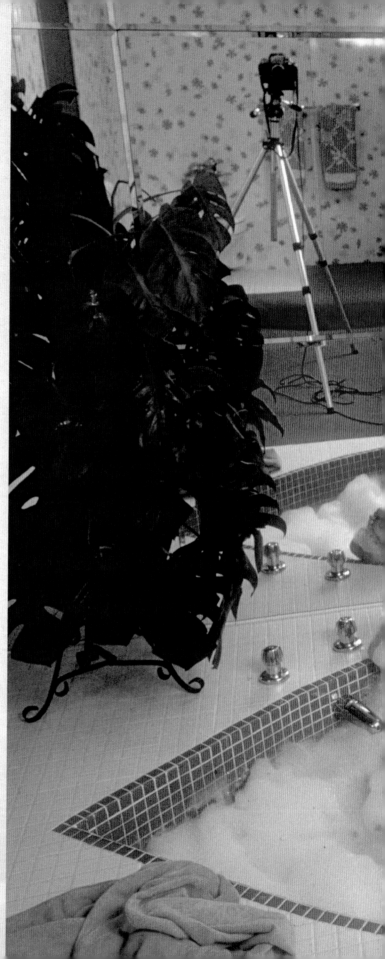

Is part of the new national Us a surfeit of affluent vulgarity? How about a honeymoon lodge, for instance? Apparently, just being with each other doesn't seem to be enough. We need, or think we need, some affirmation—mirrors, heart-shaped pools—to tell us we're really here at last. And a camera, courtesy of the thoughtful management, to remind us later when we try to recall just what it was like for those strangers, ourselves

A brand-new bride records her honeymoon bubblebath on film at Cove Haven, a Pennsylvania resort exclusively for newlyweds.

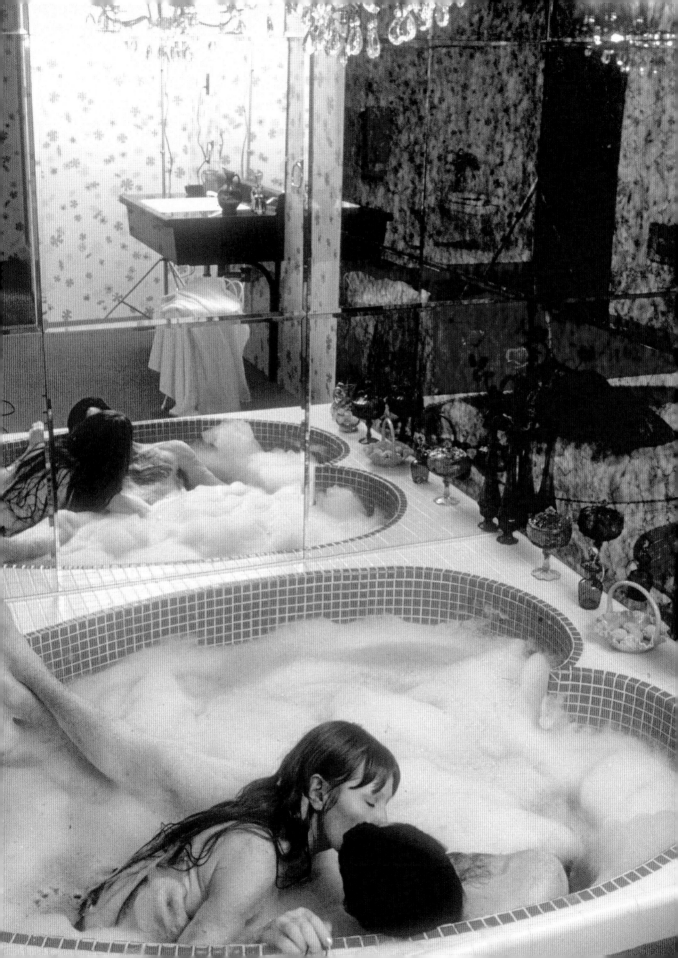

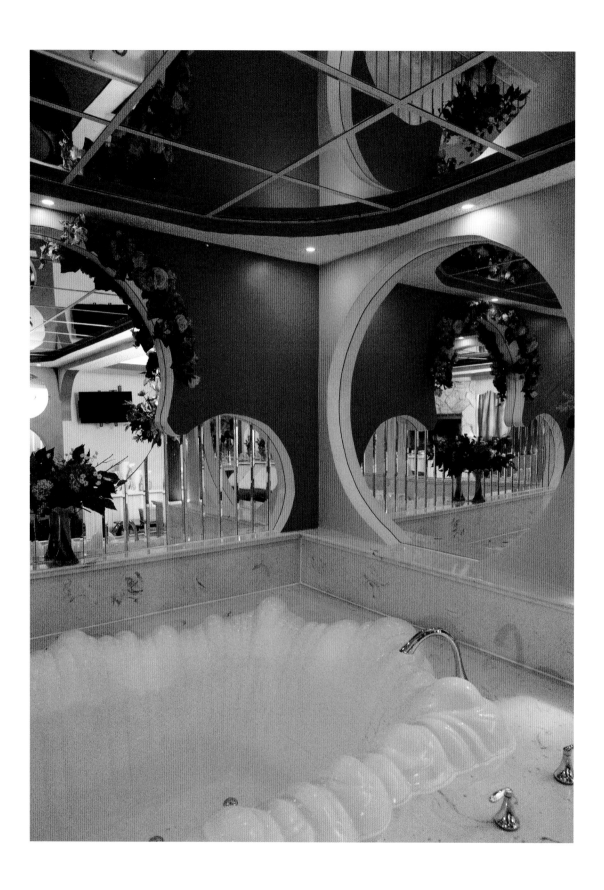

Gallery Holiday Motel

Colorful mood lighting is a key part of the design of these retro rooms.

This unassuming roadside property in New Jersey, located less than an hour from midtown Manhattan, is a classic retro love motel. Built in 1985, it features rooms designed at the height of the Poconos craze, when romance meant mirrored ceilings, velvet upholstery, and heart-shaped tubs. Throughout the years, carpeting has been replaced and some fireplaces have been converted from wood-burning to electric, but many original details remain, leaving the rooms to feel like unique time capsules. (One reason the Gallery Holiday Motel hasn't gotten the kind of modern face-lift many similar destinations have received is because the man who designed it is still the owner today.)

There are some themed rooms, like Jungle, Cave, and Beach, but there are also many rooms that simply offer the perfect setting for romance with heavily mirrored surfaces, a round bed, and a moody ambience. The light-up columns, heart-shaped window cutouts, and ridged cloudlike bathtubs are iconic pieces of eighties design that are incredibly rare to find today.

Much like its design, the operation of the hotel is reminiscent of a pre-internet era: Reservations are accepted only in person or through third-party booking services. Rooms can be rented by the night or at an hourly rate for an afternoon stay. For lovers of vintage, this roadside gem is a gold mine of nostalgia and romantic mystique.

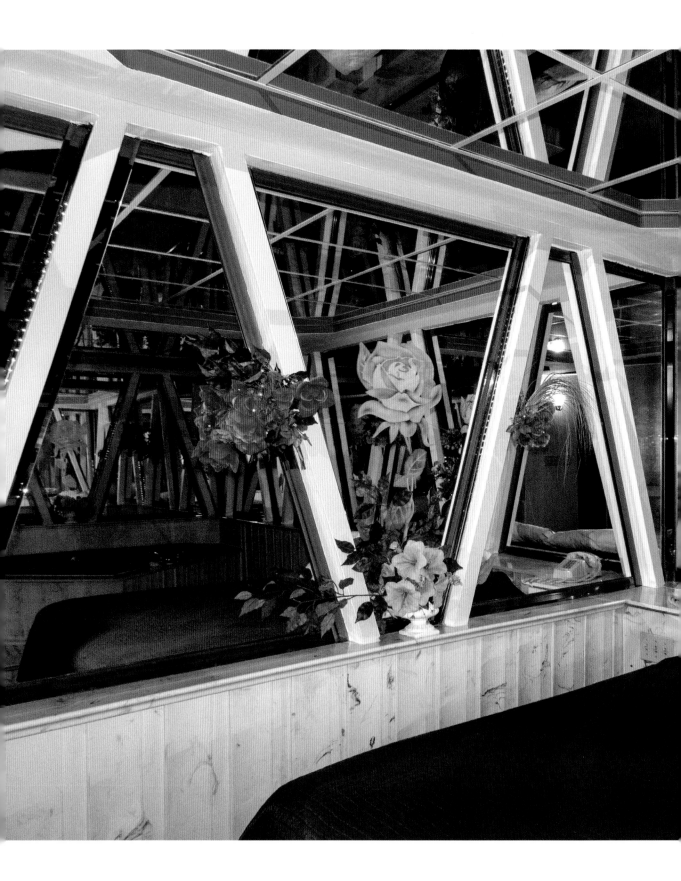

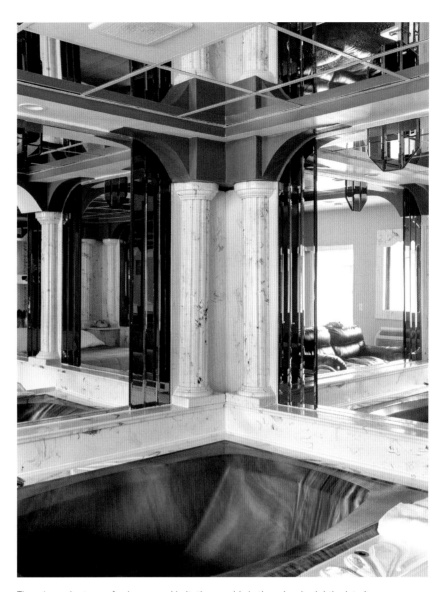

There is no shortage of columns and imitation marble in these iconic eighties interiors.

The Triangle suite features faux floral arrangements, endless mirrors, and frosted glass rose decals.

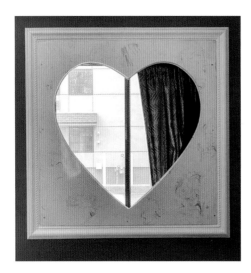

The motel's heart-shaped window frames are custom-made.

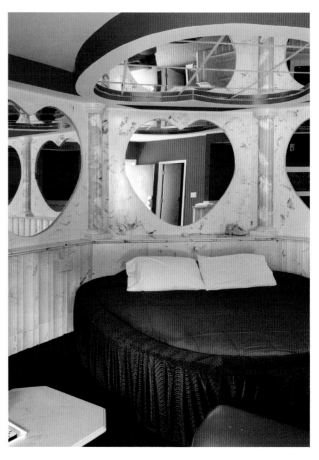

A panoply of wall (and ceiling!) mirrors are a common feature in kitschy hotels—more on this on page 74.

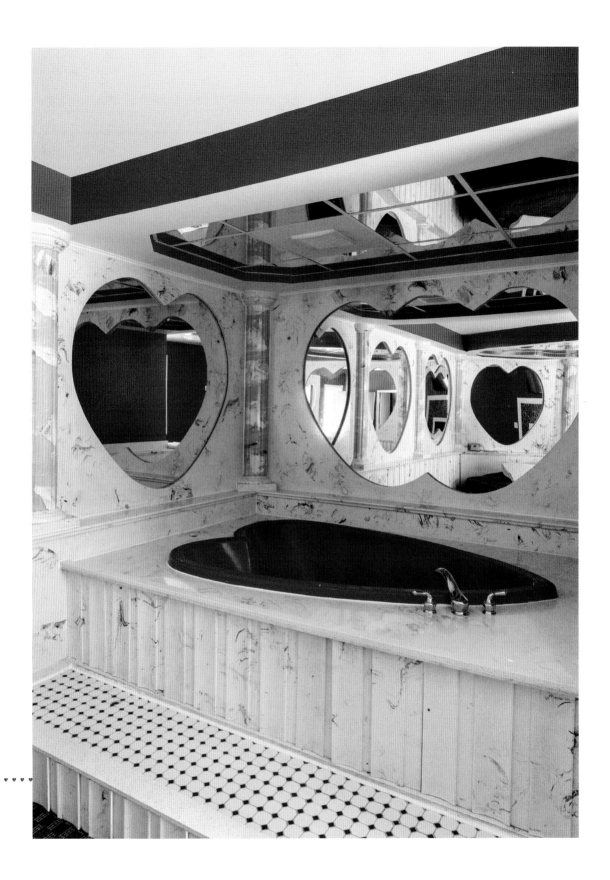

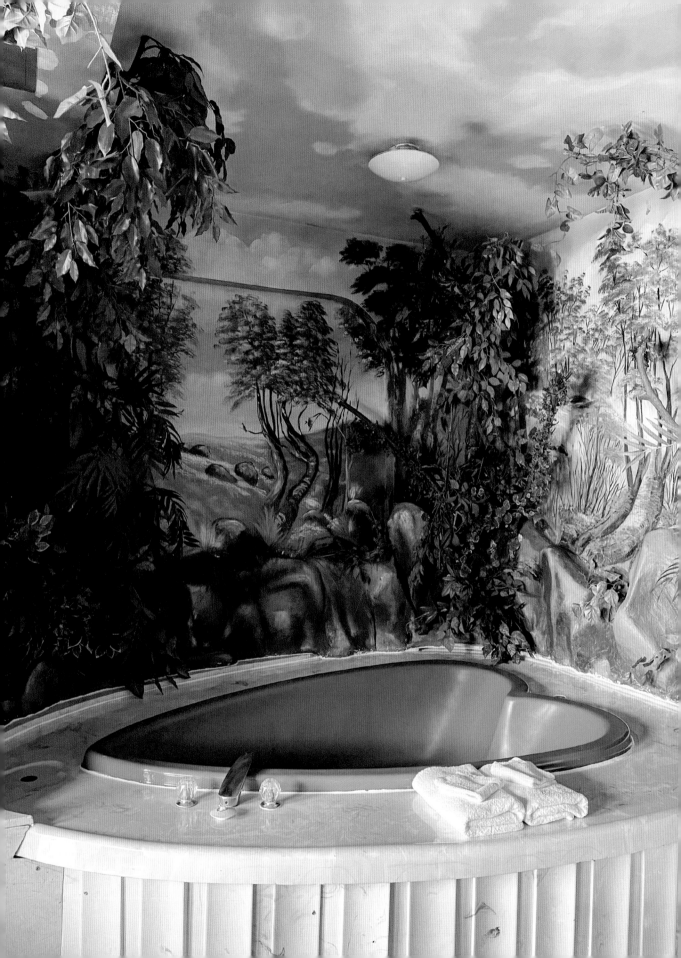

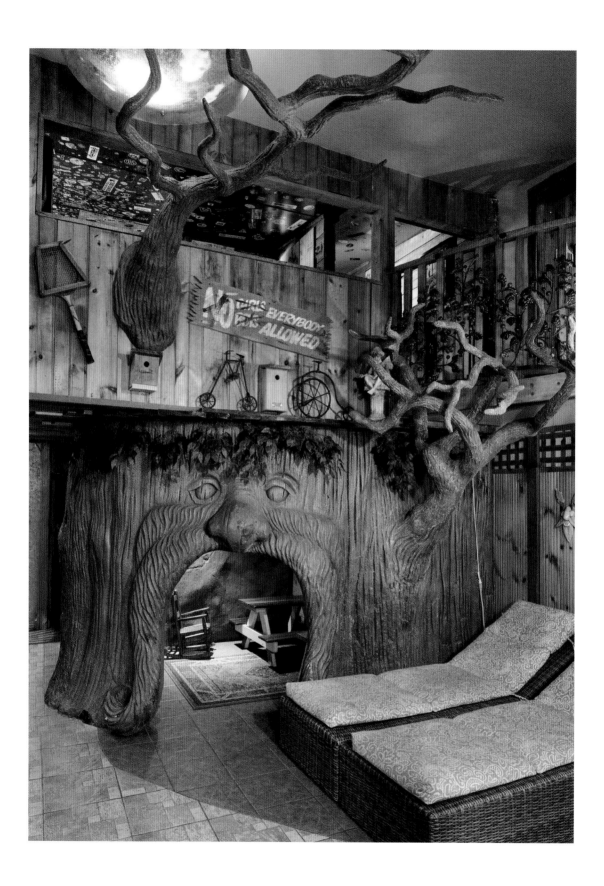

Adventure Suites

NORTH CONWAY, NEW HAMPSHIRE

The Treehouse is family-friendly and features a playroom with child-size furniture.

The adventure begins as soon as this hotel comes into view, disguised as an Old West town complete with a church, firehouse, town hall, blacksmith, and more. The hotel building, constructed in the 1950s, has been through several iterations, including as the Presidential Waterbed Motel during an era in which it billed itself as "the Poconos of the White Mountains." In the late nineties, the current owner started the long process of turning the hotel into a themed destination. These days it is a complete resort featuring nineteen themed rooms as well as a full restaurant, bar, and spa.

Adventure Suites is uniquely welcoming to not only couples but also families, and includes rooms geared toward young children, such as the Treehouse and the Cave. On the flip side, the suites built for adults are some of the most elaborate and interactive we've found: Highlights include a floating bed suspended from the ceiling in the Dragon's Lair and the stage lighting, disco ball, black-light murals, killer sound system, and light-up dance floor in the Club room.

The resort's owners pride themselves on traveling to conventions across the country in order to continue educating themselves and ensure they remain at the forefront of theme hotel immersive technology. Book a stay in the Haunted Castle room, if you dare, and you'll see the modern magic they've been able to achieve, which is both surprisingly impressive and so terrifying you certainly won't make it through the night without a fright.

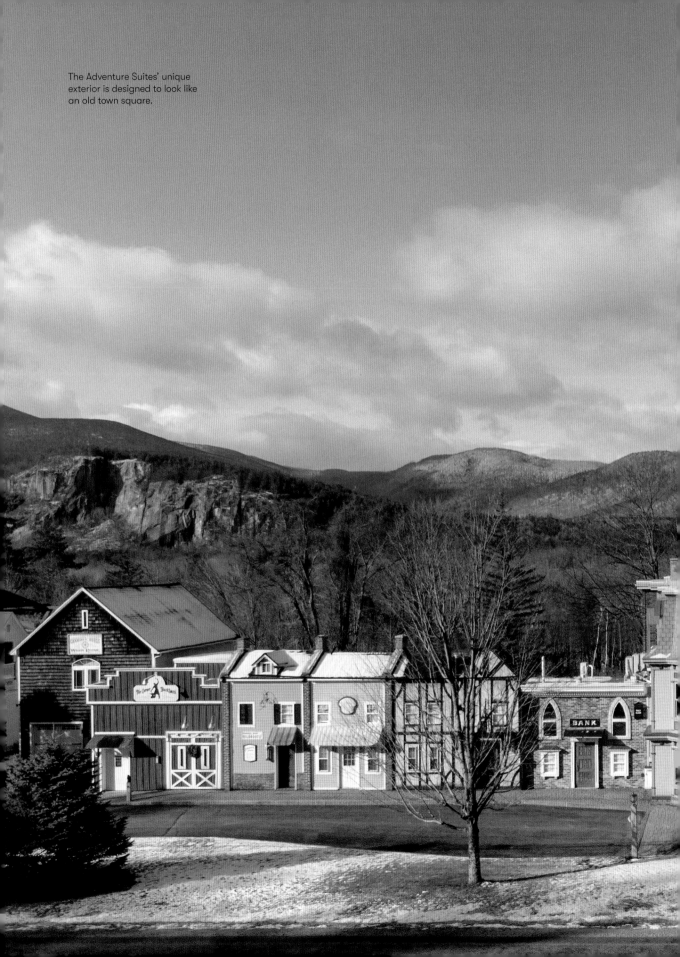

The Adventure Suites' unique exterior is designed to look like an old town square.

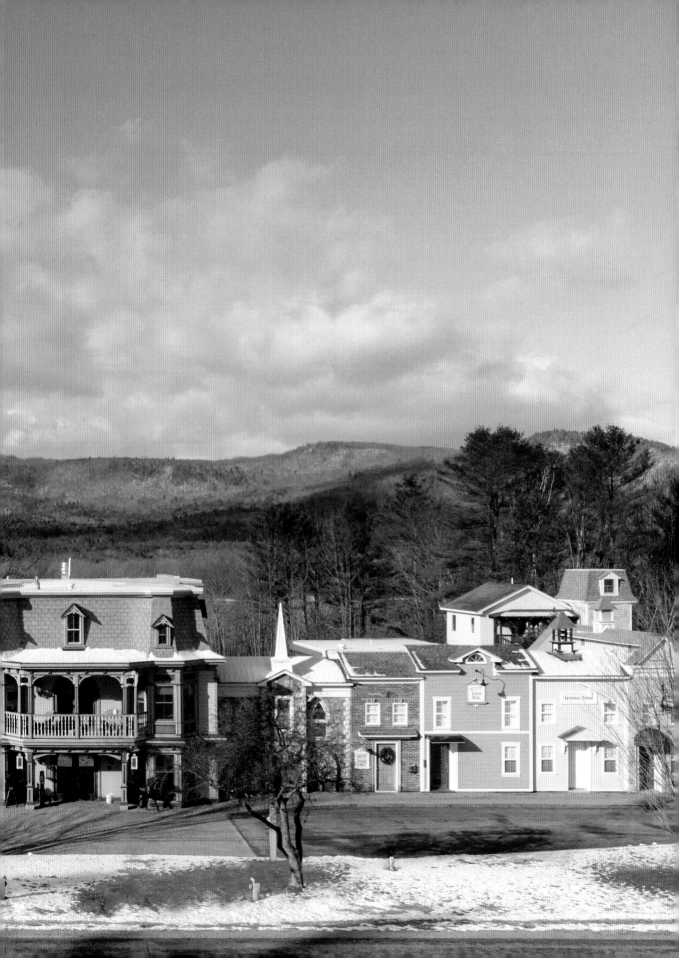

The Haunted Castle has countless spooky details—even the toilet paper holder plays a role.

Up to eighteen people can stay in the suite, which includes coffin-shaped queen-size bunk beds.

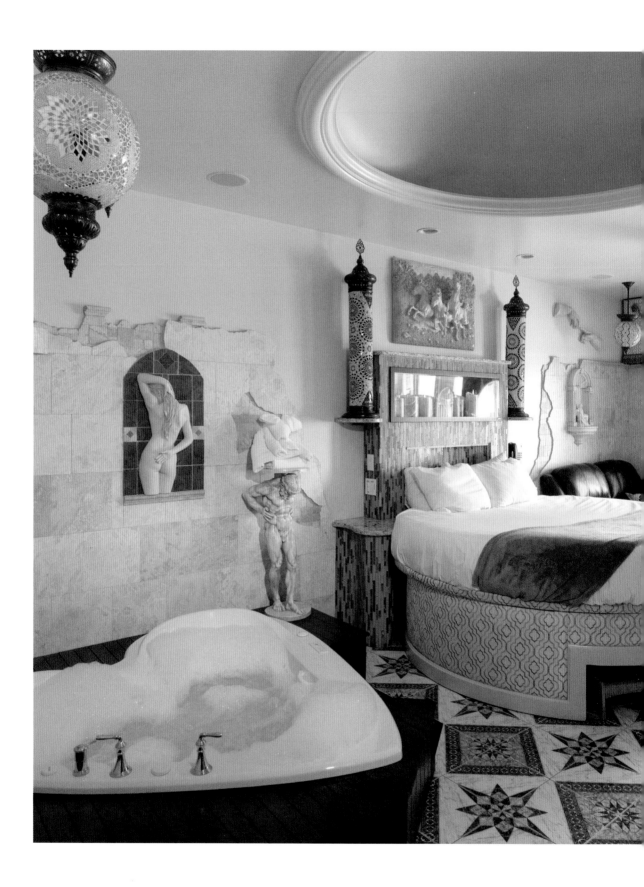

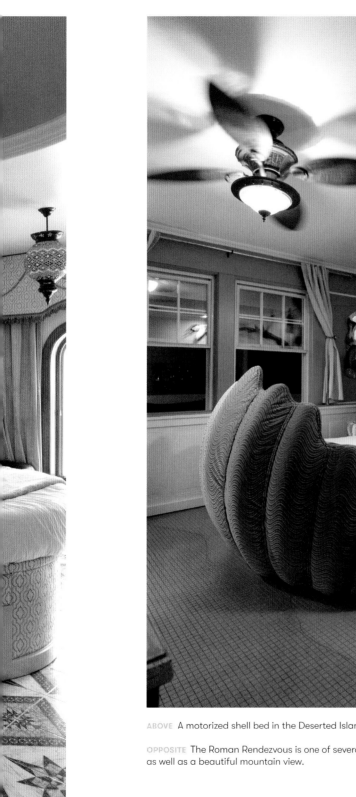
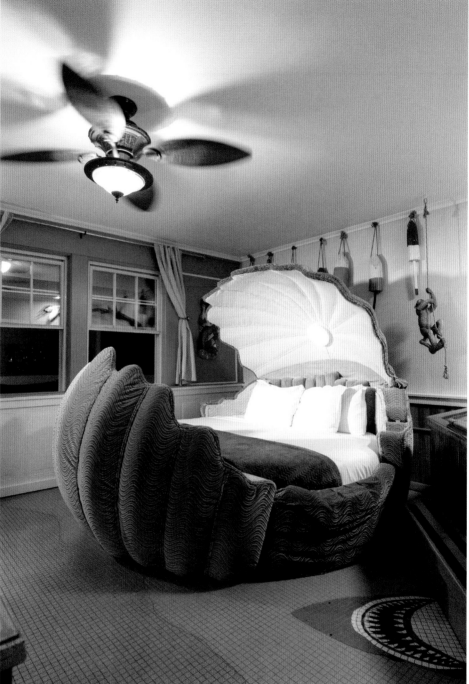

ABOVE A motorized shell bed in the Deserted Island room opens and closes with the push of a button.

OPPOSITE The Roman Rendezvous is one of several rooms at Adventure Suites with a heart-shaped tub, as well as a beautiful mountain view.

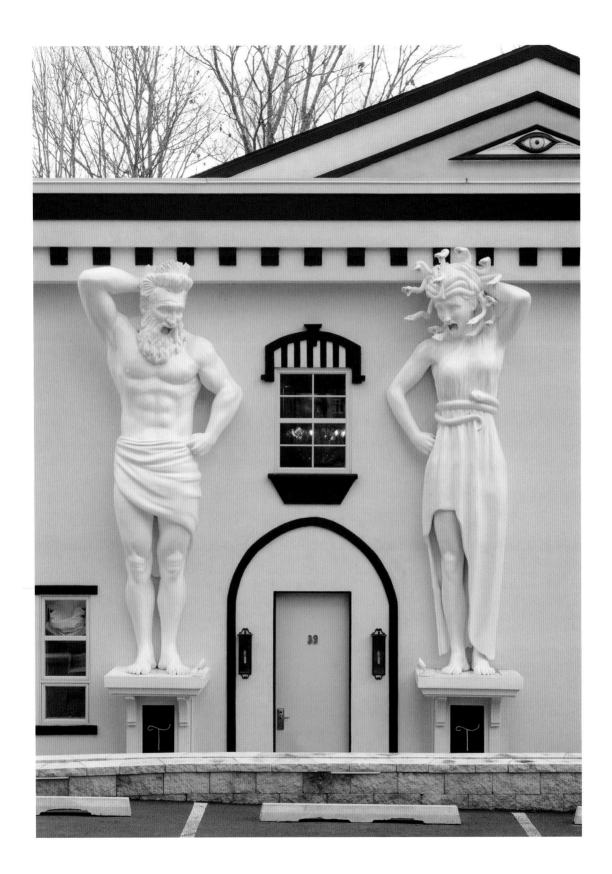

The Roxbury

ROXBURY, NEW YORK

Given the properties' theatrical, glamorous, and even sophisticated aesthetic, it's no surprise that Roxbury co-owners and married couple Gregory Henderson and Joseph Massa met while doing theater production in New York City and that each has an extensive background in writing, performing, producing, directing, and set building. In 2004, their lives changed forever when they decided to purchase the Roxbury Motel in the Catskills. Here, they have created twenty-eight unique rooms inspired by a wide range of bold styles and pop-culture references, mostly from TV shows and movies of the sixties and seventies.

Head just 2 miles (3.2 km) down the road to the Roxbury at Stratton Falls, and you're immediately invited into a fairy tale. This second location, unveiled in 2020, was inspired by the waterfall on the property, which Henderson and Massa believe is home to fairies, and the hotel's themed rooms extend this mystical feel. In Cinderella's Gown, guests will find the bathroom inside of a giant carved-out pumpkin and sleep under a large floating dress, and in the Faerie Forest, guests will interact with hand-carved set pieces surrounded by tiny twinkling lights nestled throughout the foliage to mimic fireflies.

While Henderson and Massa may not be performing onstage anymore, and "the gratification isn't as immediate as with a live audience," according to Henderson, they still get satisfaction from knowing they're bringing people joy with their work.

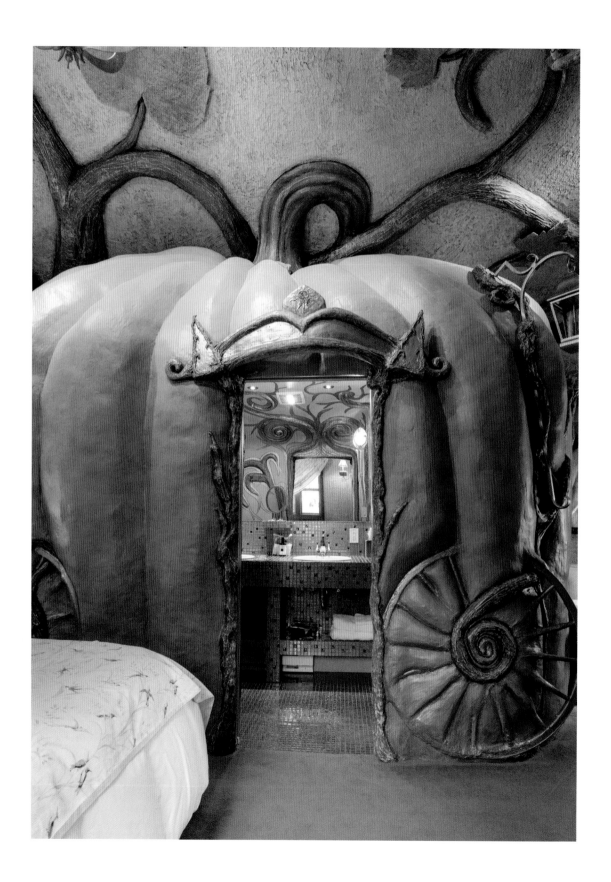

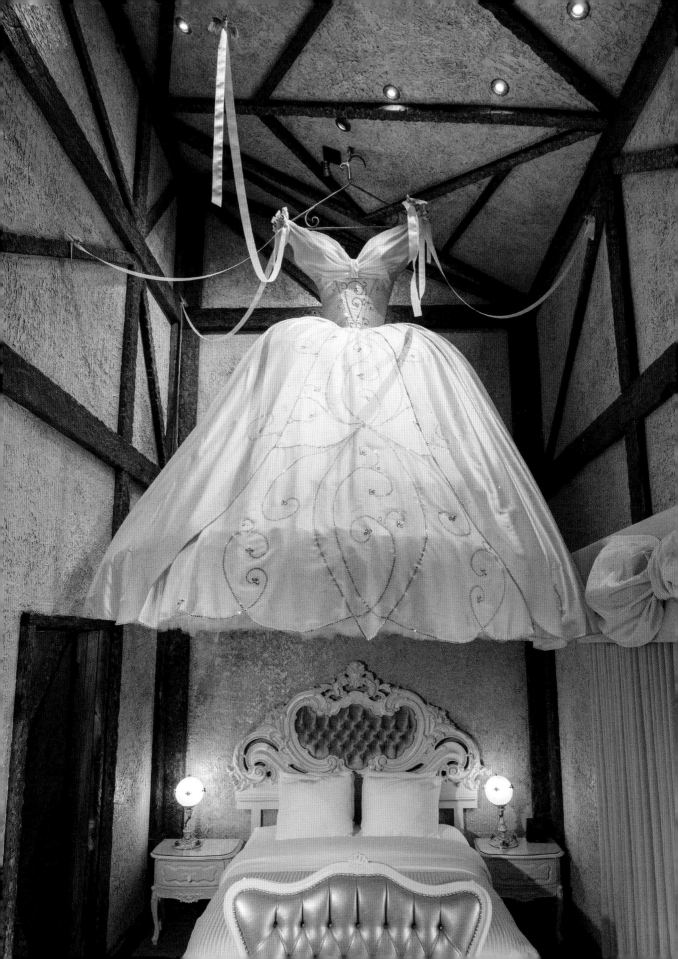

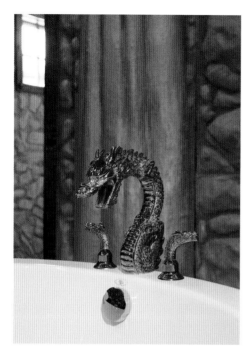

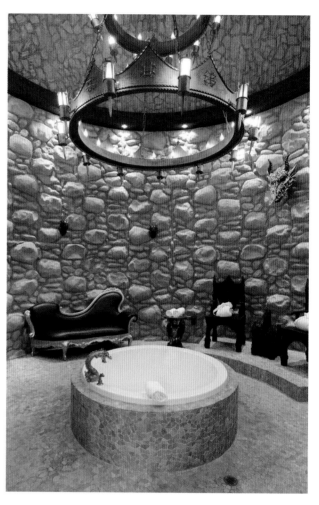

In the Crown of the Pendragons cottage at Stratton Falls, the circular bathroom is fit for royalty and built to mimic the inside of a castle turret. The 85-gallon (322 L) tub is adorned with an incredible dragon faucet.

Follow the yellow brick road into the Wizard's Emeralds room at the Roxbury Motel, which evokes the 1939 classic *The Wizard of Oz* with details including a mural of a red poppy field in the bathroom.

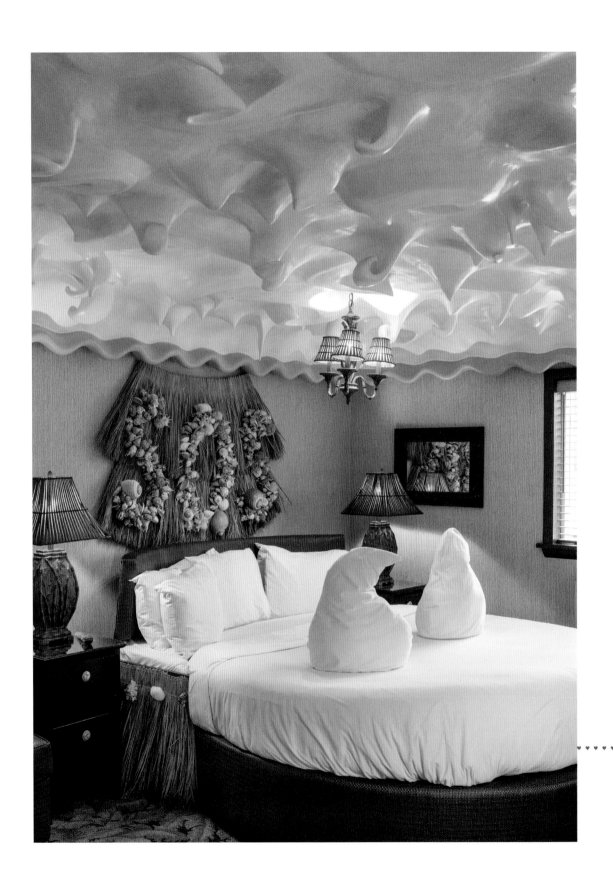

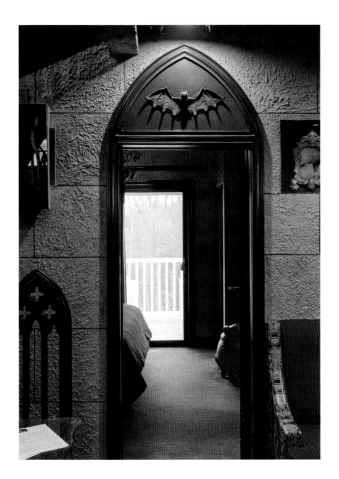

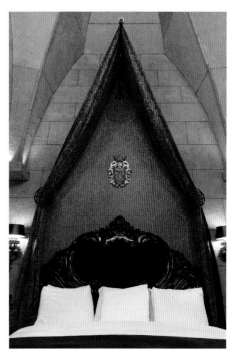

The Dracula's Fangs cottage at Stratton Falls features two unique bedrooms, one with a tall coffin-shaped canopy (*above*), the other with coffin-inspired details like brass wall railings, cushioned walls, and red velvet upholstery fit for a vampire (*left*).

Maryann's Coconut Cream Pie room at the Roxbury Motel is an homage to a dessert in *Gilligan's Island*. The impressive ceiling took the owners six months to carve, sculpt, and paint.

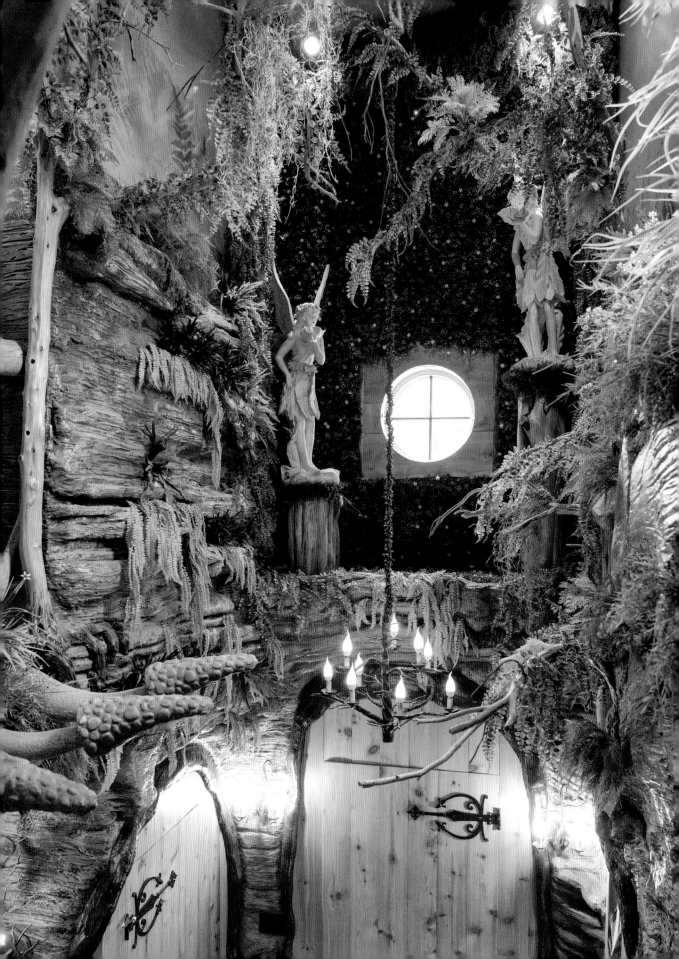

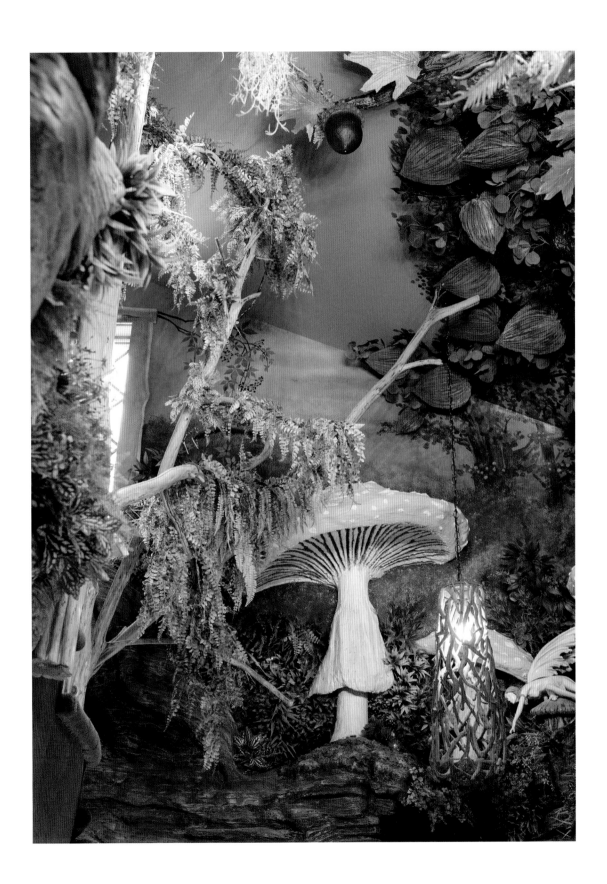

Grand Hotel

MACKINAC ISLAND, MICHIGAN

Grand Hotel boasts the longest porch in the world at 660 feet (201 m).

Grand Hotel opened on Mackinac Island, a small piece of land off the coast of Michigan, in 1887 and has been an iconic vacation destination for couples and families ever since.

One key element in its enduring appeal is its interior design, which was updated by Carleton Varney of the legendary firm Dorothy Draper & Company nearly a century after the hotel opened. Dorothy Draper was one of the most groundbreaking interior decorators of the twentieth century, known for her distinctive use of color and pattern. She created exhilarating spaces that delighted and even shocked her audience. Varney studied under her and learned the magic formula. "The key was the unexpected," he wrote, "that note in the symphony you're not ready for, the one that startles but never clashes." He went on to become the president of Dorothy Draper & Company, and in 1976, Varney took his refined but extravagant designs to the Grand Hotel, where he introduced bold patterns and bright pops of color in the more than 300 rooms. Throughout the property, you'll find carpeting, wallpaper, and drapes covered in stunning florals, plaids, and ribbons. The dining room has a cheery orange-and-green theme, and the ballroom has a vintage Hollywood Regency feel that reminds us of Palm Springs.

Mackinac Island is a car-free town; visitors get around on foot, by bike, or in horse-drawn carriages. Befitting this slow-paced escape, the Grand Hotel is a destination that feels out of time. Visitors can enjoy afternoon tea, dinner in the elegant dining room (so long as they follow the formal dress code), and even live music for evening dancing.

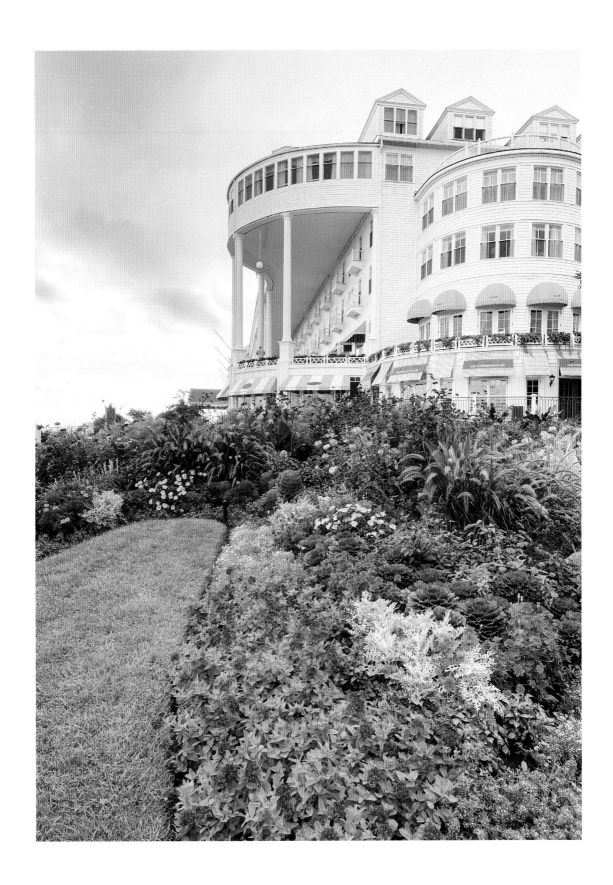

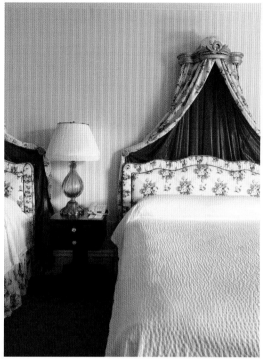
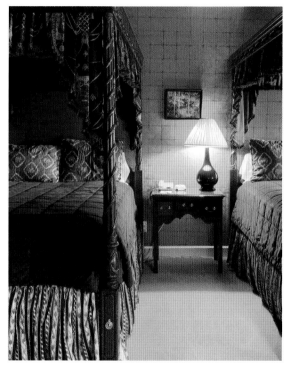

The property's impressive gardens (and in particular, its trademark geraniums) are referenced throughout the interior in the forms of carpeting, wall covering, and upholstery patterns.

♥ ♥

The highest view from the hotel can be found at the top of this magical staircase in the Cupola Bar.

The upscale dining room has a view of Lake Huron. Every meal is an event of its own with extensive menus and several courses.

Music is a key part of the Grand Hotel experience. There are several chances to catch a live performance throughout the day, from solo harpists at teatime to jazz ensembles in the evening.

Sybaris Pool Suites

LOCATIONS THROUGHOUT THE MIDWEST

The Paradise Swimming Pool suite at the Northbrook Sybaris has a view from the bedroom directly into the full-size private pool.

"A magical place where couples could shed the stress of daily life and reacquaint themselves with love. An oasis of privacy—no windows, no phones—dedicated to the enhancement of romantic marriage." This was the vision Sybaris founder Ken Knudson and his wife, Charlene, had when they opened their first hotel in Downers Grove, Illinois, in 1974. Over the next twenty-five years, they gained an adoring following that allowed them to expand to four more properties, in Frankfort and Northbrook, Illinois; Indianapolis, Indiana; and Mequon, Wisconsin.

Each Sybaris location offers several tiers of rooms, all of which have a full-size indoor private pool; other amenities include a Jacuzzi tub, mirrors, mood lighting, hooks above the bed outfitted with intimacy swings, and a Kama Sutra lounger that enables users to get into . . . unique positions. The largest Sybaris suite, the Chalet Swimming Pool, has one of everything—and even boasts a waterslide leading from the upper floor of the bedroom into the pool below. (Riding a waterslide while naked was one of the most hilarious and memorable experiences of our lives. We dare you to try it!)

In stark contrast to the explicitly sexy red satin and heart-shaped furniture found in most theme hotels, the chain's decor has a quintessentially midwestern, wholesome feel. The Knudsons' dedication to offering a sexy getaway in this immaculately clean and warmly welcoming environment has earned them a five-star reputation among their loyal fans.

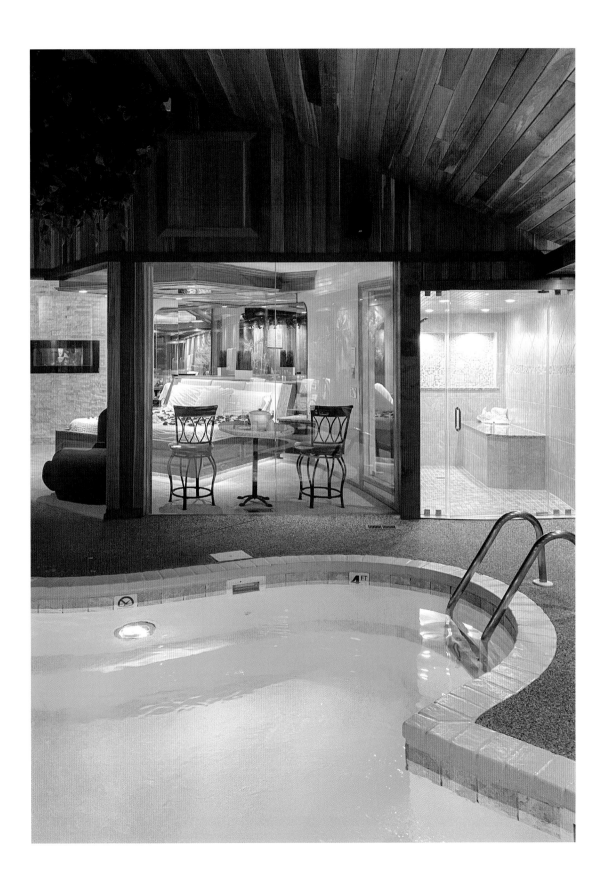

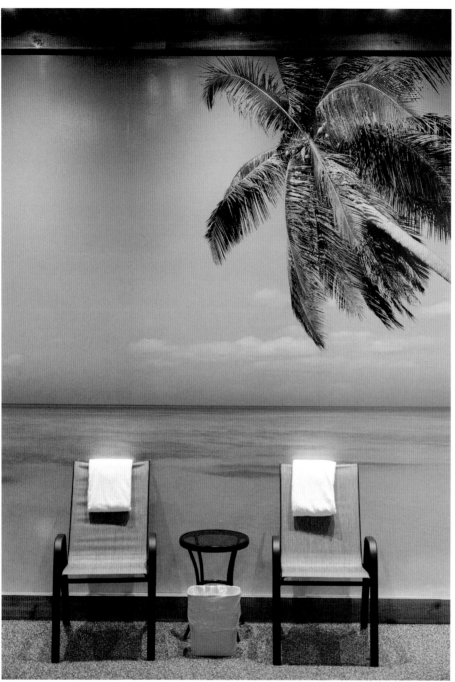

Murals around the Chalet Swimming Pool suite depict a breezy island getaway.

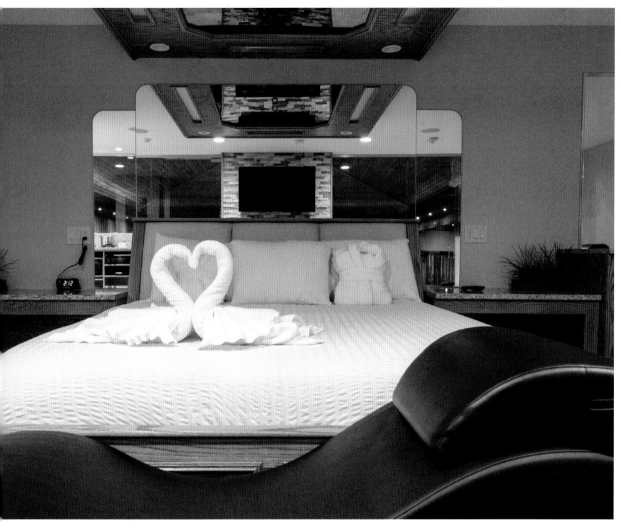

Each room has thoughtful touches, like towel swans, fluffy robes, and massage chairs.

The Anatomy of a PRETTY COOL Hotel Room

There are a few items everyone is used to seeing in a basic hotel room: a telephone, a TV, a desk, a bed, a single-cup coffee maker, generic artwork, maybe a robe if you're lucky. After staying in more than fifty theme hotels and adult escapes, however, we've discovered a whole new set of "staples." While not every item is always accounted for, these are the features that make regular appearances.

An Unconventional Bed

It's no surprise that hotels geared toward adults have made the bed their rooms' extravagant focal points, from the igloo bed of the Don Q Inn (page 92) to Sunset Inn & Suites' light-up UFO (page 85) to the sandwich bed in the Out to Lunch suite at the Rainbow Motel (*right*).

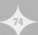

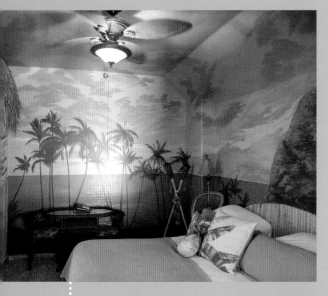

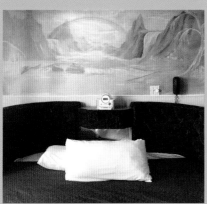

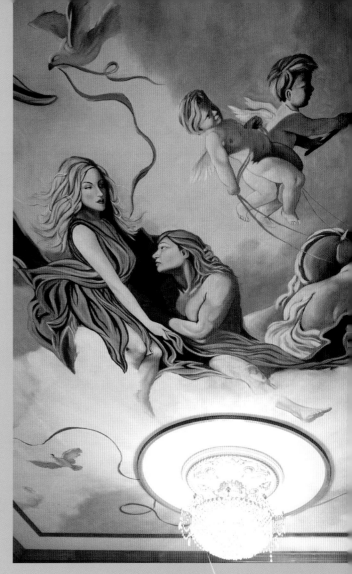

All-Encompassing Artwork

The best fantasy escapes are ones that can draw you into a whole new world—
one outside of time, space, and your day-to-day life. While oversize set pieces and
elaborately crafted beds can often be the most impressive aspects of a themed suite, a
mural can be the finishing touch that transforms a uniquely decorated hotel room into
a fully immersive experience. From the hieroglyphics in the Egyptian suite at the Black
Swan Inn (page 175) to the yellow brick road in the *Wizard of Oz*–themed suite at the
Roxbury (page 57), and from the 360-degree experience at sea in the Pirate Ship suite at
the Wildwood Inn (page 115) to the streets of France in the Paris room at Destinations Inn
(page 179), murals are key components of a fantastical design.

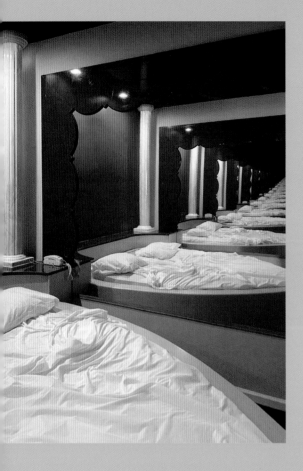

Mirrors on Mirrors on Mirrors

While seeing multiple reflections of yourself may not be your idea of a fantasy, mirrors on ceilings and surrounding tubs are one of the more common features in adults-only rooms. This sexy style was widely popularized in the seventies and installed in the honeymoon suites in the Poconos, and it can still be found in many romantic getaways today.

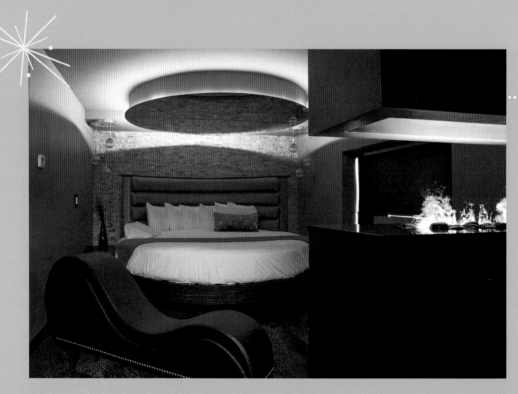

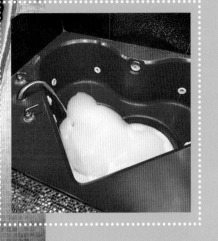

A Heart-Shaped Tub

Undoubtedly the symbol of the Poconos honeymoon heyday (more on this on page 28), the heart-shaped tub has become an Americana classic and will never go out of style for fans of romantic kitsch. Since *Life* magazine helped popularize the design in 1971, hotels across the country have created their own versions to entice visitors. Cove Pocono Resorts (page 15) still has some of the best we've ever seen, and for even wilder bathroom designs, don't miss the dragon tub at Anniversary Inn (page 169) or the Eiffel Tower shower at Destinations Inn (page 179).

Erotic Furniture

Since adults-only hotels' designs are geared toward creating a romantic environment perfect for anniversaries, honeymoons, or just a spicy afternoon away from the kids, erotic pieces are sometimes added as a perk for customers seeking a new and exciting experience in the safety and comfort of their private hotel room. These can range from a simple dance pole or curved lounger (as pictured here in the Lush suite at Axis in Chicago, Illinois) all the way to the elaborate Love Chair you find at Mon Chalet (page 157) or a Taiwan basket, invented by hotel founder Ken Knudson for his rooms at Sybaris Pool Suites (page 70).

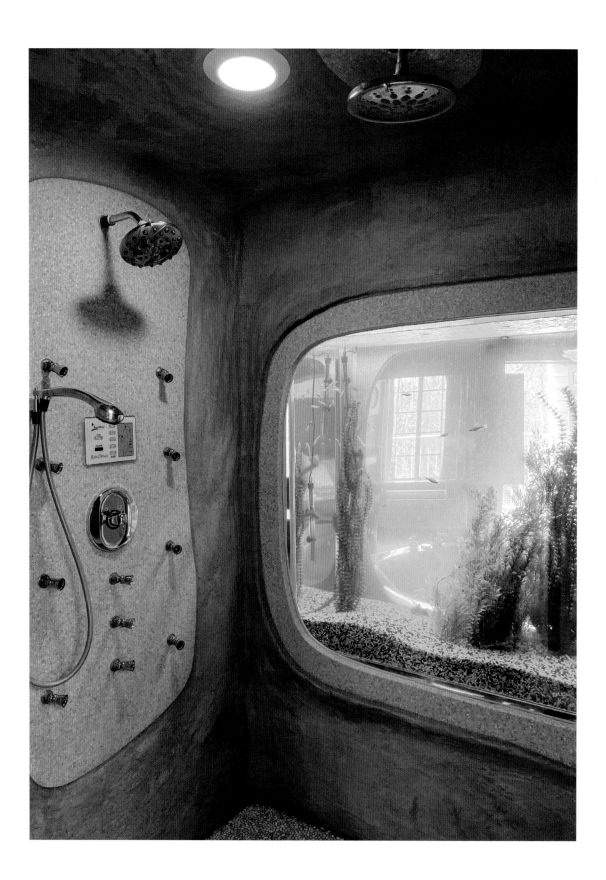

Best Western

In the Pearl Under the Sea room, a 350-gallon (1,325 L) aquarium serves as a window between the bedroom and the shower.

You could easily stay at this unassuming hotel and have no idea that there are themed rooms hidden just down the hall! With no signage to advertise them out front and no indications in the lobby, you really have to know what you're looking for. The website features the standard Best Western interface, but if you scroll through their room photos, you will notice several adults-only fantasy suites, including Crystal Cave, Pearl Under the Sea, Roman Palace, and Hearts Delight.

These rooms were designed by Gary Strobusch in 2010, when the hotel was a Designer Inn (see page 95), and the current owner decided to keep them intact. Before Gary and his wife, Sally, purchased the hotel, it was owned by Tom and Kathy Scholl, who were players in the themed suites category as well, specializing in rooms that honored the local history and landscape. One of their original designs for this hotel was a fur trapper–themed room; it has since been converted into a cabin room, with the animal pelts replaced by paintings of serene nature scenes, but the wooden logs mimicking cabin walls remain.

While Best Western is an international chain with thousands of franchises around the world, it is incredibly rare for them to have elaborate themed suites, and they aren't usually advertised—you have to find them through word of mouth or by asking each hotel. Two others worth seeking out are the Best Western Route 66 Rail Haven in Missouri (see page 135) and the Best Western Fireside Inn in Kingston, Ontario (see page 234).

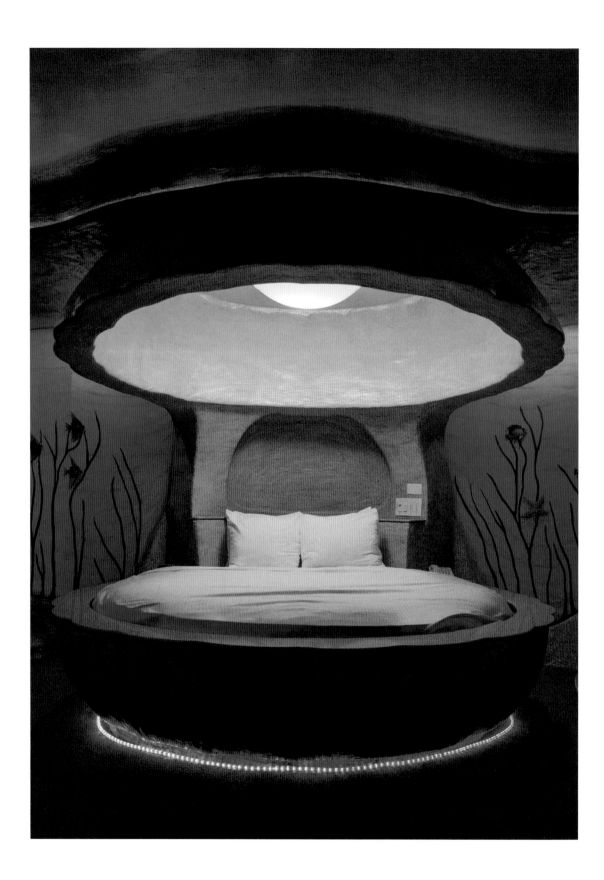

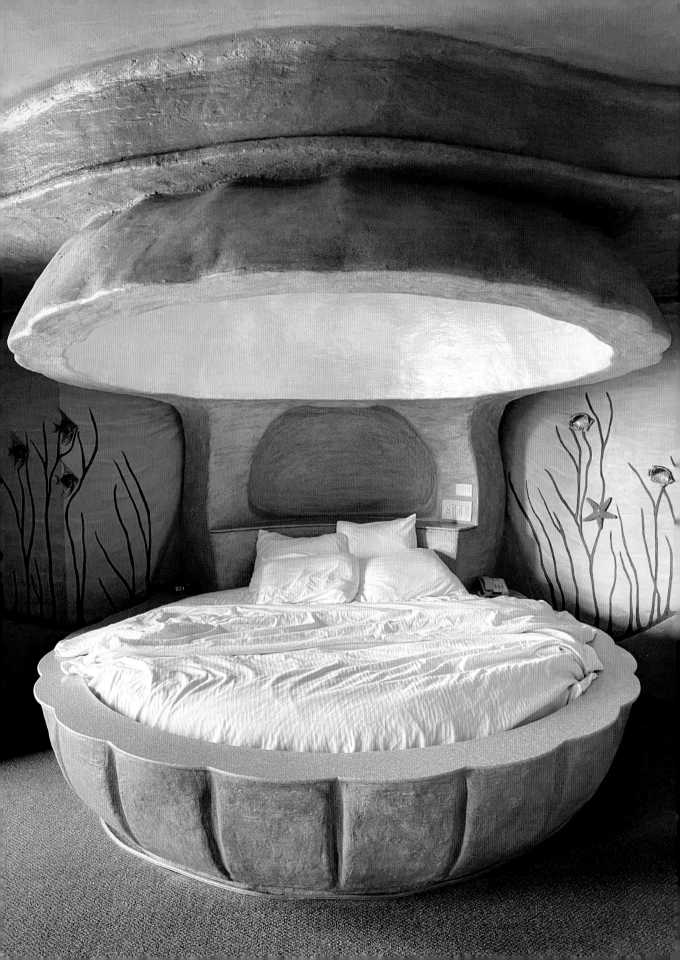

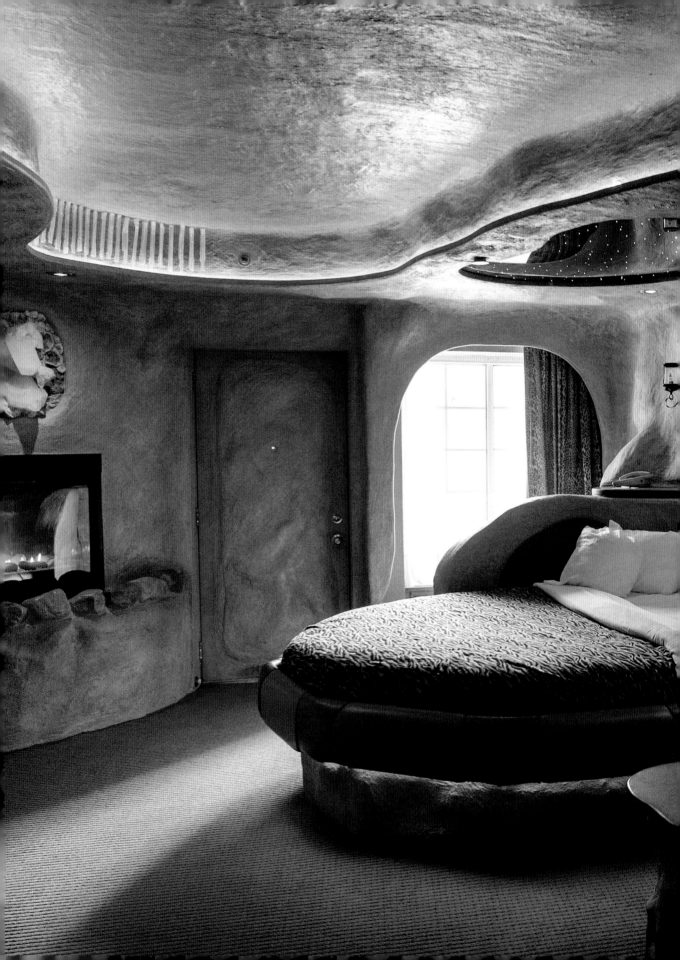

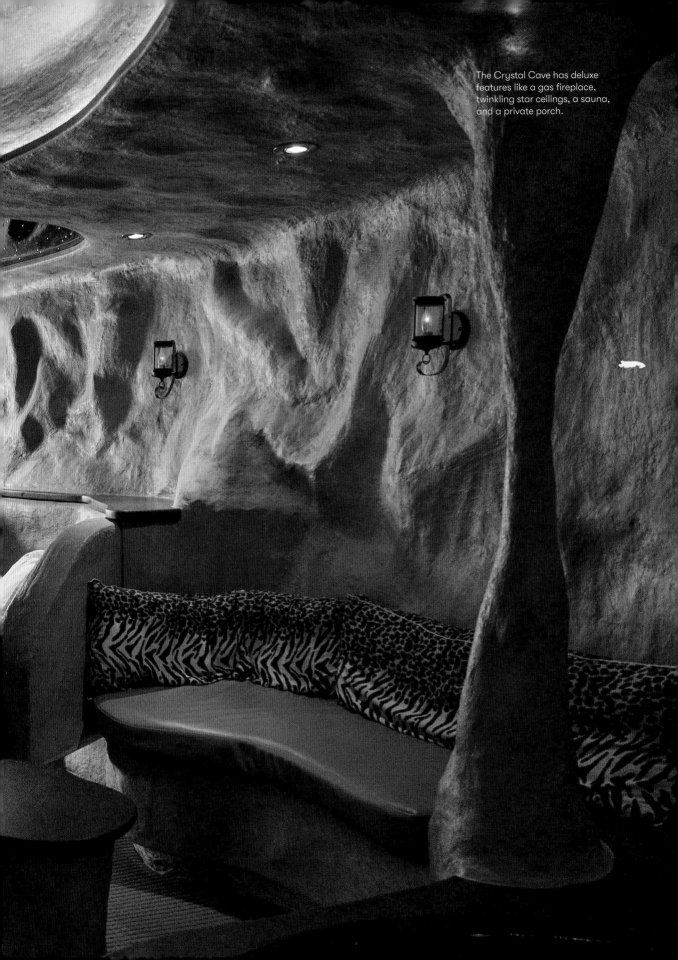

The Crystal Cave has deluxe features like a gas fireplace, twinkling star ceilings, a sauna, and a private porch.

Sunset Inn & Suites

CLINTON, ILLINOIS

Space Odyssey features a giant UFO bed with built-in speakers and glowing black-light murals throughout the room.

This family-owned hotel sits in the countryside of Illinois, roughly two and a half hours from Chicago, Indianapolis, and St. Louis. It has thirteen fantasy suites that are adults-only, but it also offers standard rooms and an indoor pool that are child-friendly. The themed rooms are a mixture of classic designs made by Gary Strobusch and his manufacturing company Rainbow Nights Inc. (see page 104), and newer, custom styles that are unique to the hotel. Two of our favorites are the Rainforest room, with palm trees, foliage, and a light-up star ceiling, and the Cabin Fever room, which perfectly mimics the feel of a cozy cottage in the woods. Some of the themed rooms are smoking-optional, but the hotel offers to neutralize the odor before the next guests' arrival and has high-quality air filters to make the spaces as comfortable as possible.

A Vegas-like gaming parlor with slot machines and a tiki-themed room that has several arcade games and is connected to the hotel pool make this a perfect destination for locals looking to enjoy a night away from home or host an afternoon kids' birthday party. For out-of-towners like us, several nights were required to make the most of our journey. We loved hopping from Safari Adventure with its giraffe-print carpeting to the winter wonderland of Starlight Glacier to a night at Paradise Beach, a sunny escape in the middle of the midwestern winter.

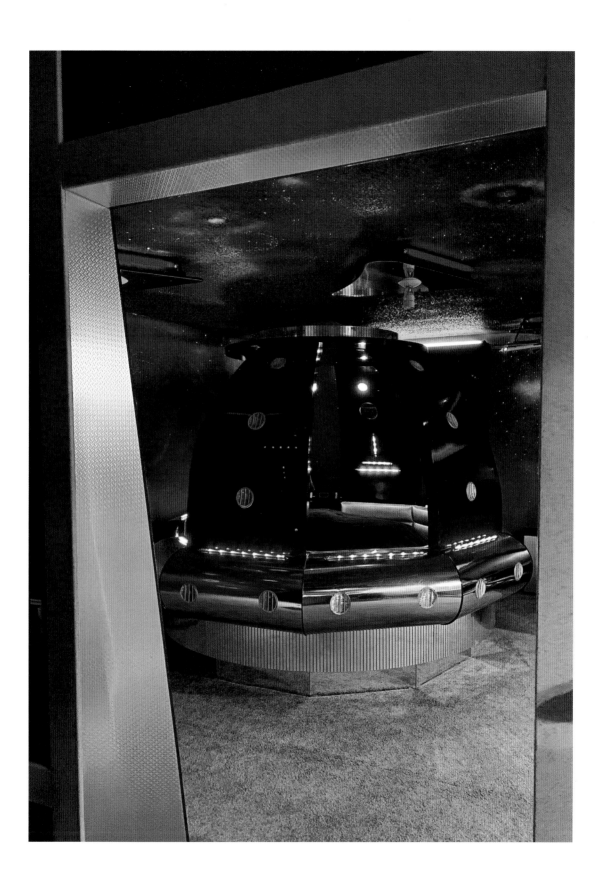

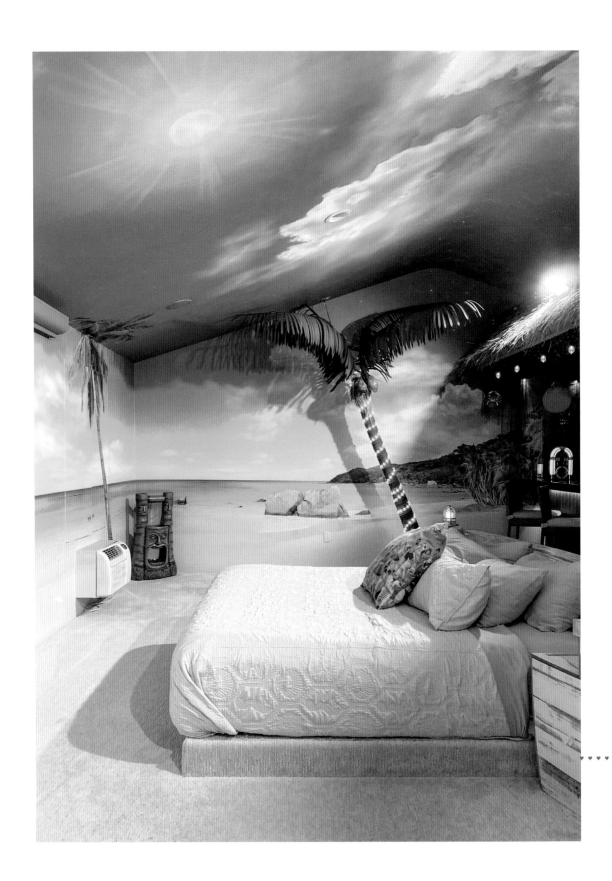

Hawaiian Waters is full of colorful murals depicting ocean views, sunset skies, and jungle scenes.

Paradise Beach offers guests a 360-degree island experience. From the sand-colored carpeting to the palm trees and tiki bar, this room had us reaching for the sunscreen.

Don Q Inn

DODGEVILLE, WISCONSIN

Don Quinn was a pilot, which is why he wanted to incorporate an airplane into the property.

While many theme hotels are hiding in plain sight, Don Q Inn announces itself as a quirky destination as soon as you approach the lawn, which has a retired military cargo plane parked right up front. The unusual decor doesn't stop there: When you enter the lobby, you're greeted with a circle of vintage barber chairs around a fireplace. The whole hotel is filled with these recycled antiques, ranging from wagon wheels and rifles to 300-gallon (1,136 L) cheese vats turned into soaking tubs. This creative and eccentric aesthetic is said to have been inspired by the House on the Rock, a nearby attraction full of bizarre inventions and eclectic collections.

Opened in 1974 by Don Quinn, the inn originally had several standard rooms, seven themed suites, and a restaurant that was connected to the hotel by an underground tunnel. Quinn sold the property five years later to developer Roger Dehring, who recognized the special experience Don Q Inn offered guests and decided to keep the hotel true to its original style, adding thirteen more themed rooms. Inspired by the creativity of the Don Q, Dehring went on to open the theme hotel chain FantaSuites with his business partner, Michael Isabella (read more about the chain on page 100). Dehring described Don Quinn as one of the most interesting and unusual characters he'd ever met: "He was able to see and do things that no one else in the world would have." Dehring continued to think outside the box when it came to adding fantasy rooms to the hotel. The new themes included Up, Up, and Away! (featuring a hot-air-balloon bed suspended from the ceiling), a classic cave suite,

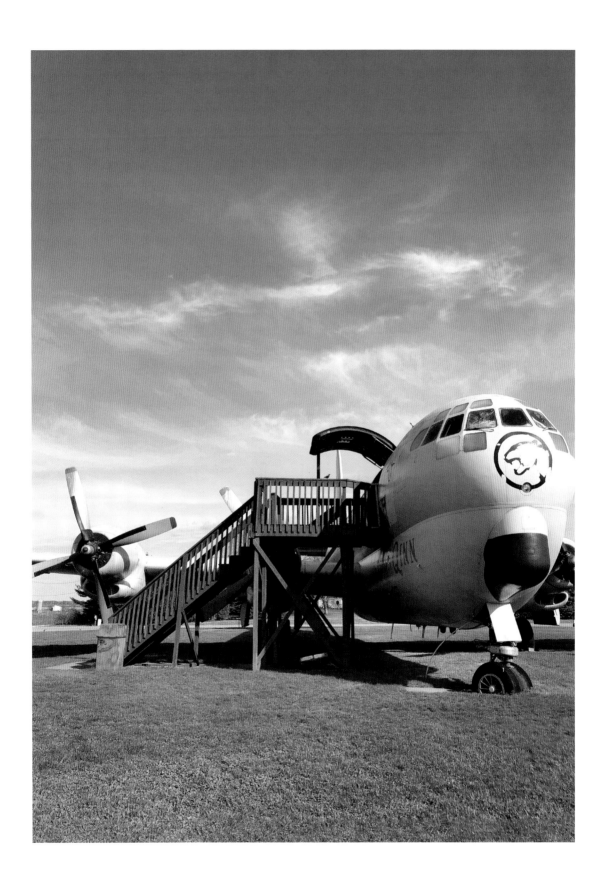

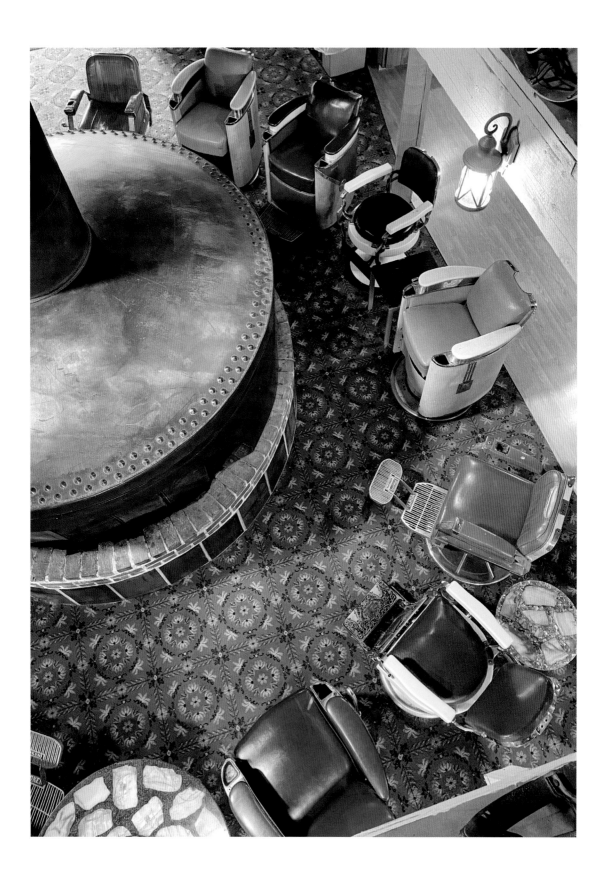

OPPOSITE The fireplace in the lobby was made from a locomotive engine.

BELOW LEFT The lobby decor shows the complexities of maintaining a vintage facility in the modern age.

BELOW RIGHT Long hallways that feel like underground tunnels lead from one wing of the hotel to the other.

and iconic outer space–themed rooms called Tranquility Base No. 1 and Tranquility Base No. 2.

Much of the hotel remains as it was after Dehring took over, though the restaurant had to be shut down due to a devastating fire. (The Swingers room, which featured a bed hanging from the ceiling by large chains, was also eliminated after frequent noise complaints from nearby rooms.) This hotel is rich in history and certainly worth a visit for fans of themed decor, whether for an overnight or for one of its weekly public tours.

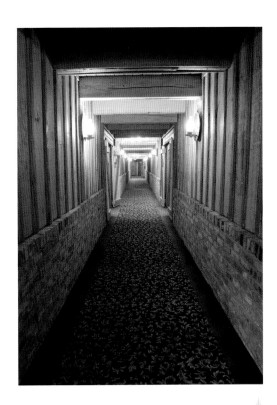

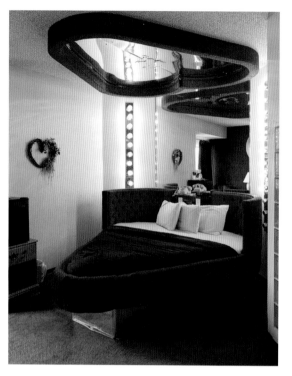
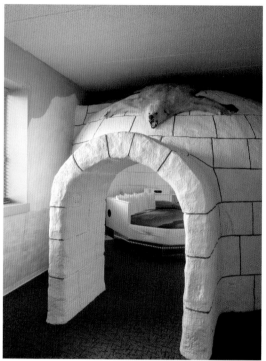
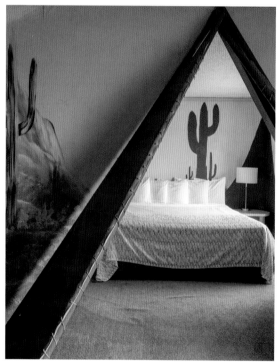
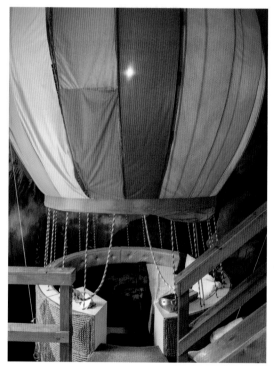

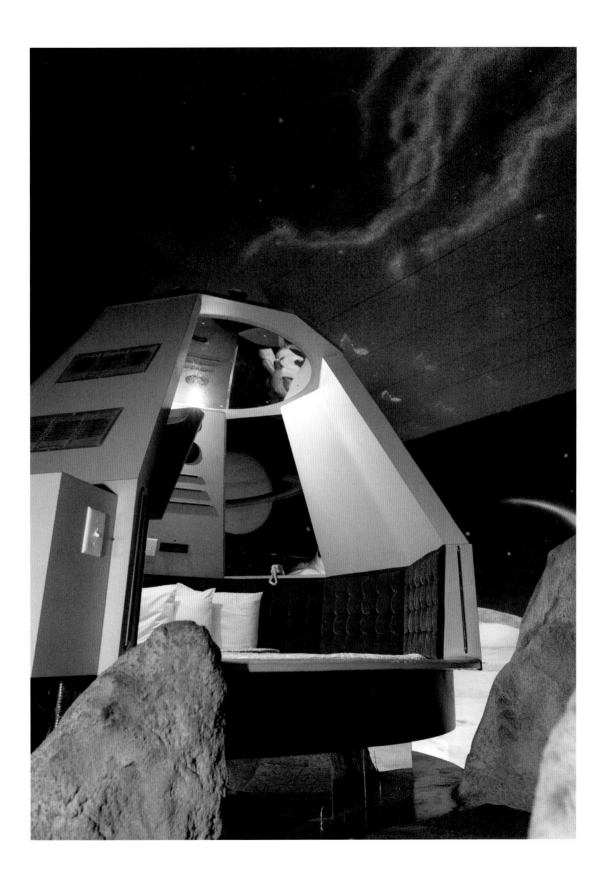

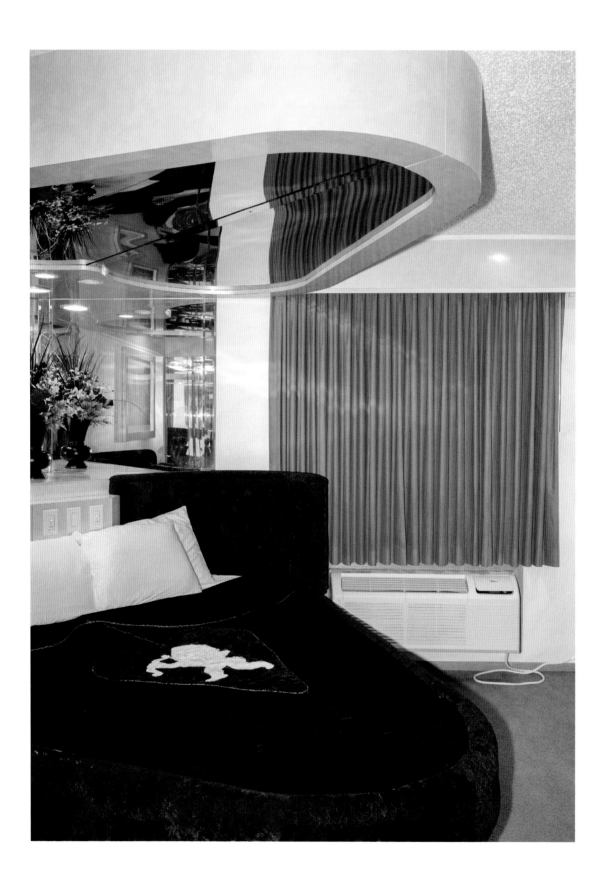

Designer Inn & Suites

TOLEDO, IOWA

In the Hearts Delight room, pink heart-shaped mirrors have been installed on the ceiling above both the bed and Jacuzzi.

This former Days Inn was purchased by Gary and Sally Strobusch in 2003. At the time, Gary was a highly sought-after fantasy suite designer for hotel brands across the United States with his manufacturing company, Rainbow Nights Inc. (see page 104). Finally taking the opportunity to create a fantasy getaway for himself, Strobusch went to work producing seven elaborate suites, some of which took six months to complete.

Bolstered by technological advances since he first began designing fantasy suites, he ushered in a new style that was a departure from the classic eighties look. Hand-tiled tubs and waterfalls were replaced by sleek Jacuzzis and fiber-optic-star ceilings, which helped bring an updated, futuristic feel to the rooms. Showers were outfitted with elaborate bells and whistles, including more than ten steam functions and spray nozzles. His version of the cave suite, the Crystal Cave, has a typical floor-to-ceiling rock texture but also incorporates windows and natural light, giving it a fresh feel.

The rooms at Designer Inn have been well loved over the years, but many of Strobusch's original designs are still intact and in good condition. Turn to page 79 to see more of his work at a property in Galena, Illinois, that is now a Best Western.

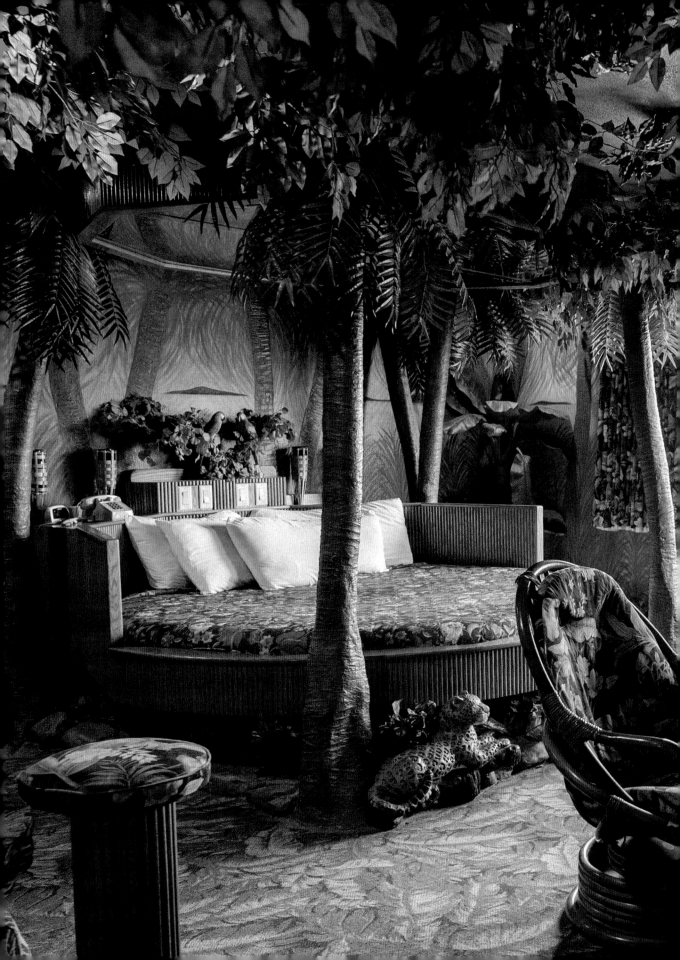

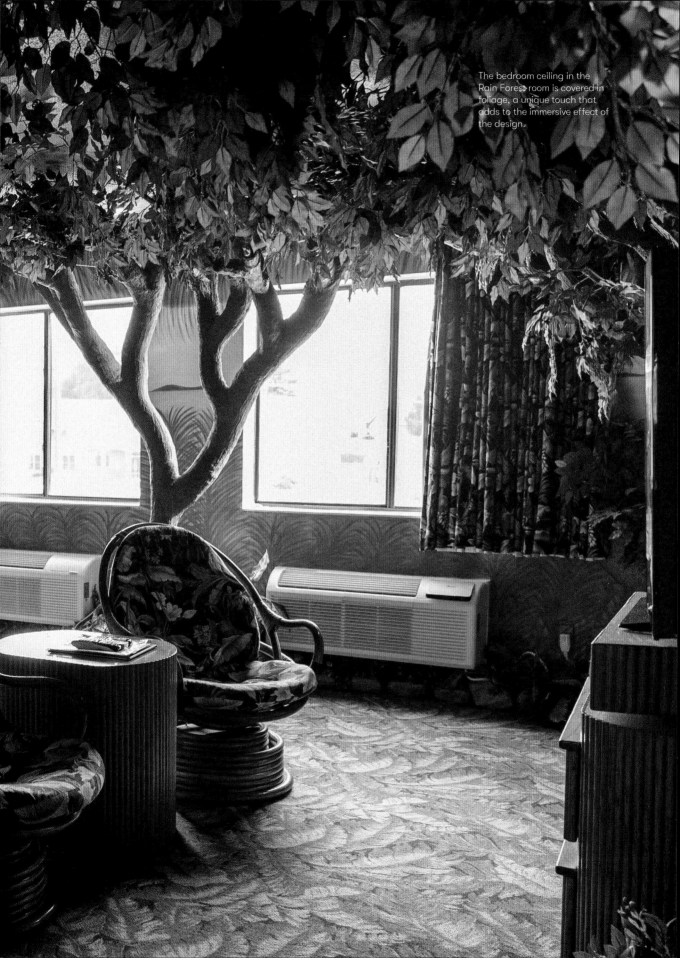

The bedroom ceiling in the Rain Forest room is covered in foliage, a unique touch that adds to the immersive effect of the design.

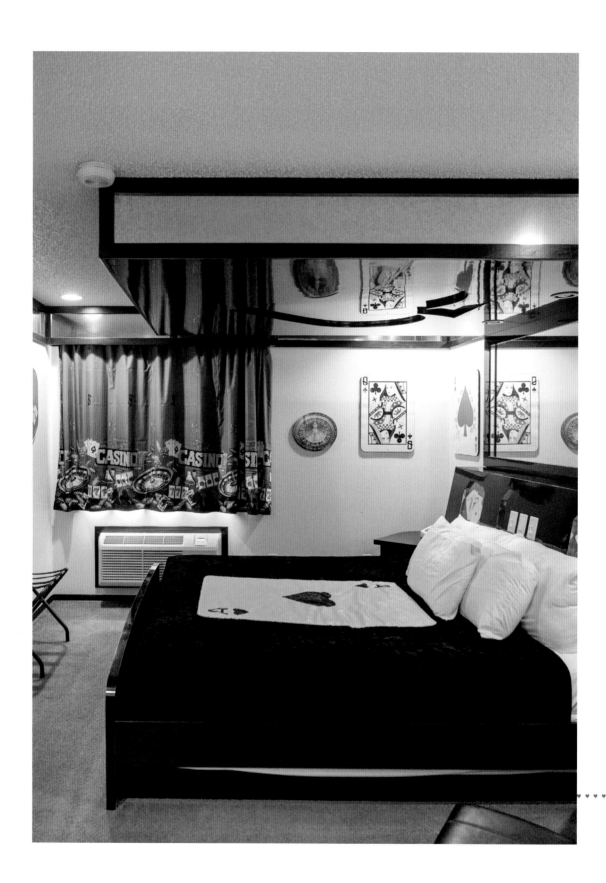

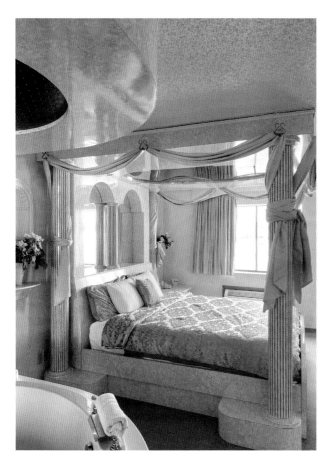

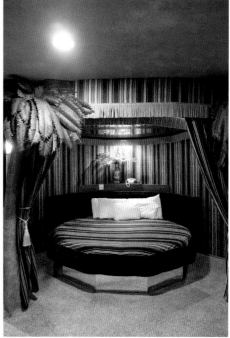

ABOVE Arabian Nights features floor-to-ceiling curtains that were cut and sewn right in the room to be sure they were the perfect dimensions.

LEFT Light switches by the pillows control a starlit ceiling built directly into the Roman Retreat bedframe.

Aces Wild is a Vegas-inspired suite that includes a reflective ceiling in the shape of a spade.

FantaSuites and the Rise of the American Theme Hotel

After the Great Depression and World War II, America entered an era in which escape and fantasy were welcome (Disneyland opened in 1955) and vacations were becoming more affordable for the middle class. Enter the Madonna Inn (page 193), considered the destination that broke the mold when it came to hotel design. In the sixties, when every room was expected to look the same, the Madonna's owners used themed and colorful designs to make each room stand out.

A decade later, Don Quinn built his semi-eponymous hotel (Don Q Inn, page 88), which took a much more literal approach to themed design. In the Float room, you could sleep in an actual boat turned bed; the Arabian Nights room was styled to feel like a lavish tent; and the Mid-Evil room featured shackles and suits of armor. Heavily influenced by the nearby attraction House on the Rock (a home and interactive museum), the hotel had an

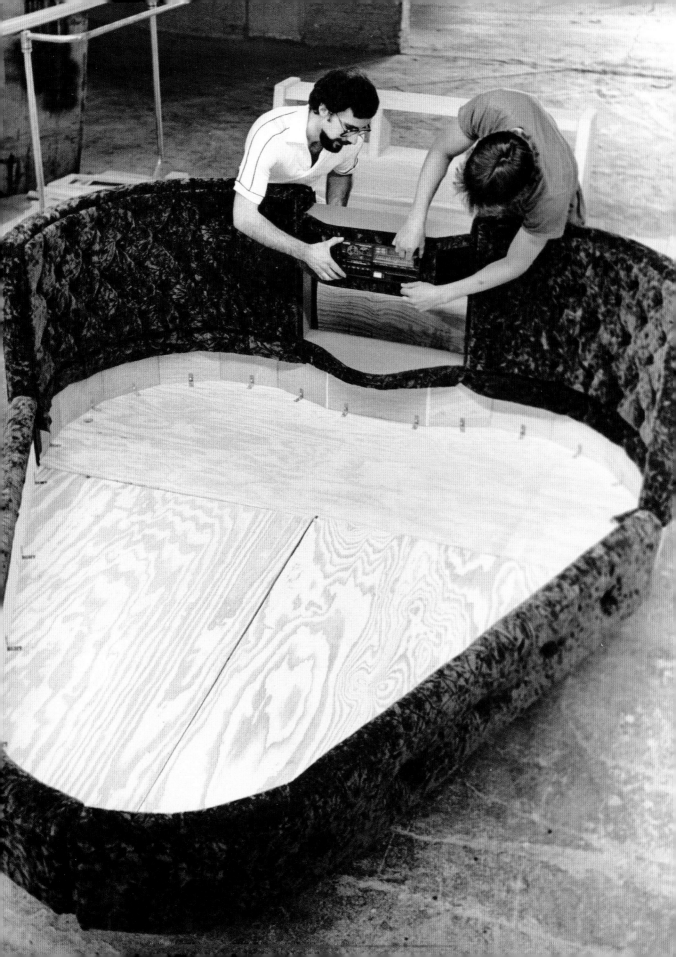

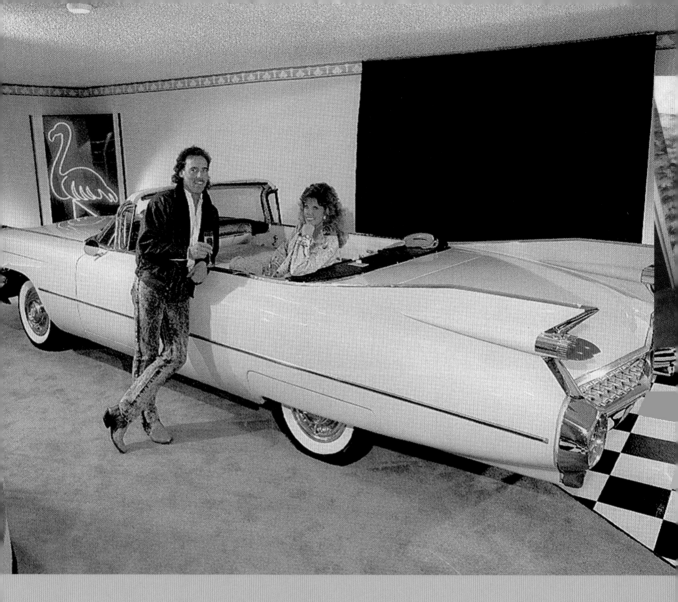

intentionally eclectic and curious feel. After just five years, Quinn sold the inn to real estate developer Roger Dehring, who decided to expand on Quinn's ideas and create a chain of theme hotels. It was then that the FantaSuites brand was born.

Dehring worked with his brother-in-law Michael Isabella to bring the FantaSuites to life. FantaSuites was not always the name of the hotel but referred to the style of room offered.

This allowed Dehring and Isabella to either build a business geared strictly toward fantasy or convert a few rooms in an existing chain hotel into themed suites but with recognizable branding.

FantaSuites' popularity quickly grew, and within the next few years, Dehring and Isabella had opened locations in Michigan, Indiana, Iowa, Texas, and Colorado, and added themed rooms to several of Dehring's other hotel chains. Business

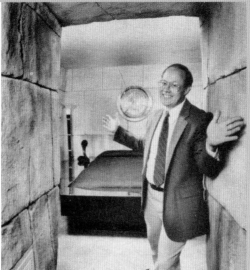

was booming, and there was an
obvious demand for this adults-only
fantasy escape. Other hoteliers,
like Tom and Kathy Scholl, began
to entice travelers with specialty
rooms. Their chain of Midwest hotels
offered historical and region-specific
themes, like the Farmer room in
Wisconsin (which had a farm gate
as a headboard) and the Fur Trapper
room in Illinois (which mimicked the
inside of a log cabin).

Unlike Poconos-style lovers
escapes, as a *Chicago Tribune* article
noted, these hotels had a mood that
was "more playful than sensual"
and, except for in a few suites with
ceiling mirrors, "not erotic." With
FantaSuites, Dehring and Isabella's
aim was to give their local customers
something unusual but affordable.
Once their business reached
Colorado, Dehring remembers a
local minister telling his sizable

congregation that these hotel rooms were ideal for a marriage retreat.

Something that made the fantasy rooms especially difficult to execute, however, was that property owners had to find both specialty contractors and artists to create and maintain these attractions. One hugely useful resource was Rainbow Nights Inc., a company owned by Gary Strobusch, who had a background in custom car designs and metal fabrication and had started making furniture geared toward specialty hotels. By 2003, Strobusch had spent the majority of his career designing and installing themed rooms for places he didn't own. He was the industry's best-kept secret and was in high demand for those in the know—he spent 300 days a year on the road in hotel rooms across the Midwest and surrounding regions, working on installations. In 2003, Strobusch and his wife, Sally, decided it was time to open their own hotel, and Designer Inn & Suites (page 95) was born. They purchased a second hotel, in Galena, Illinois, in 2010 (it was later turned into a Best Western—see page 79).

Despite the wild success of these fantasy and theme hotels, most of them have shut down or been demolished or, at the very least, rebranded. Dehring speculates that the increased affordability of long-distance travel has much to do with the decline: "Now instead of going to a room that makes you feel like you're in the Caribbean, you just get on a plane and go to the Caribbean." Strobusch also points to a shift in the manufacturing side of things. Companies don't want to do small runs of custom-colored tubs or fiberglass ceiling panels—they want standardized furniture and fewer options, leaving room for more profit. The suites themselves have become more expensive to build, which in turn makes maintenance and expansion difficult.

Every theme hotel owner seems to talk about the challenge of preserving the details and character of a fantasy room. "You really have to keep them up," says Strobusch, who considers his rooms his artwork, and if the company buying the hotel doesn't understand, the rooms will slowly fall apart and become less desirable. Thankfully, despite the decline, a number of themed gems remain. The Don Q Inn maintains many of its original rooms despite changing ownership multiple times, and although the FantaSuites heyday has come and gone, their iconic designs and kitschy replicas remain a legacy in the theme hotel category, as well as a rich example of American imagination and creativity.

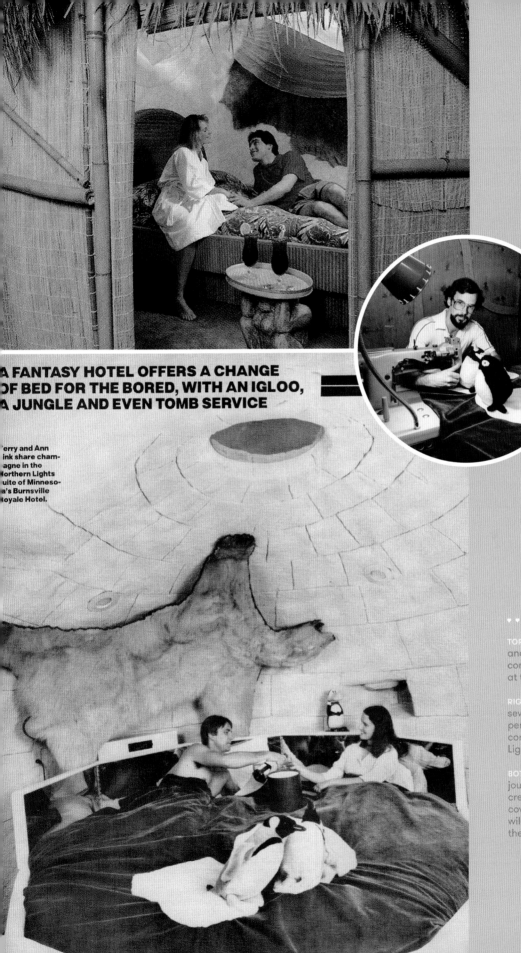

A FANTASY HOTEL OFFERS A CHANGE OF BED FOR THE BORED, WITH AN IGLOO, A JUNGLE AND EVEN TOMB SERVICE

Terry and Ann
Fink share cham-
pagne in the
Northern Lights
Suite of Minneso-
ta's Burnsville
Royale Hotel.

105

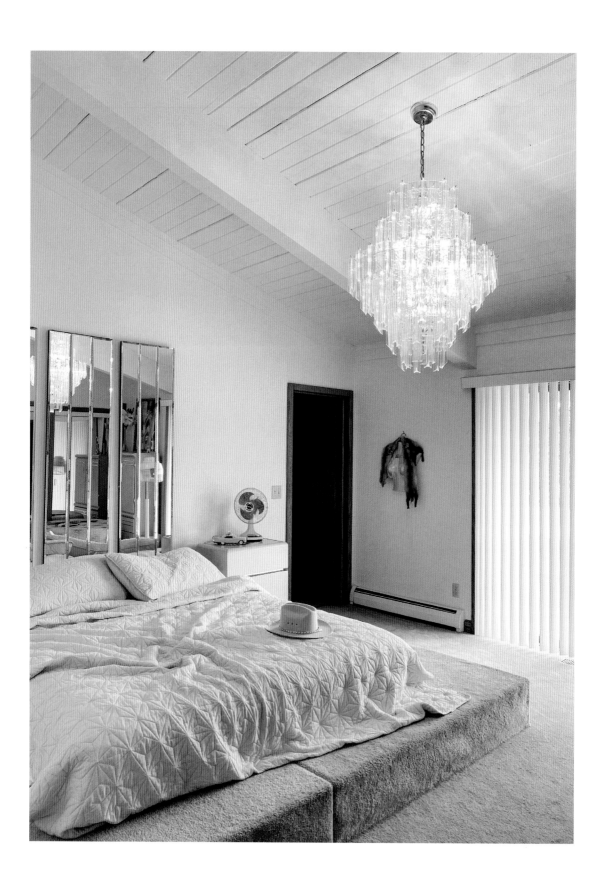

Grandpa's Pool House

STANCHFIELD, MINNESOTA

The carpeted platform and beveled mirrors instantly bring a vintage feel to this modern-day bedroom.

While scouring the country for vintage hotels with authentic eighties furniture and artwork, we were thrilled to stumble upon this vacation rental in the small town of Stanchfield, Minnesota. The project started in 2020 when Eva Slattery purchased her grandparents' former home, originally built in 1980, and began to redesign the interiors to transform the property into a retro, kitschy getaway with a Hollywood Regency flair. Complete with massive Lucite chandeliers, thrifted taxidermy, wood paneling, and religious imagery, this home feels warmly nostalgic and incredibly familiar, like a childhood memory.

Something as unique as Grandpa's Pool House was sure to raise some eyebrows in Stanchfield, which has a population of just over seventy. But thanks to Slattery's incredible knack for design, people are coming from surrounding cities and states to enjoy her creation. "Grandpa's" full-size indoor pool can be seen through large windows in the living room, inviting visitors to swim and relax any time of day or night. This eclectic destination can accommodate large groups and is perfect for a vacation, event, or photo shoot. It's a wonderful example of how to stay true to oneself and not be afraid to stand out.

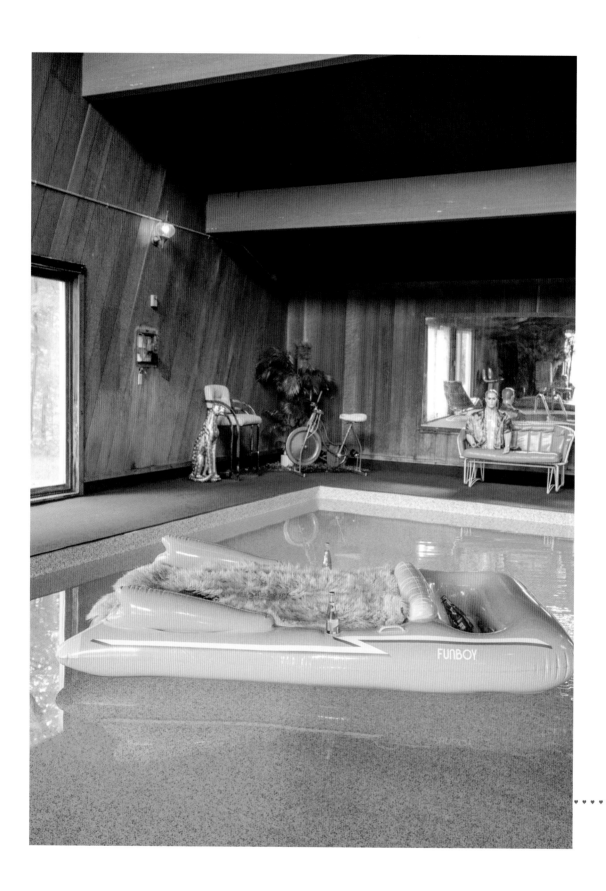

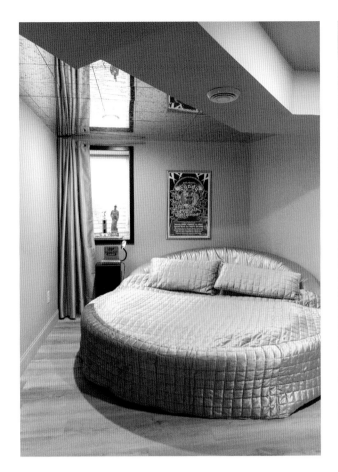

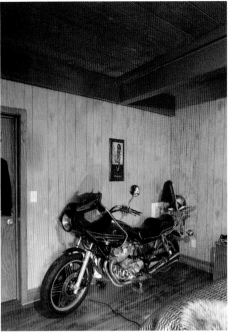

ABOVE A motorcycle bolted to the floor in the Biker bedroom provides a unique photo op.

LEFT Each bedroom has a specific color or theme, including gold, wilderness, and lily pad green.

The eponymous indoor pool (the rental's main attraction) is styled like a colorful movie set.

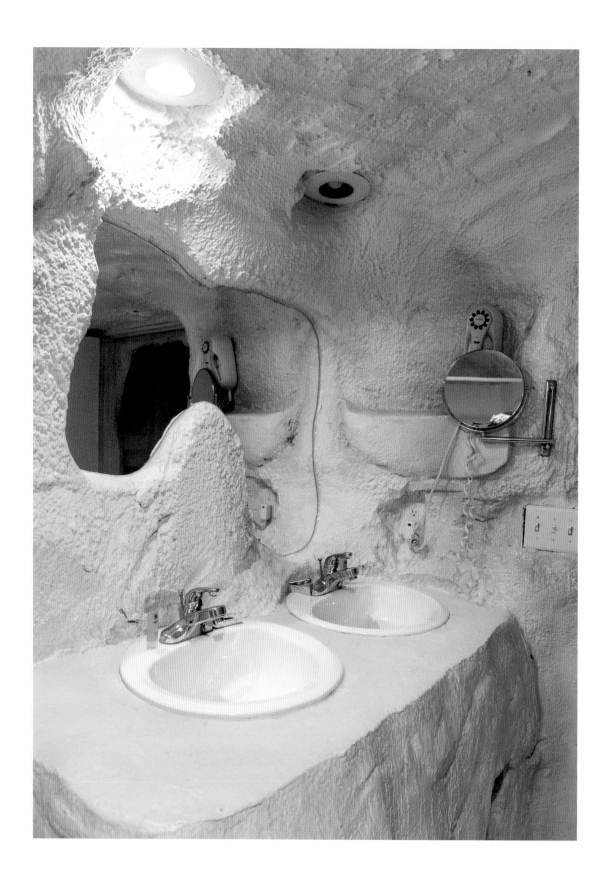

Wildwood Inn

Each element of the Arctic Cave is carved out of "ice," from the bathroom counter to the side tables and chairs.

This sprawling theme hotel in northern Kentucky boasts twenty-seven different themed rooms, including family suites, which feature bunk beds and extra space for children. Opened in 1932, the Wildwood Inn was generic lodging until 1978, when the owners' son (who took over in 1976) added the first spa to a suite. From there, he created the Tropical Dome: an indoor pool in what feels like a greenhouse enclosure with both real and fake greenery all around as well as large seashells, hanging parrot sculptures, and a waterfall feature. The hotel continued to expand until 2004, when the latest themed rooms were added.

The themes range from the classics made popular by the FantaSuites brand (see page 100), like nautical and fifties, to the totally unique Pirate Ship suite, which uses large-scale murals intersecting with set pieces to mimic the feeling of being on a ship. Some rooms include a heart-shaped tub or a replica of the champagne-glass whirlpool from the Poconos (see page 18), and the elaborate Arctic Cave room has meticulously carved blue walls and no windows. This family-friendly hotel hosts groups and birthday parties, so it might not have the quiet, intimate feel of a couples resort, but the dramatically designed rooms are certainly enough to draw interest from any theme hotel fan.

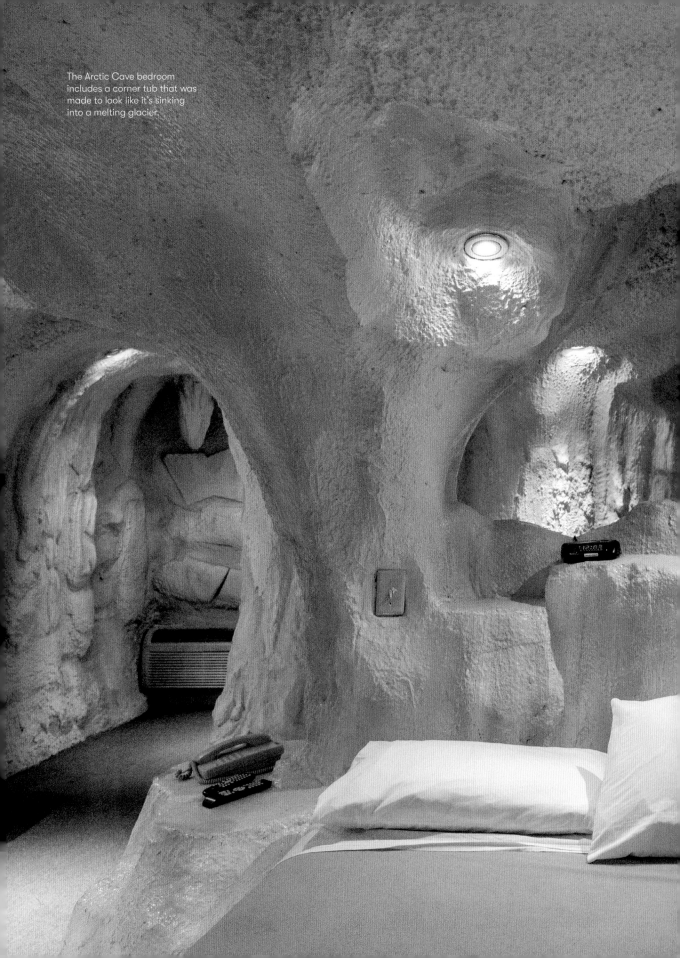

The Arctic Cave bedroom includes a corner tub that was made to look like it's sinking into a melting glacier.

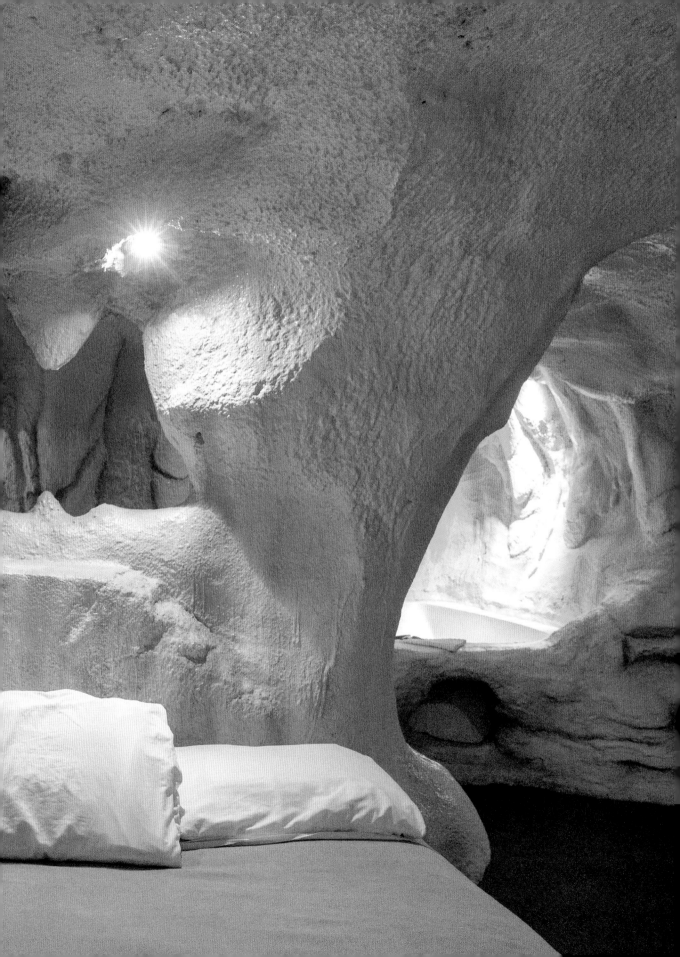

The Tropical Dome is a family-friendly space that includes arcade games along with the water features.

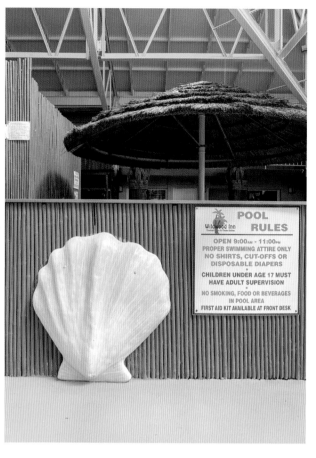

The Pirate Ship is multilevel and, in addition to this king-size bed, has numerous bunk beds, accommodating up to six guests.

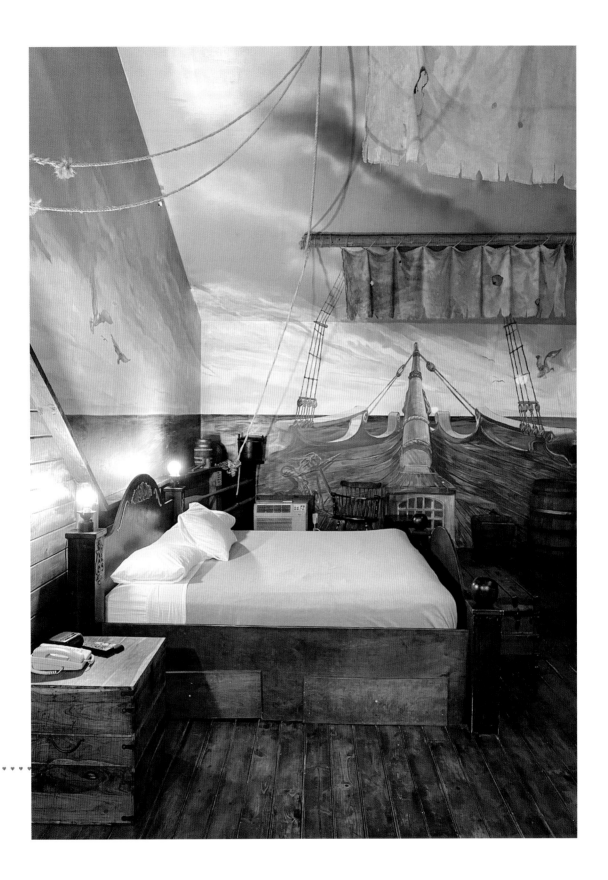

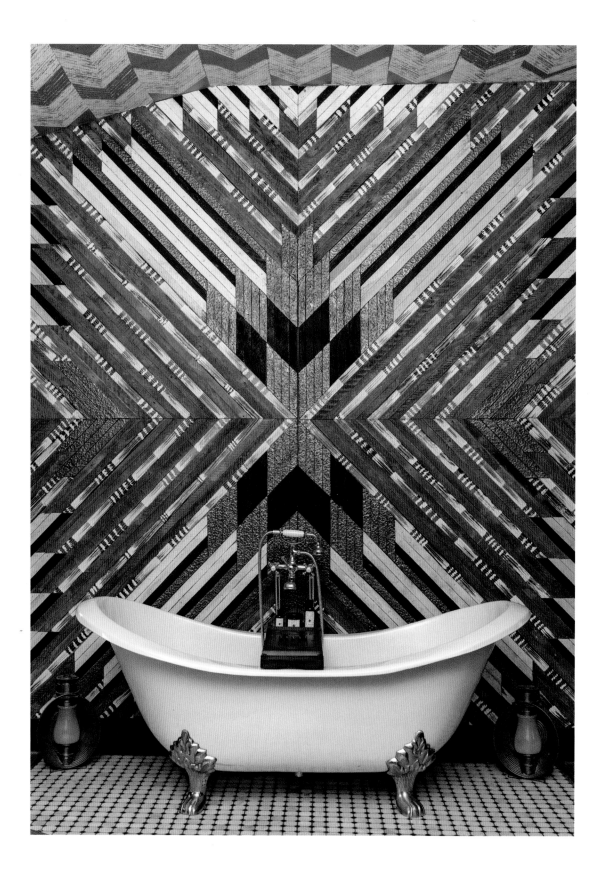

Urban Cowboy Hotels

BIG INDIAN, NEW YORK; NASHVILLE, TENNESSEE

The Cabin at Urban Cowboy Nashville (as well as the Catskills location, pictured on the following pages) features their signature woodwork designs and intricate ceiling patterns.

From the moment you walk in, Urban Cowboy Hotels transport you to a perfectly curated rustic-but-glamorous world. While most theme hotels save their pizzazz for the guest rooms, these are top-to-bottom handcrafted, stylistically impressive southwestern designs. The floors are solid wood, much of the furniture is well-worn leather, antlers are used in just about every type of fixture, and the walls and ceilings have hand-printed patterns by artist Clinton Van Gemert. The animal skulls, taxidermy, and antique musical instruments make for a perfect mixture of cowboy kitsch. The check-in desk doubles as a bar that feels like an Old West saloon, and you walk away with a welcome whiskey in hand along with your room key.

Lyon Porter and his partner, Jersey Banks, started Urban Cowboy in 2014 in Brooklyn, New York, but that original location now serves as a design studio while the Catskills and Nashville spots are home to the hotels (a new property in Denver is also in development). Each location has a bar and restaurant on-site, and the drinks and food are some of the best we've had on the road.

Both locations have an adults-only, elevated summer camp feel. The atmosphere is sophisticated but communal, and the decor is raw and authentic. Sitting by a fire listening to live music in the parlor, you can't help but feel transported to a simpler, warmer time.

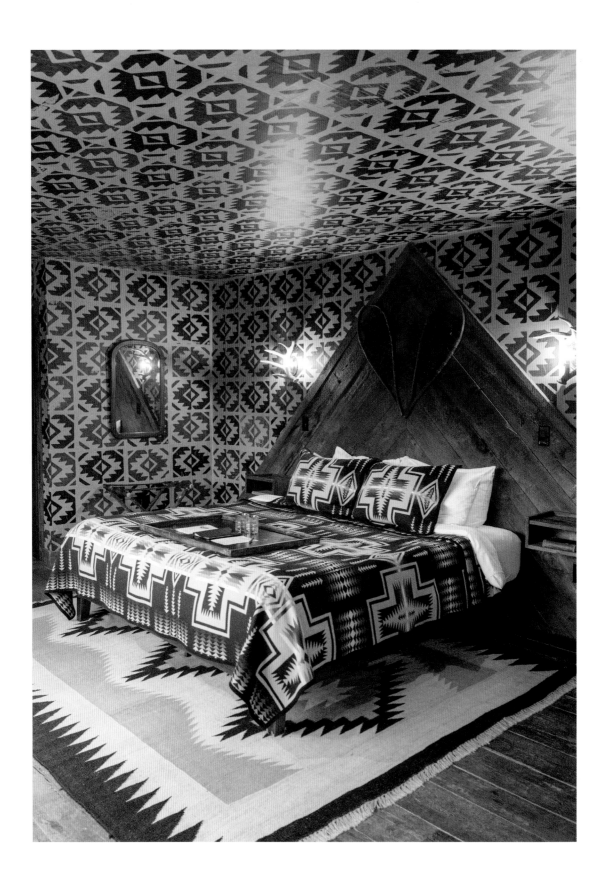

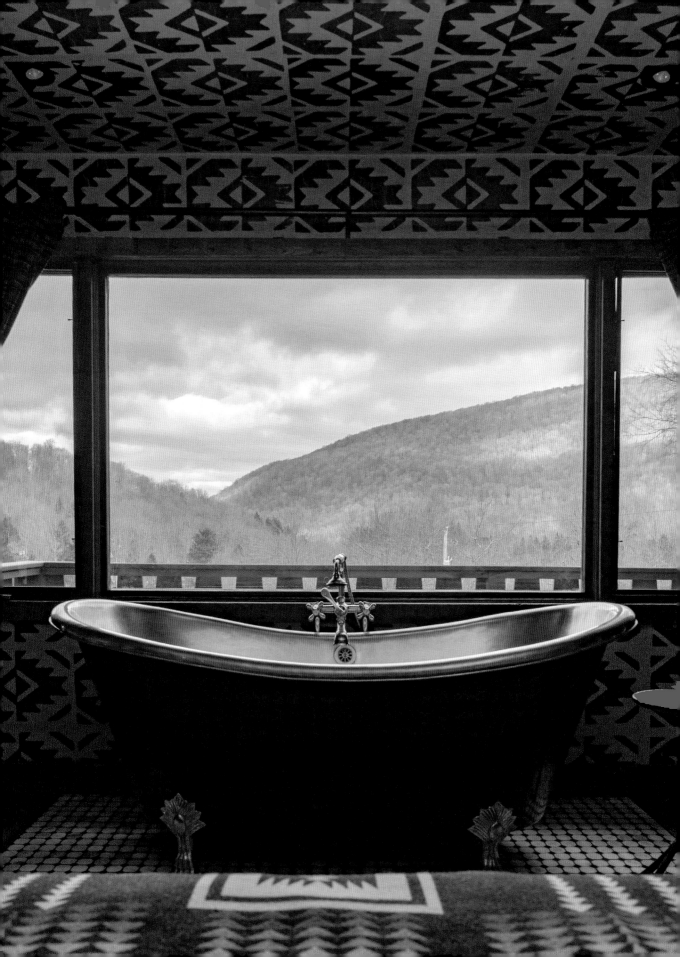

ABOVE Billiards, board games, ax throwing, and an outdoor sauna are all available on-site in the Catskills.

LEFT The lounge area decor in the Catskills draws inspiration from the surrounding nature and wildlife.

The Parlor Bar in Nashville hosts live music and is a cozy place for guests to gather.

The Dive Motel

NASHVILLE, TENNESSEE

The Honeymoon suite is the ultimate lovers escape, with a pair of disco balls over a matching pair of tubs.

Walking through the doors of the Dive Motel feels like stepping back in time. The wood paneling, tufted leather barstools, checkered linoleum flooring, and massive disco ball certainly don't seem like modern features, which is exactly what the designers intended when they opened the place in 2019.

The building is from the 1950s, and before it became a revamped vintage-inspired resort, it was a run-down motor inn called the Key Motel. In its heyday, this Nashville motel hosted the likes of music legends Johnny Cash, Hank Williams, and Dolly Parton. The motel's current owners and designers, Lyon Porter and Jersey Banks (who also created the Urban Cowboy Hotels—see page 117), decided to bring it back in time by creating twenty-three uniquely styled rooms with lots of seventies flair. Depending on which you get, you might be greeted by an abundance of leopard-print upholstery, shag carpeting, or retro floral patterns. Our favorite feature at this property is called the "Party Switch": Each room has one, and when you flip it on, a disco ball starts to spin in a spotlight while music from the motel's curated Dive Radio begins to play. Guests can choose from the four channels (Sex, Drugs, Rock 'n Roll, and Sleep), depending on their mood.

This place is the perfect location for a group getaway or romantic escape. Whether you fill up both of the side-by-side tubs in the Honeymoon suite or just share one is up to you!

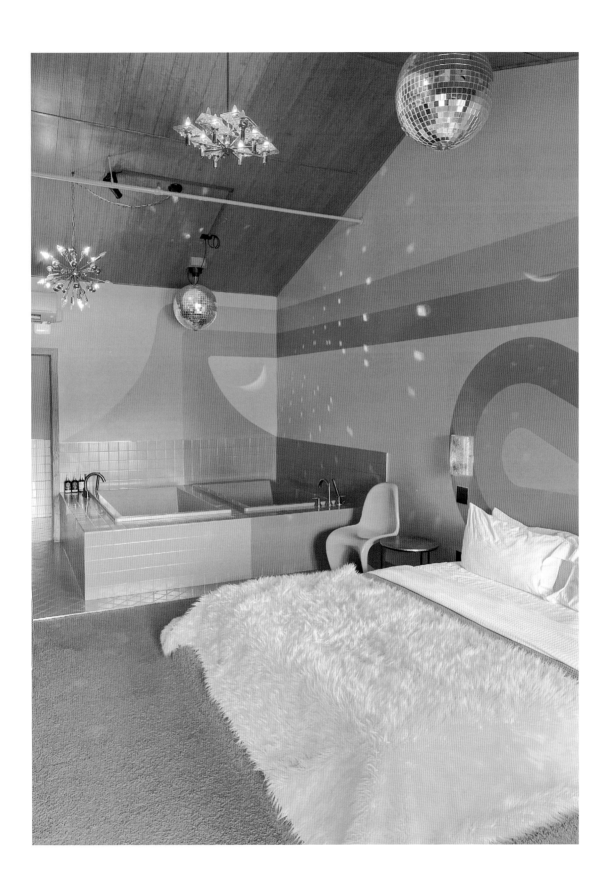

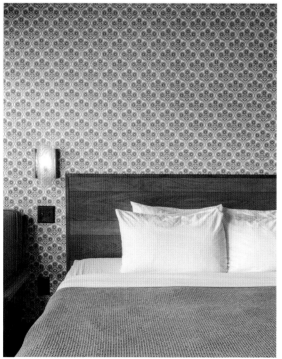
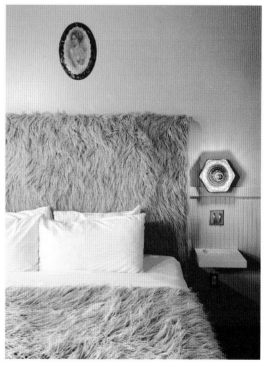

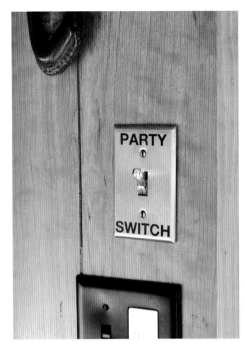

ABOVE The Party Switch, which controls the disco ball and spotlight, is undoubtedly the coolest feature we've seen in a hotel room.

RIGHT Neon signs create a soft red glow that really brings out the unique retro motel feel.

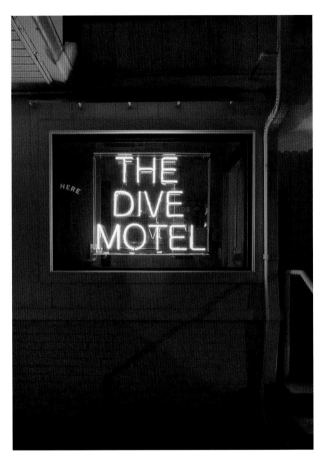

Vintage tube TVs around the bar play seventies variety shows, adding to the nostalgia.

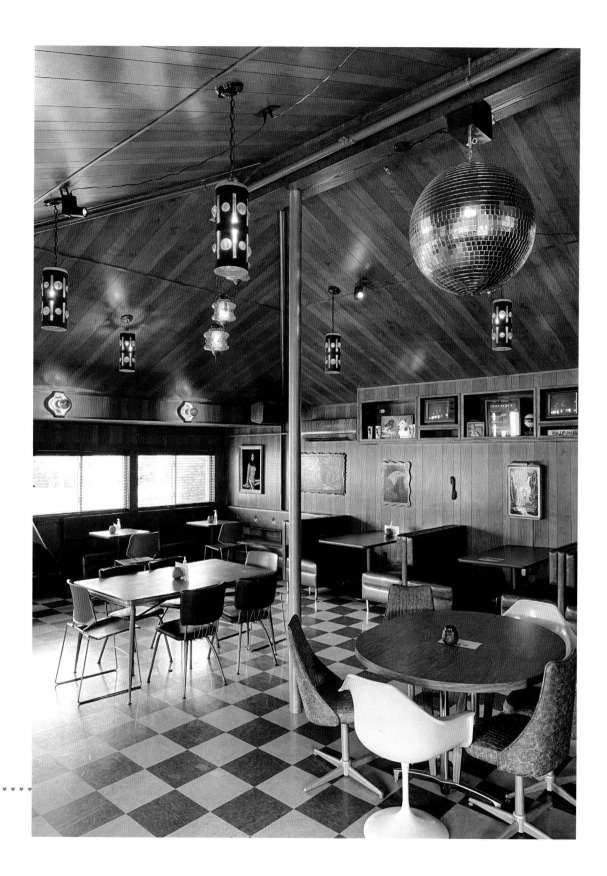

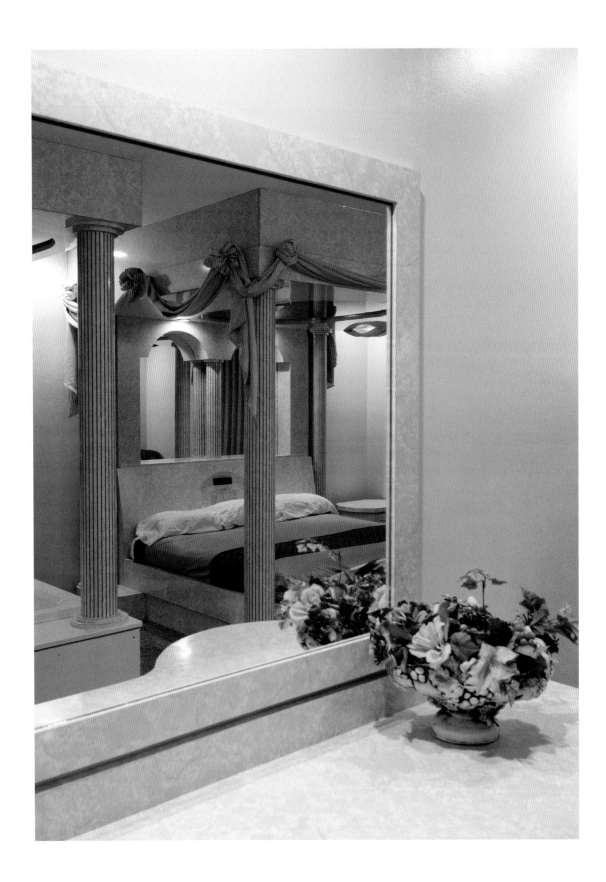

Magnolia Inn & Suites

SOUTHAVEN, MISSISSIPPI

The Roman room features a bedroom set that is incredibly similar to that of the Roman Retreat at Designer Inn & Suites in Toledo, Iowa (page 95).

Right across the border from Memphis, Tennessee, just fifteen minutes from Elvis Presley's famous home Graceland, is a Magnolia Inn & Suites. This small chain of hotels bills itself as "Southern Luxury at Its Finest," and a few of the locations added themed suites in the early aughts, commissioning Gary Strobusch (see more of his work on pages 79 and 95). His signature furniture is sturdy and was often created right in the room, so it's not surprising to see his craftsmanship outlast the decor of many other hotels that tried to cheaply copy his style.

The Southaven property boasts five fantasy suites: Roman, Hawaiian Waters, Heart 2 Heart, Heart's Hideaway, and Oriental Escape. Each one has a large Jacuzzi tub and a custom bed frame. The Roman room has columns and drapery; Hawaiian Waters features a beautiful sunset any time of day; Heart 2 Heart has a glistening, pearlescent heart-shaped tub; Heart's Hideaway has a round bed with a mirrored headboard; and Oriental Escape takes you on a trip to China without ever leaving the South. Whether you're in the area to visit Graceland or just passing through, an unexpected adventure awaits.

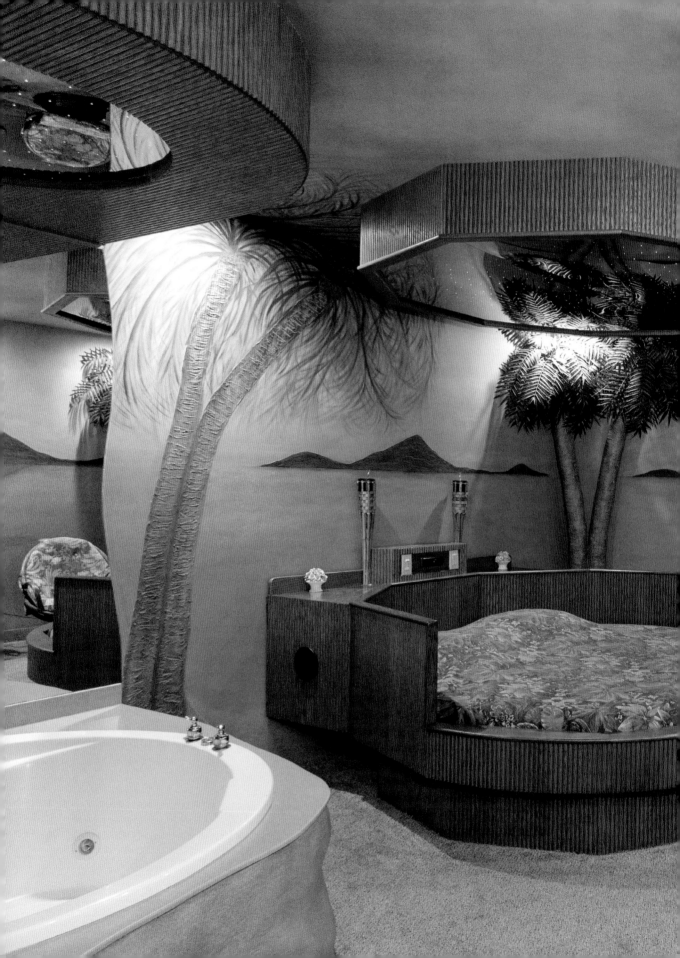

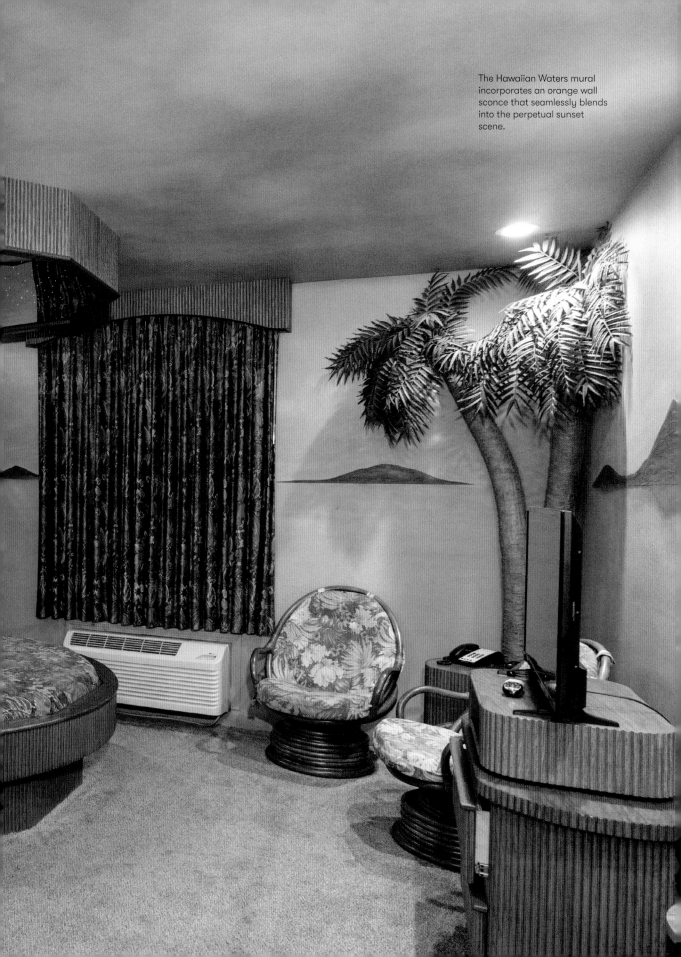

The Hawaiian Waters mural incorporates an orange wall sconce that seamlessly blends into the perpetual sunset scene.

HIDDEN ROADSIDE Gems

You really can't judge a hotel by its exterior! With the rise of theme hotels' popularity in the 1980s, even basic roadside motels began to install a honeymoon suite or offer a fantasy room to entice travelers to upgrade their stay. These options can be especially hard to track down—they aren't often advertised—so we've learned that the best way to make sure you're not missing out is to ask at check-in. We probably get ninety-nine noes for each yes, but every time we find one of these hidden gems, we agree that it's worth all the odd looks we get when we ask at the wrong places. In addition to the Best Western with hidden themed rooms in Galena, Illinois (see page 79), here are four of our favorite surprises from the road.

Express Suites Riverport Conference & Event Center

WINONA, MINNESOTA

You'd never know this hotel has two fifties-themed rooms with cars turned beds. The one we booked had a stunning white Chevrolet Impala convertible from 1959. Just getting up close and personal with such a stunning classic car was already fun—sleeping in it was quite the memorable experience. Best sleep we've ever had in a car!

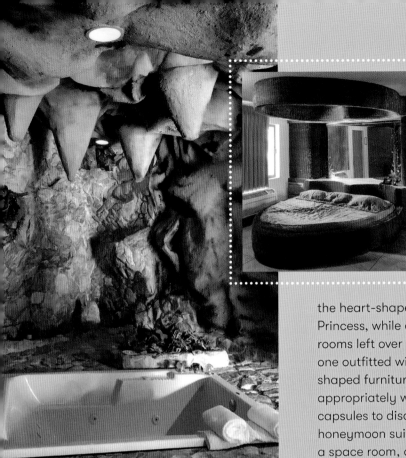

Miami Princess Hotel

MIAMI, FLORIDA

· ▼ · ▼ · ▼ · ▼ · ▼ · ▼ · ▼ · ▼ · ▼

We have found enough heart-shaped tubs that they've almost started to feel common to us, but the heart-shaped bed is another story. The Miami Princess, while otherwise basic, has a couple of rooms left over from an eighties remodel, including one outfitted with entirely custom-made heart-shaped furniture. While certainly outdated and appropriately worn, the rooms were exciting time capsules to discover. Besides its more classic honeymoon suite, the motel has a cave room, a space room, and even a disco room!

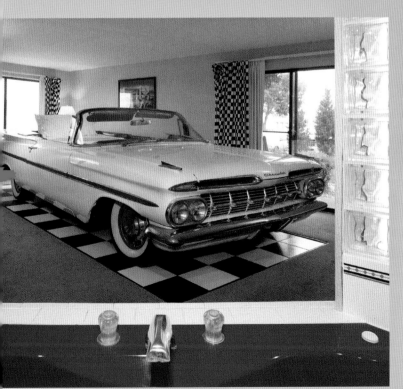

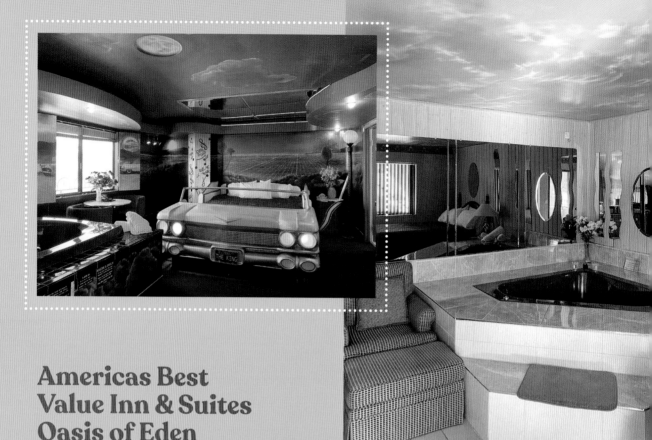

Americas Best Value Inn & Suites Oasis of Eden

YUCCA VALLEY, CALIFORNIA

We drove by this chain hotel several times before finding out that it had unique suites. Located near Joshua Tree National Park, the Oasis of Eden appears to be just like any other unremarkable motel on the road. When we finally booked a room here, we discovered the Rockin' Fifties suite, which mimics the FantaSuites car bed design (see page 102), except this one is just a plastic replica of a Cadillac. Before leaving, we also got to peek inside their jungle room, cave room, New York room, and Swimmers Paradise, the last featuring a stunning sky mural on the ceiling.

Best Western Route 66 Rail Haven

SPRINGFIELD, MISSOURI

Located in the birthplace of Route 66, this Best Western has been home to its fair share of notable overnight guests, including Elvis Presley in 1956. The historic hotel has vintage cars parked throughout the property, as well as a pink Cadillac bench in the room where Elvis stayed. There's also a Wild Bill Hickok room where you can soak in a giant tub under a mural depicting a famous shoot-out that took place in Springfield in 1865.

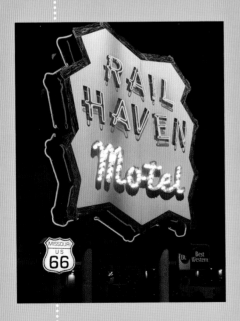

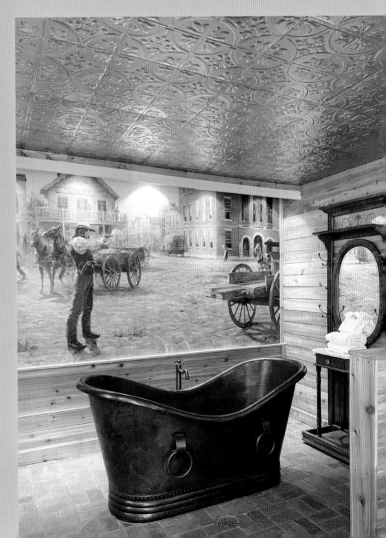

Jules' Undersea Lodge

KEY LARGO, FLORIDA

Everything inside the lodge must be brought down in a waterproof case, including these fresh flowers.

"Under the sea" is a common motif in theme hotels around the country. In Key Largo, Florida, you can take that fantasy a step further and actually sleep in an underwater hotel. While many hotels boast underwater dwellings, Jules' is unique in that you have to scuba dive to get to your room. Guests who are not already PADI certified take a crash course before gearing up and swimming down through the lagoon and up through a moon pool to the lodge's underwater entrance. Staying here was our first scuba diving experience, which certainly added to the sense of adventure!

This two-bedroom structure was originally a research laboratory. Founded by Dr. Neil Monney, a professor and the director of Ocean Engineering at the United States Naval Academy, and ocean explorer Ian Koblick, it operated from 1972 to 1975 and was the largest and most advanced laboratory where aquanauts could live and become part of an underwater habitat. In 1986, it was converted into a hotel that welcomes guests from around the world. (If sleeping underwater doesn't appeal, you can also book a tour that doesn't include an overnight stay.)

The lodge was named after Jules Verne, author of *Twenty Thousand Leagues Under the Sea*, and the interiors are like something you would see in an eighties movie: Landline phones hang on many of the walls, clocklike instruments gauge the pressure level, and nondescript utility boxes abound. To move

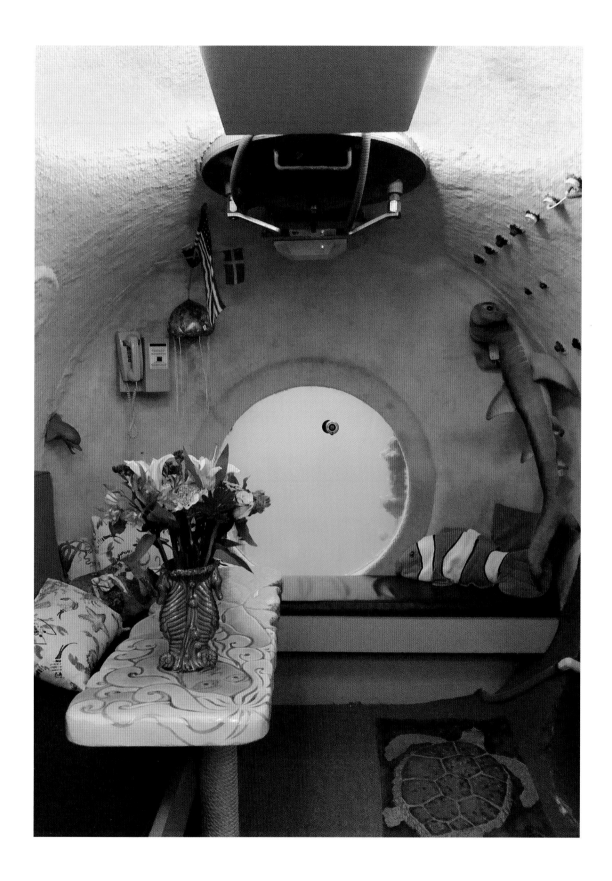

throughout the interior, you slide open large panels to reveal circular doorways to each room, and the curve of the walls makes you feel like you're in an aircraft. Since the habitat is completely underwater, everything you bring with you has to be in an airtight, waterproof case. When dinnertime rolls around, guests are treated to room service delivered via scuba diver, who swims down with a small suitcase containing their meal. This whole experience is fantastical and, for novice scuba divers like us, educational!

Sleeping in a room 30 feet (9 m) underwater was unnerving and thrilling. It felt a bit like how we imagine space travel—quiet, isolated, daring, and adventurous. There is nothing quite like waking up to see what looks like an aquarium out your window, then making yourself a cup of coffee before swimming to the surface for checkout.

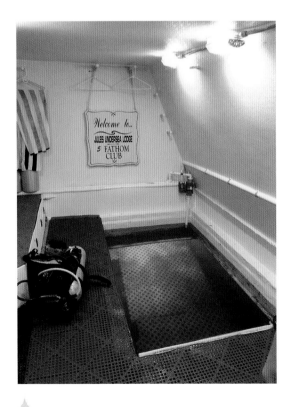

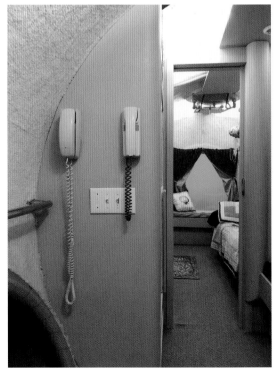

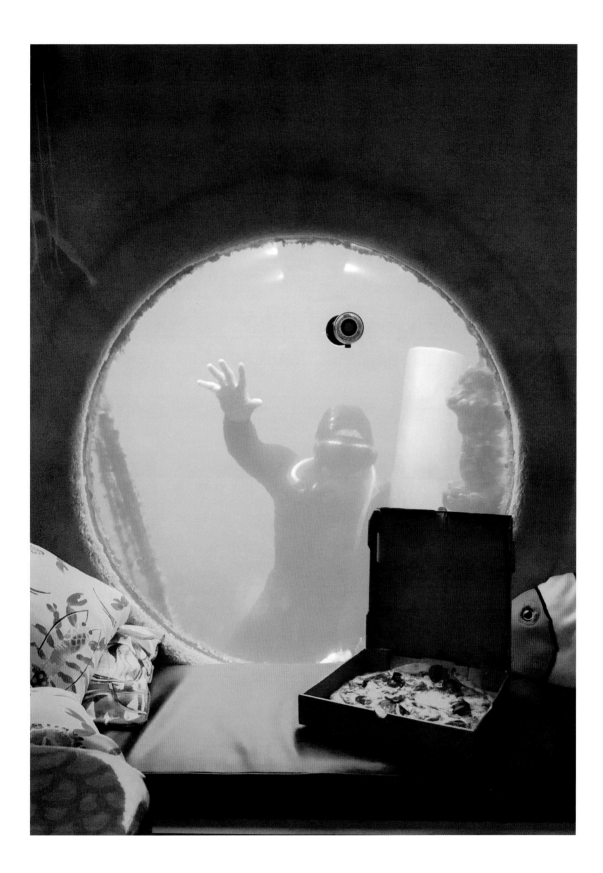

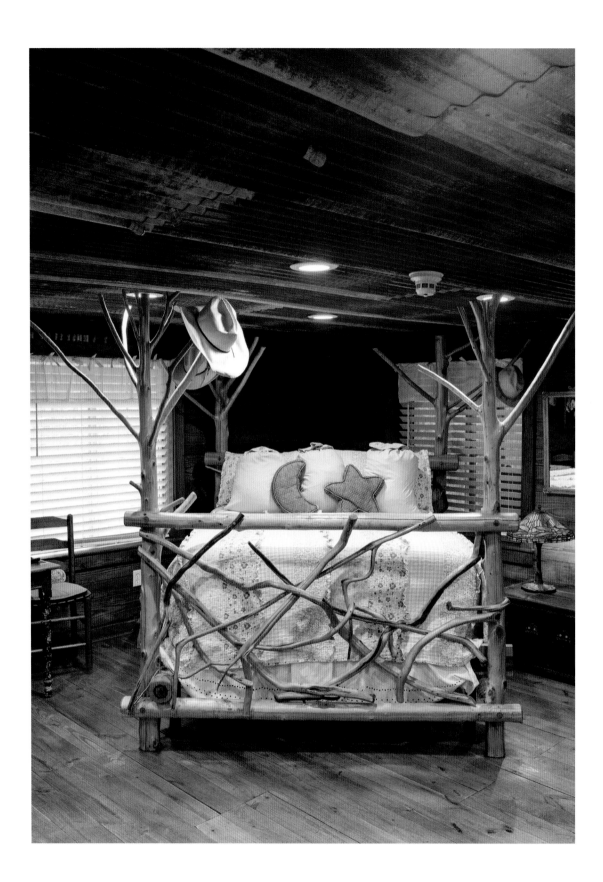

7F Lodge

COLLEGE STATION, TEXAS

In addition to the carved bed frame, the Hill Country cottage has a Jacuzzi on the porch and an indoor claw-foot tub.

About 100 miles (161 km) from both Austin and Houston, this romantic bed-and-breakfast is a couples paradise. The lodging is split up into private themed cabins ranging from the seventies-inspired Sugar Shack to the cozy Hill Country. The rustic decor is influenced by the rich history of Texas, drawing from Spain, Mexico, and France (all of which claimed territory in the state between 1600 and 1800).

Each unit is equipped for a completely relaxing stay, with dreamy amenities like a heart-shaped Jacuzzi or a claw-foot tub, rocking chairs with a view of the stars, a firepit, and even a kitchen area. Breakfast is waiting in the fridge upon arrival, so the next morning you can stay in your robe and enjoy a meal on your screened-in porch. And each cabin comes with appropriate music to help set the specific scene: When we checked into the Barn, country hits were already playing through the speakers (Patsy Cline's "I Fall to Pieces" greeted us with a nostalgic and welcoming tone). Romance and connection are truly at the center of the experience, and the cabins are offered as "sacred healing chambers" for this reason.

7F Lodge has been family owned and operated for twenty-five years. It has an on-site chapel and venue ready to host weddings and other celebrations. While you're there, be sure to pick up a copy of *Love Saves Lives*, a collection of short stories that match the theme of each cabin. The book was written by founder Carol Conlee, and each passionate tale is intended to help ignite your senses and "anchor the fantasy experience" of a dreamy getaway to 7F Lodge.

ABOVE The France cottage has countryside decor and a celestial mural above the bathtub.

RIGHT The Spain cottage uses traditional garb and Catholic symbolism to set the historic scene.

♥ ♥

In Sully's Place, the heart-shaped tub gets a new setting on a rustic porch instead of its usual pink or red honeymoon suite.

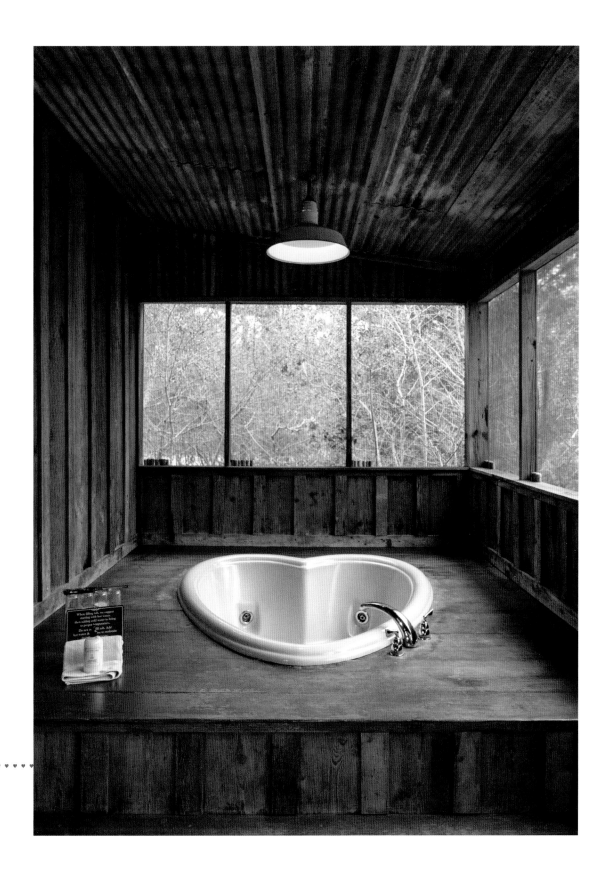

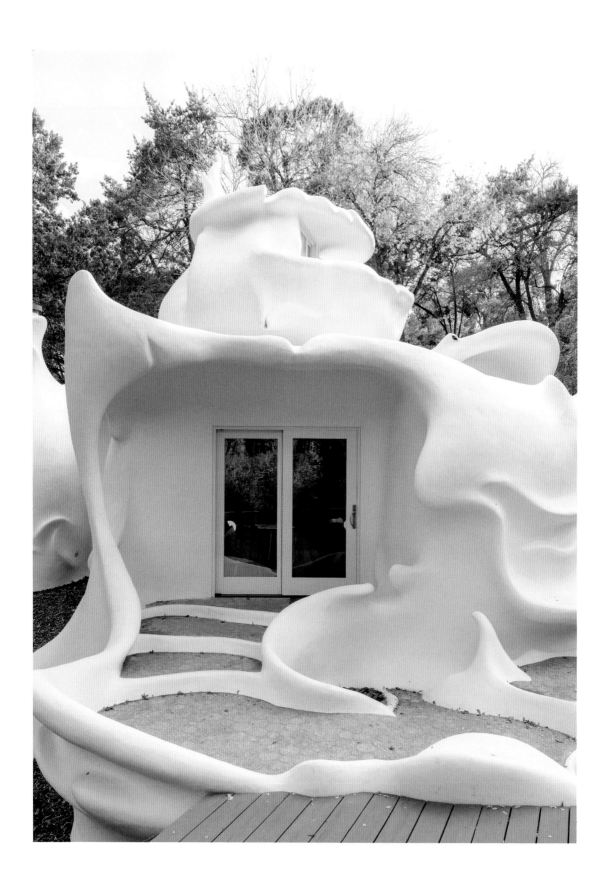

The Bloomhouse

AUSTIN, TEXAS

Even the back of the Bloomhouse is beautifully designed, with an entrance leading directly into the bedroom.

When you first catch a glimpse of the Bloomhouse, it doesn't look real. You think you're seeing a cartoon, or a cloud, or something out of a fairy tale—which is exactly what architect Charles Harker intended. Designer and original owner Dalton Bloom commissioned Harker to bring this unique structure to life in the seventies, and the home was his response to what he perceived as the predominant cookie-cutter styling and sterile dwellings of the era. Harker wanted the home to be soothing and calming and to flow in the same way that music does. He believed that functional art could help a person grow and "become something more than he was before."

The property was purchased in 2017 by David and Susan Claunch, who (lucky for us!) decided to restore and repair the home in order to rent it out so that many people could experience its magic. They spent more than eighteen months renovating, being sure to honor the original design but bringing in some modern comfort and function.

The experience of staying at the Bloomhouse is otherworldly. You feel like you're not in Texas—or America, for that matter—but rather in a dreamland outside of time. The beauty of the home and the way the surrounding trees, sunlight, and nature interact with it bring a sense of peace, wonder, and whimsy to its guests.

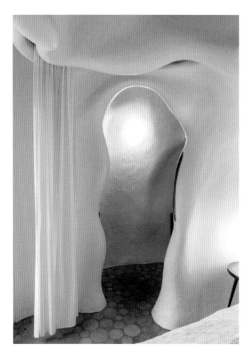

Harker accomplished the light, airy design of the home by starting with metal framework, adding polyurethane foam, then carving out the spaces inside, creating rounded ceilings and passageways.

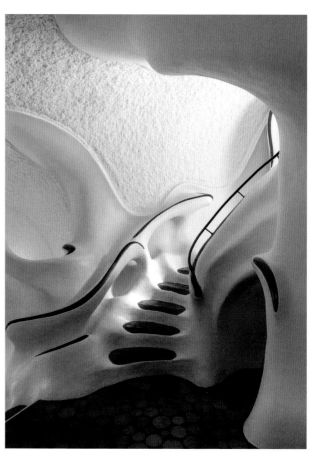

The home's smooth surfaces feel like a cross between an ice cave and the inside of a hollowed-out marshmallow.

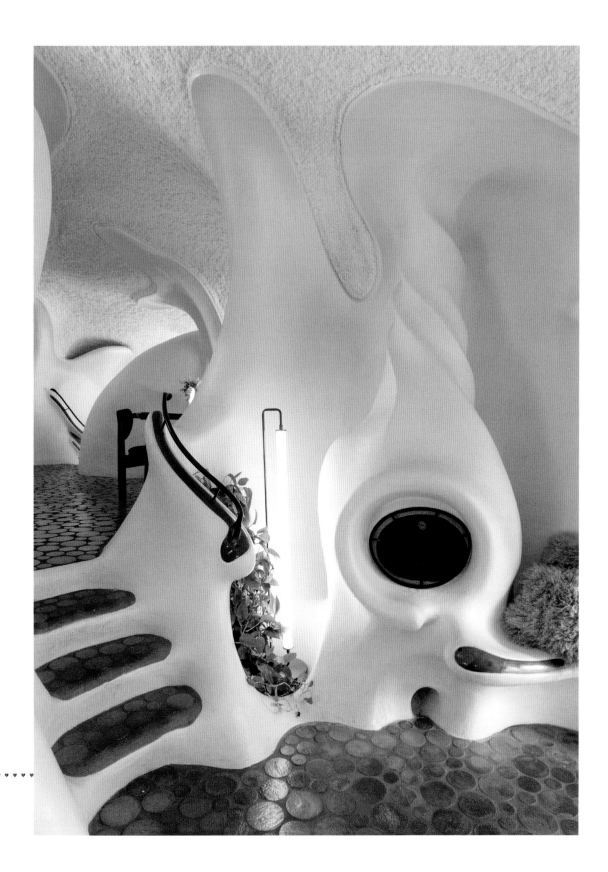

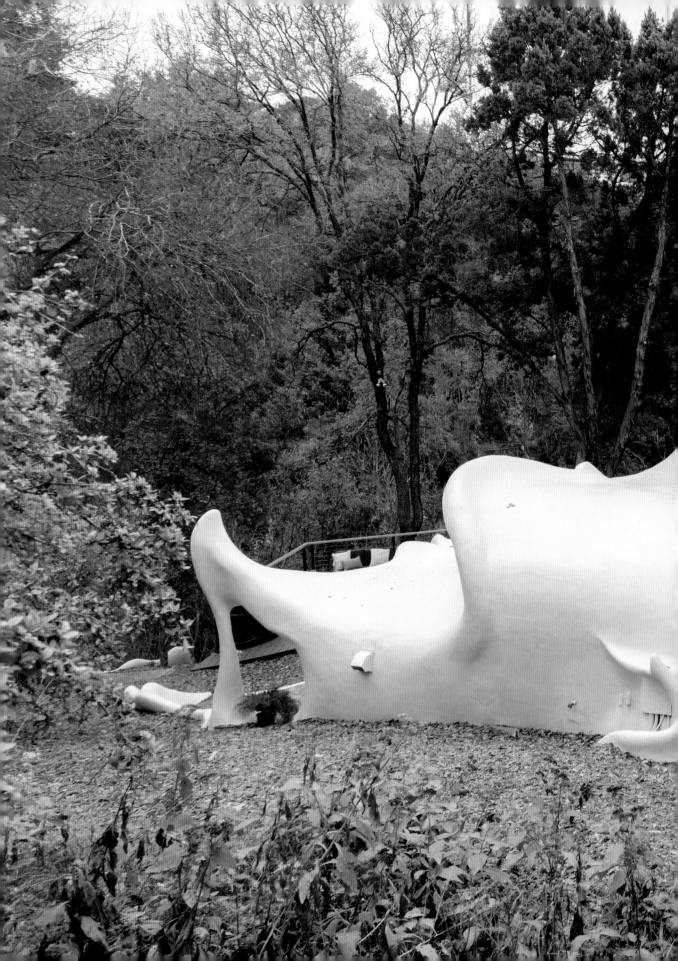

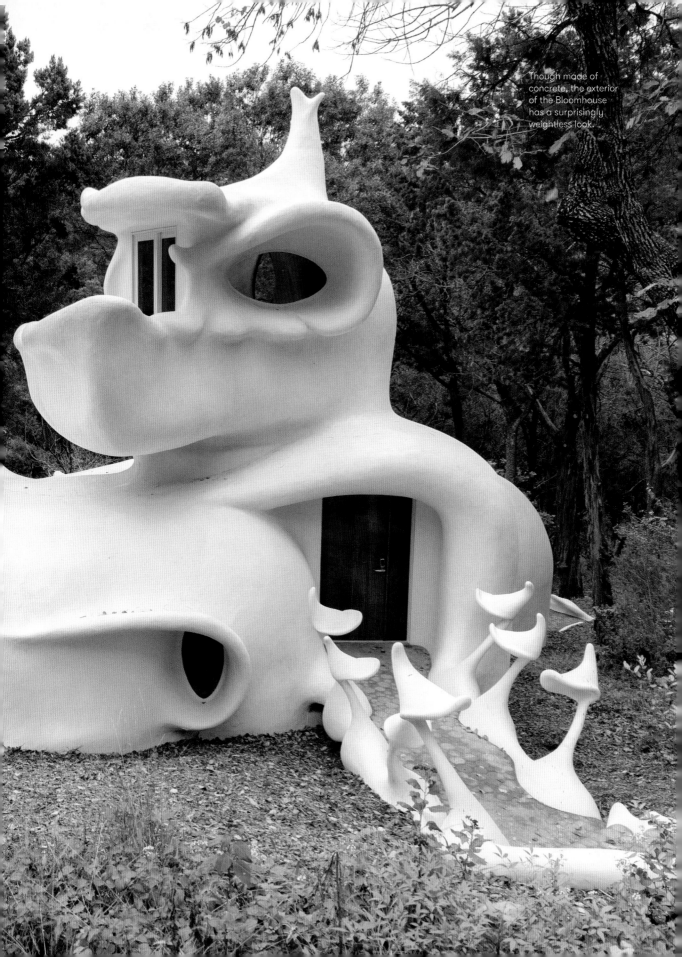

Though made of concrete, the exterior of the Bloomhouse has a surprisingly weightless look.

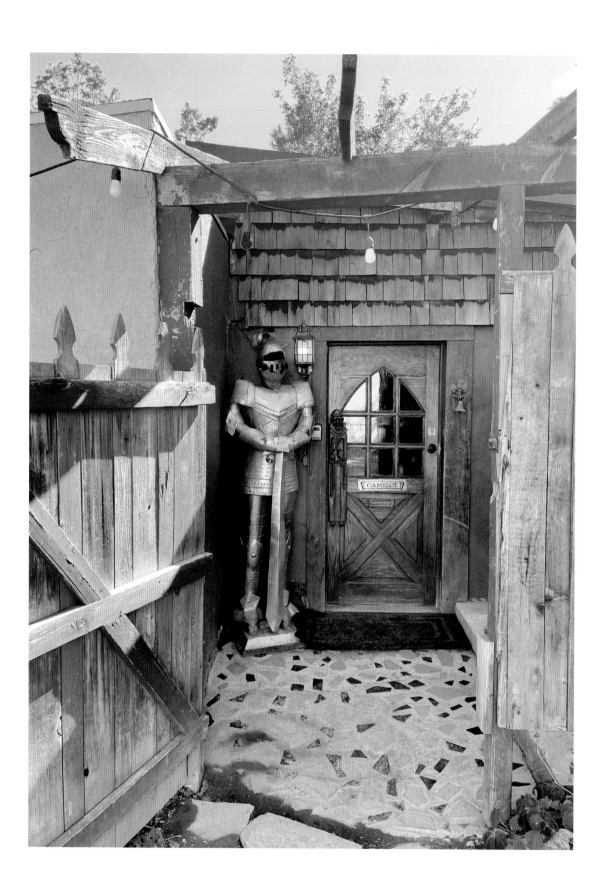

Cliff House Lodge

MORRISON, COLORADO

The entrance to the Camelot cabin is decked out with a suit of armor, carved wooden details, and a bell.

Cliff House Lodge was created in 1864 when George Morrison Sr. built his family a home using materials sourced from his nearby quarry. His development of local building stone and industrial construction materials like lime and gypsum brought fame to the region, and his house, now recognized as a historic site by the National Registry of Historic Places, is one of the oldest structures standing in Morrison today.

Throughout the decades, the property has expanded into a beautiful destination for couples that includes more buildings and several stand-alone cabins added in the 1940s. Each suite is themed (though there is a broad spectrum of how elaborate the decor is), and each has a private outdoor hot tub, indoor Jacuzzi, or both. Among the choices are the Rose, a boudoir-themed cabin with pink walls adorned with vintage risqué photos; Hogback Hideaway, a rustic "hunters' fantasy"; and Camelot, the most decked out of all. Here you are greeted with a suit of armor, large throne-style chairs, and a gold Jacuzzi beneath a beautiful stained-glass window separating the tub from the kitchen area.

The lodge feels secluded and private, but the surrounding town offers many attractions, including the famous Red Rocks Amphitheatre. Breakfast, which is included with your stay, is a delicious homemade meal cooked right in the lodge. Couples from around the country find the peace and ambience they're looking for at this charming adults-only destination.

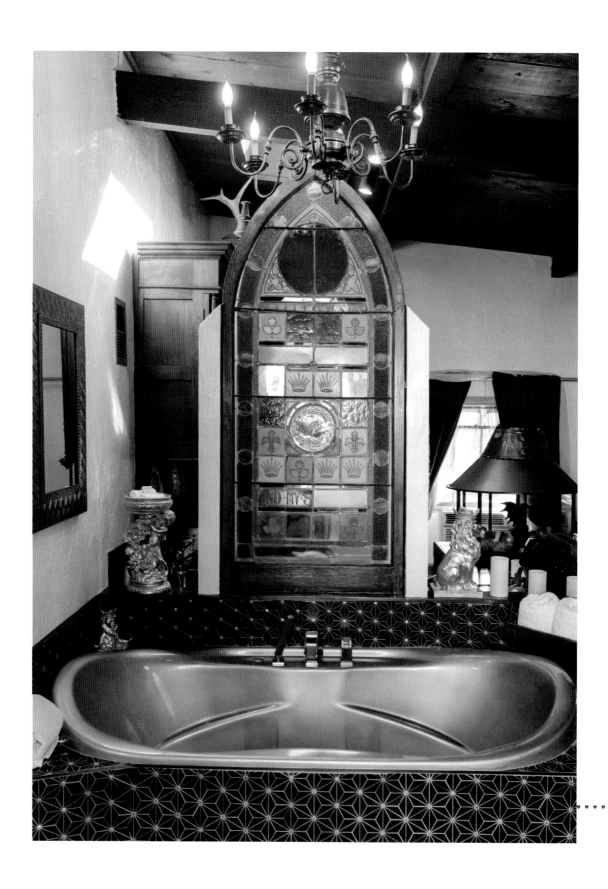

Castle-inspired details are found throughout the cozy Camelot cottage, including a luxurious velvety bed and a chess set.

♥ ♥

The Camelot Jacuzzi tub is fit for a king.

Mon Chalet

AURORA, COLORADO

The photorealistic artwork reflects around the room in each mirror, creating an optical illusion that extends the space.

If you're looking for the sexiest hotel in America, Mon Chalet is surely in the running. This adults-only fantasy hotel is geared specifically toward swingers, although not exclusively, and the rooms are strikingly sensual. The hotel reflects its 1985 inception: Ceiling mirrors, light-up bubble columns, LED panels with nude artwork, sex swings, Love Chairs (which offer users more potential sexual positions), and lots of other quintessential "love hotel" decor can be found here. Some guests have complained that the rooms are outdated and feel like an eighties porn set, while others, us included, are delighted by the design elements and find them to be quite the draw.

The public pool area is clothing-optional and includes several hot tubs and a few "play areas." The entrance to the pool features a list of rules as well as bracelets in a large variety of colors to signify to the other guests what you're looking for; among the options are blue to communicate that you're single and looking to meet a man, pink for couples looking to meet another couple, and yellow, which means "Please leave me alone. I'm not looking to meet anyone."

While the public pool is the hot spot for meeting others, the rooms are completely private, and in our experience, guests don't have to swing to enjoy a stay at the hotel. The culture is friendly and open, and though many couples find an outside connection, there are just as many looking to spice up their private romance—there's no shame in keeping to yourself.

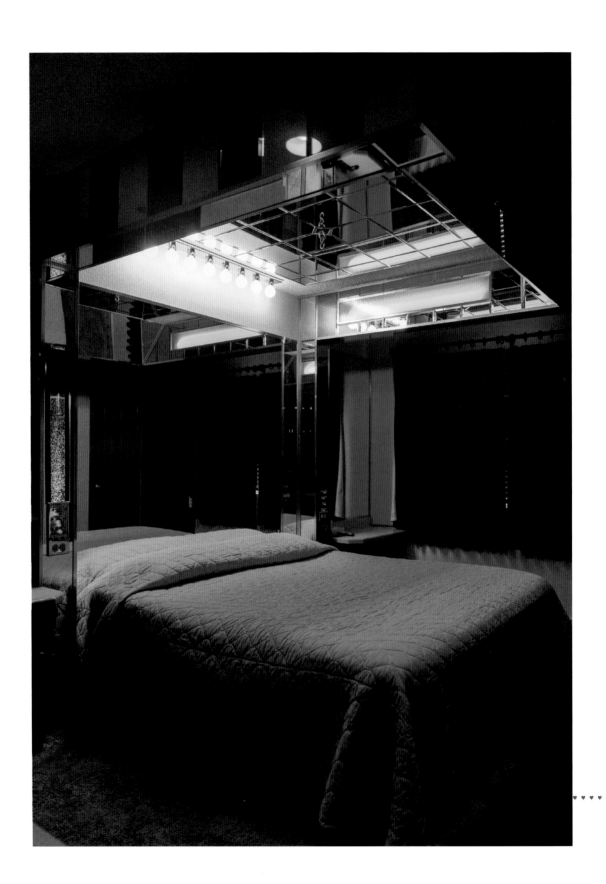

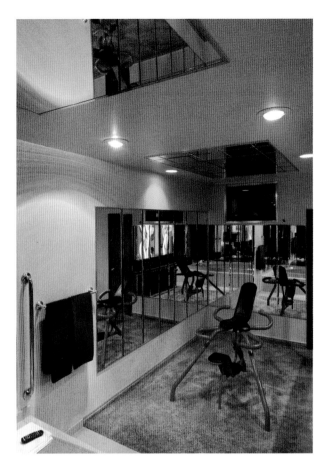

ABOVE The vintage designs around the rooms are in spectacular condition.

LEFT The Love Chair is one of the erotic furniture pieces we have found in many adults-only hotels. See page 77 for more on this unique feature.

♥ ♥

The stunning bedroom furniture is covered in colored mirrors and beveled glass.

So You Want to Open a PRETTY COOL Hotel

Since the end of the FantaSuites heyday (see page 104), it would have been easy to write off theme hotels as a fad that passed as quickly as carpeted bathrooms or inflatable furniture. But unlike interior design trends that come and go, fantasy escapes offer something evergreen. Several boutique theme hotels made it through the era of changing travel trends by finding the right buyer to continue the original owners' vision and following these tenets.

Maintain the Vintage Charm

When running a theme hotel, being strategic about how much you can take on at once, and how much existing charm you can salvage, is key to keeping the business afloat while slowly introducing upgrades. In 2007, Rod Rigole became the new owner of the Victorian Mansion in Los Alamos, California (page 200). He knew it needed major repairs and focused on restoring it to its former glory before going on to expand the hotel. He hired the original muralist to touch up the elaborate scenes and even built a protective spray booth around the Cadillac convertible bed in the fifties-themed suite so he could give it a fresh coat of paint. Once the original suites were back in business, Rigole could start to dream up additions to the already magical getaway. Today, he's making progress on building a hobbit house and a tree house on the property.

Embrace the Internet Age

It's no longer enough to have a *pleasant* vacation—today's travelers want a photogenic one. Fantasy rooms are already built to be stunning works of art, offering visitors the perfect backdrop for photos, so lean into it! For the Trixie Motel, social media was a huge part of its marketing before it even opened. Seeing owner and beloved *Drag Race* star Trixie Mattel posting selfies to Instagram with the adorable pink backdrops gave fans an immediate desire to re-create the photos themselves during a visit.

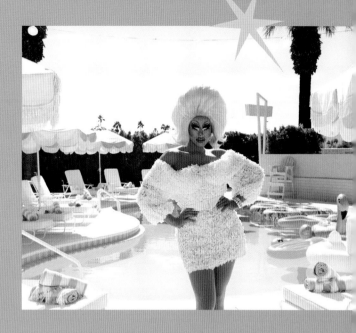

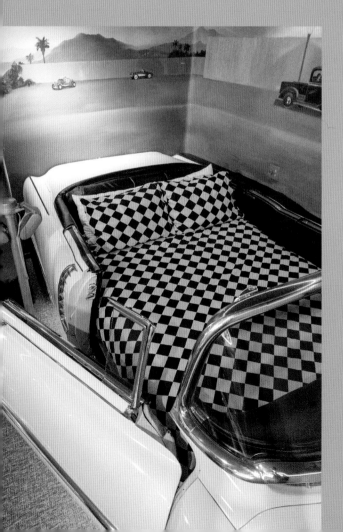

Become the Destination

You don't have to be located in a vacation town or popular city to entice travelers to visit. If you offer distinctive and stunning rooms, people will go to great lengths to get the exclusive experience. At Adventure Suites in New Hampshire (page 45), each fantasy suite is elaborate and completely custom built. From the Deserted Island room with a motorized seashell bed that opens and closes to the Club room with light-up floors and a DJ booth, the hotel offers one-of-a-kind experiences that are worth traveling for. In addition to the impressive rooms, there's a bar, restaurant, and full-service spa on the property, so guests don't even need to leave the premises to have a full day of activities. People love a unique experience, and to paraphrase a famous midwesterner, "If you build it, they will come."

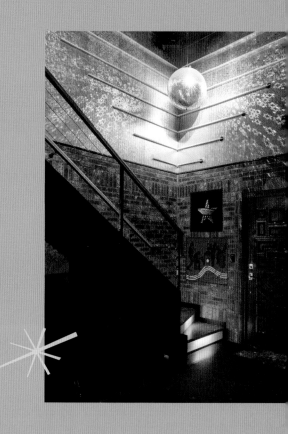

Assemble Your Team

It's the rare hotelier who is also professionally trained to do things like sculpt a fake forest or build a lighthouse indoors. There are so many specialty jobs involved when crafting a room that can transport guests into another realm, and no matter how talented you are, you shouldn't attempt to do it all on your own. Gregory Henderson and Joseph Massa (pictured), owners of the Roxbury (page 53), are both incredibly talented artists, but getting the right construction company to work with, along with scenic carpenters from Broadway and other locals to join the team, was what allowed them to create one of the most elaborate and impressive theme hotels in the world.

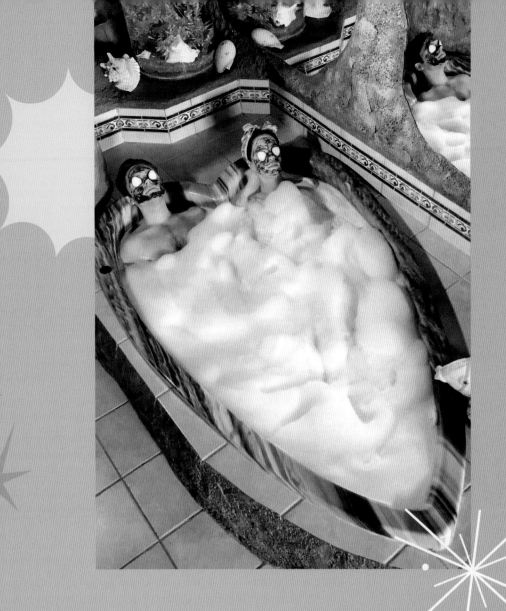

Remember That Romance Never Goes Out of Style

If there's one thing a fantasy hotel can offer that will always be in demand, it's a setting for connection and romance. When quality and hospitality meet fantasy, couples are in the ideal environment to make memories that last a lifetime, and to let loose and not take themselves too seriously. Giving lovers a chance to relax in a heart-shaped tub or spend the night in a seashell bed can add a welcome spark of adventure. Larry and Debbie Fisher, owners and designers of the Black Swan Inn in Pocatello, Idaho (page 171), help nurture relationships by giving people a reason to get away. Their suites are designed so that when you come in and shut the door, you enter a whole new world, and nothing matters but being there together.

Anniversary Inn

BOISE, IDAHO; LOGAN AND SALT LAKE CITY, UTAH

The Romeo and Juliet suite in Salt Lake City is a favorite among honeymooners.

Anniversary Inn, a small chain of theme hotels in Idaho and Utah, takes a wholesome approach to the fantasy suite. Though these are adults-only establishments, you won't find mirrored ceilings or explicit decor. Instead, the hotels offer fun and unique getaways to exotic or imaginary destinations—without guests having to travel too far. Original owners Tom and Dorothy Heers, inspired by a trip to the Madonna Inn in California (see page 193), decided to open a themed destination of their own in the early nineties. With Tom's background in home building and Dorothy's love of creative expression and celebrating special occasions, they were well positioned to excel in their new venture of unique, romance-focused hospitality. Dorothy recalls the experimentation and collaboration it took to create each room and says that many people could take credit for the work. The couple hired artists and college students and even involved their children in the process. The craftsmanship that resulted from this collaboration is notable: Anniversary Inn suites are larger than life. Guests can sleep in a gondola in Venice, in a lighthouse on Cape Cod, or on a bed held up by two elephants in Sultan's Palace.

After about a decade of running the hotels, the Heerses decided to sell them. Luckily, the new owners continue to add themed rooms and expand the chain; as of today, their masterpieces include classics like the Wild West, Lost in Space, and Amazon Rainforest as well as travel-themed suites like London Fog, European Honeymoon, Vegas Nights, Hawaiian Hideaway, Tuscany, Venice, and Caribbean Sea Cave. Suites

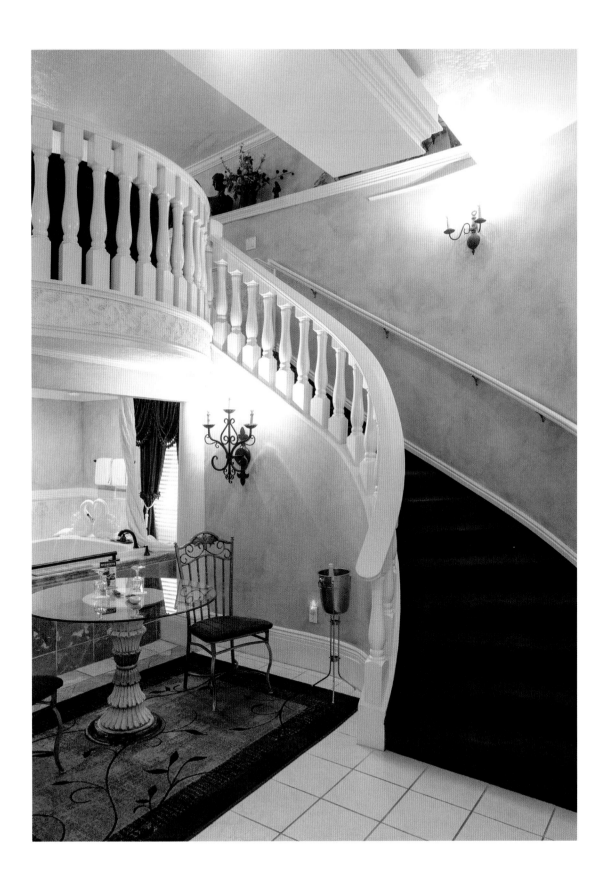

Ocean themes are common at Anniversary Inn and can be found in the Caribbean Sea Cave at the Logan location (*bottom left*) as well as the Lighthouse (*bottom right*) and Cape Cod suites (*opposite*) in Salt Lake City.

inspired by popular stories are also found throughout the hotels, with rooms like Phantom of the Opera, 007, Romeo and Juliet, and several that feature lifelike animal statues, from small frogs to a massive dragon (at the Salt Lake City location).

There seems to be no end to the creativity found in these rooms, and staying in one for a special occasion is unforgettable. Special touches abound—upon arrival, you're greeted with a chilled bottle of sparkling apple cider, and breakfast is delivered to your door. With these thoughtful gestures, and the completely transporting design of their suites, it's no wonder these locations have remained popular destinations for so many years.

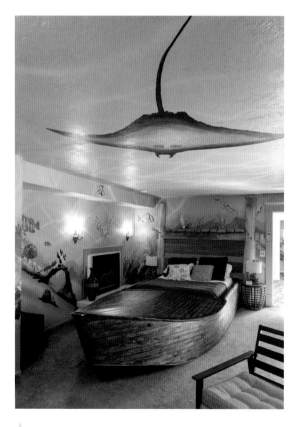

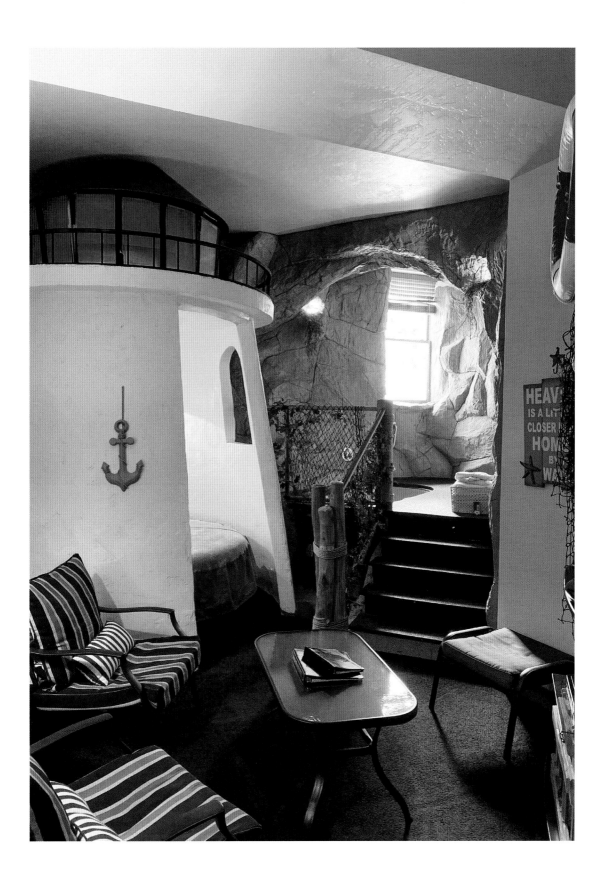

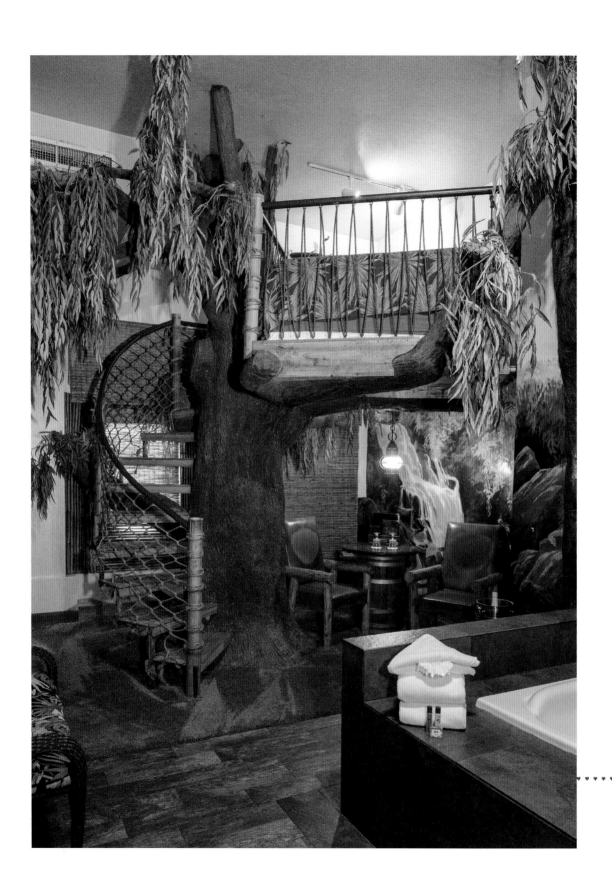

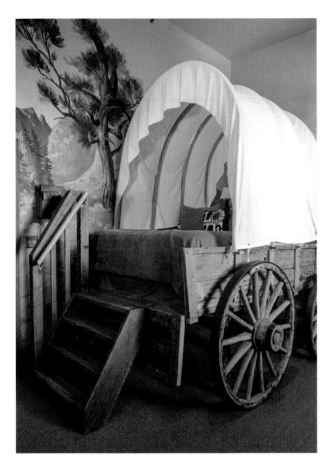

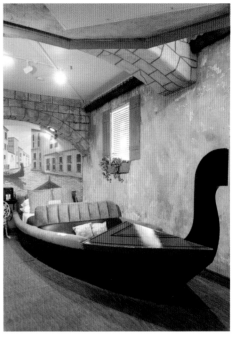

The elaborate beds in the Jackson Hole room (*left*) and Venice suite (*right*) in Salt Lake City are surrounded by theme-appropriate murals.

The *Swiss Family Robinson* suite in Salt Lake City features a bed in a tree house, as seen in the 1960 Disney movie of the same name.

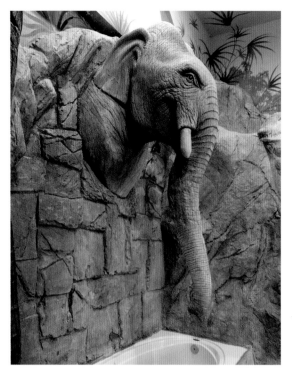
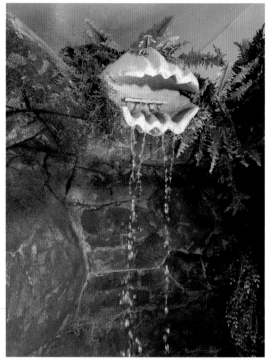

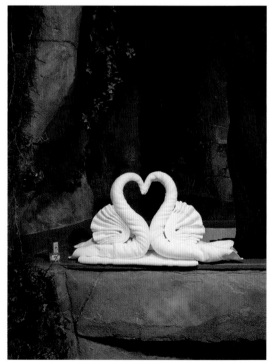

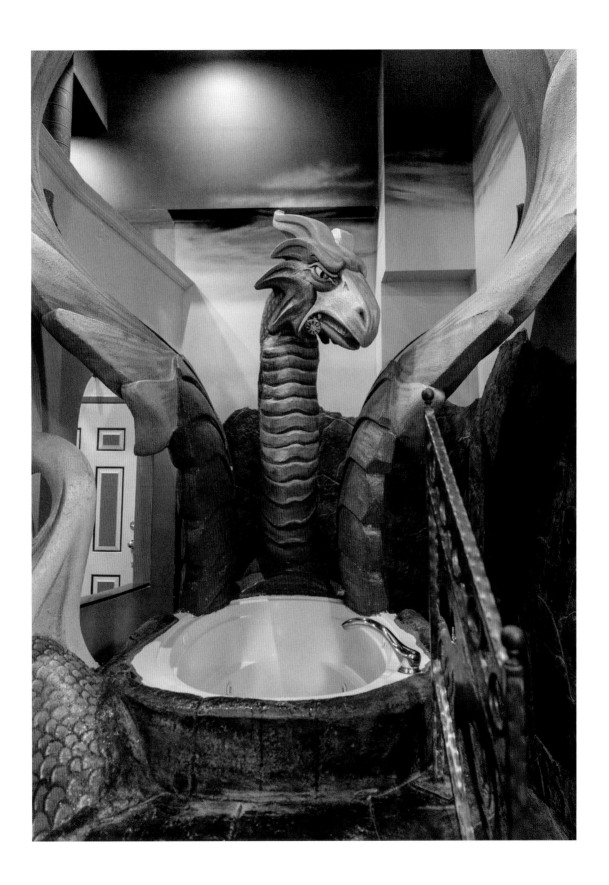

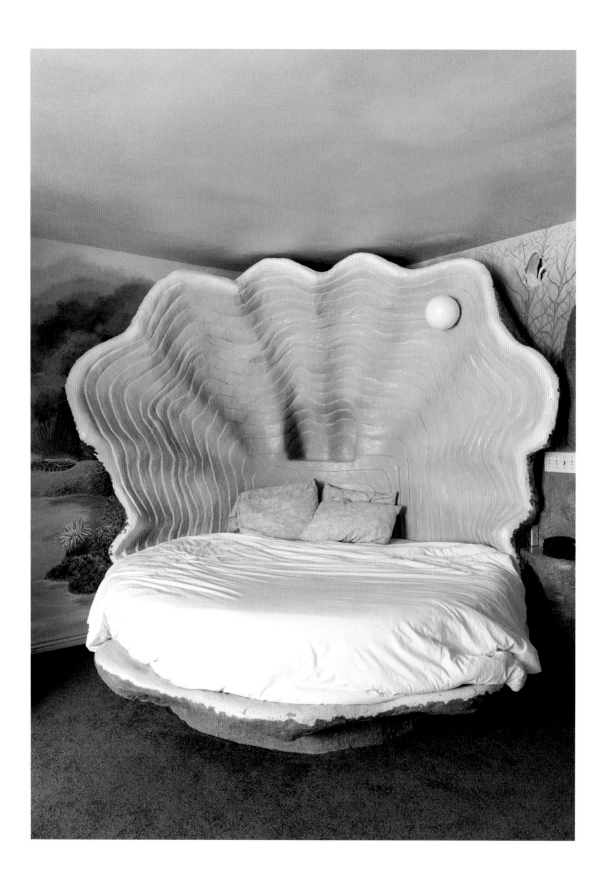

Black Swan Inn

The beautifully carved seashell bed in the Sea Cave suite is one of the most impressive pieces crafted by the Fishers.

This Tudor-style building was constructed in 1933 for the purpose of being rented as two-story apartments, but since 1996, it has been owned and operated as a theme hotel by Larry and Debbie Fisher, along with several of their children. The couple's first themed room, the Cave suite, opened in 1997; by the following summer, they had already added seven more. They currently offer fourteen suites, including Tropical Paradise, Black Swan Garden, Atlantis Under the Sea, Pirate's, Romeo and Juliet, and the Wild West.

Although they are inspired by themes you can find at other hotels, the Fishers have brought their fantasy suites to life with meticulous skill and a true vision for both romance and theatrics. The pair are both artists and builders, with a background in running a local performing arts center. The inn's rooms are known for their colorful murals, which Debbie paints, and larger-than-life handmade pieces, like a clamshell bed, Egyptian statues, and a Juliet balcony.

The Fishers say that what they love most about running a theme hotel is creating a world where their guests can escape from the day-to-day and just focus on each other. When we first visited, we thought it would surely be the only time in our lives we made it out to the distant town of Pocatello. We were so impressed that we've now stayed at the Black Swan Inn four times in four years and hope to continue the tradition. When we asked Larry Fisher if he was worried that theme hotel trends come and go, he smiled and confidently declared that "romance never goes out of style."

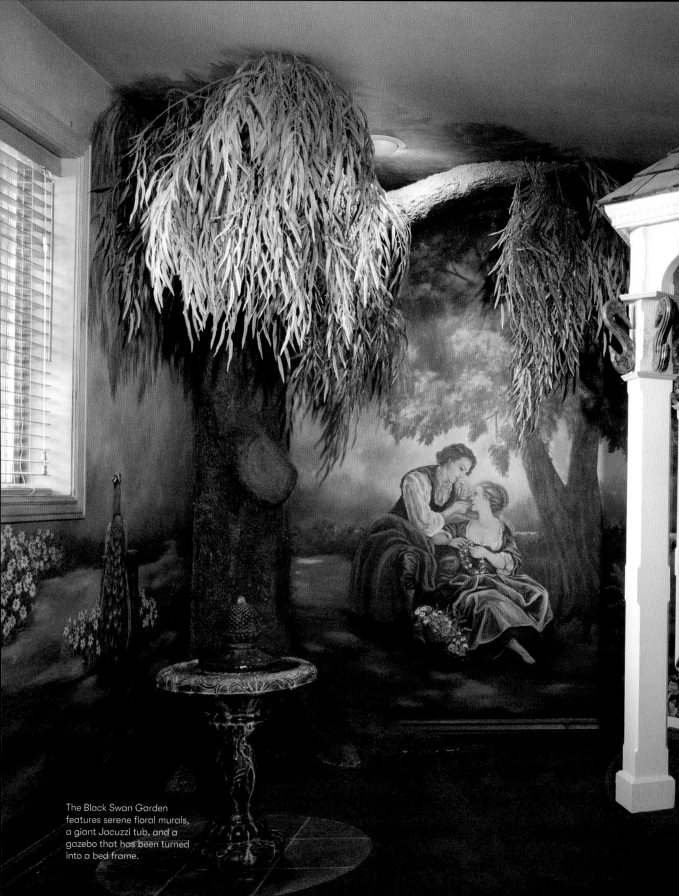

The Black Swan Garden features serene floral murals, a giant Jacuzzi tub, and a gazebo that has been turned into a bed frame.

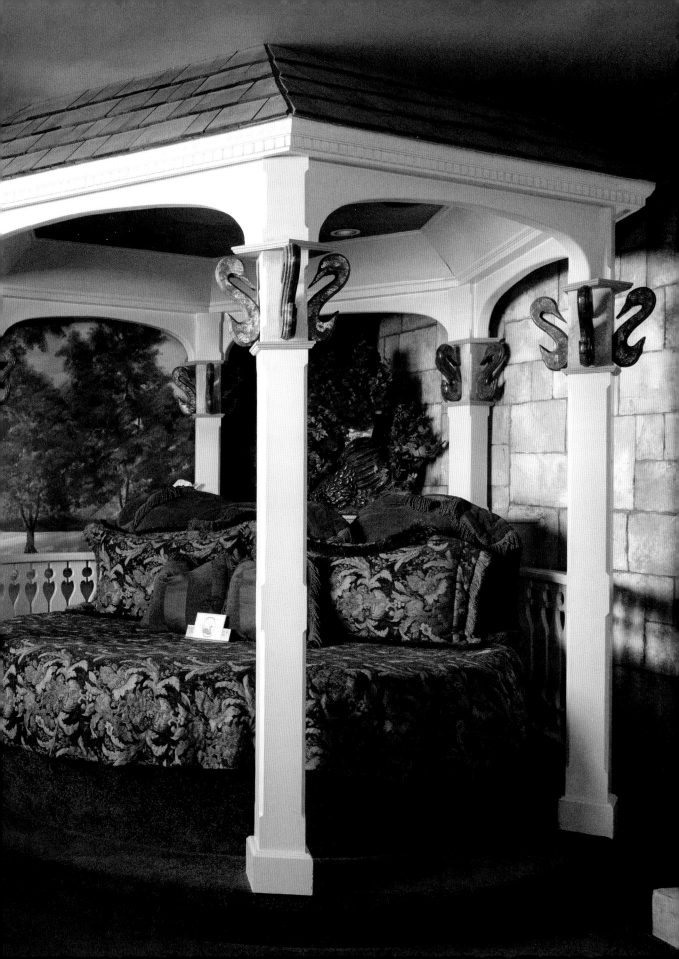

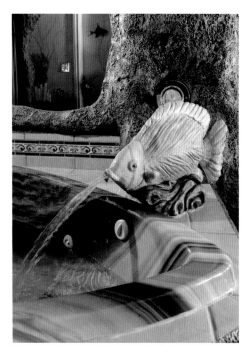

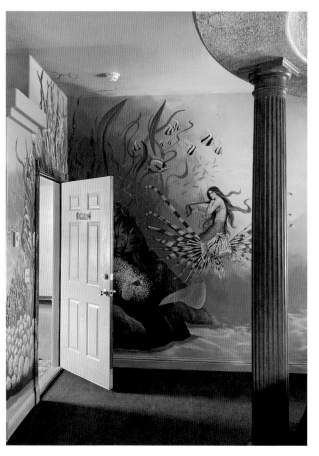

ABOVE The fish faucet in the Sea Cave tub is accompanied by an actual aquarium tank next to the shower.

RIGHT The rooms' all-encompassing murals are hand-painted by co-owner Debbie Fisher.

♥ ♥ ♥ ♥ ♥ ♥ ♥ ♥ ♥ ♥ ♥ ♥ ♥ ♥ ♥ ♥ ♥ ♥ ♥

The hand-carved statues in the Egyptian suite stand 12 feet (3.7 m) tall.

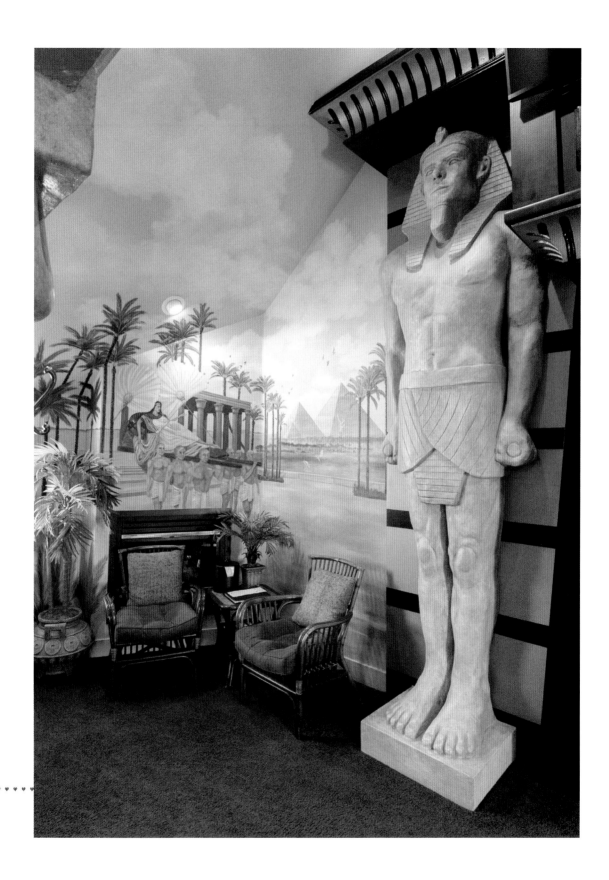

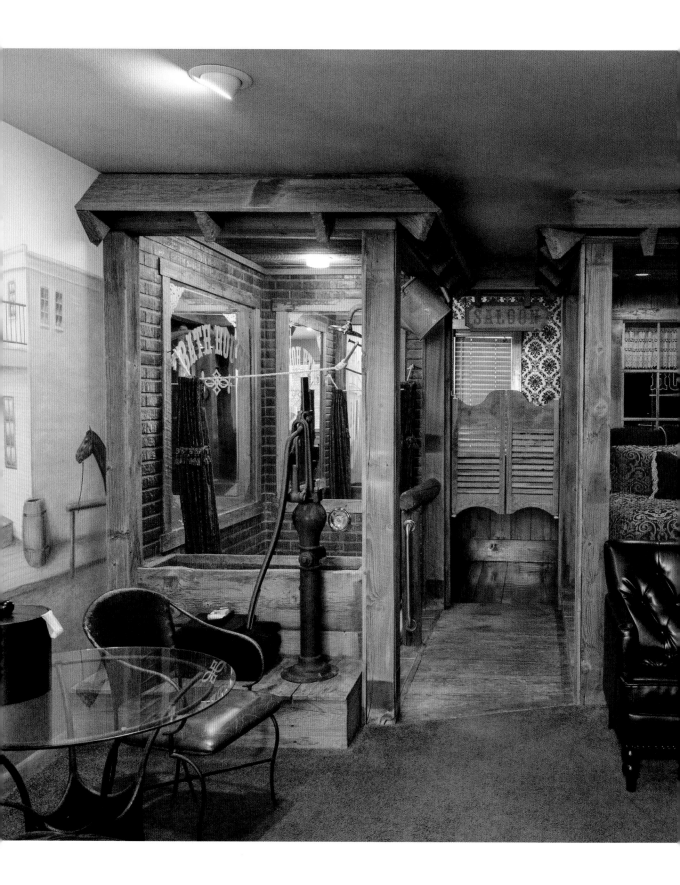

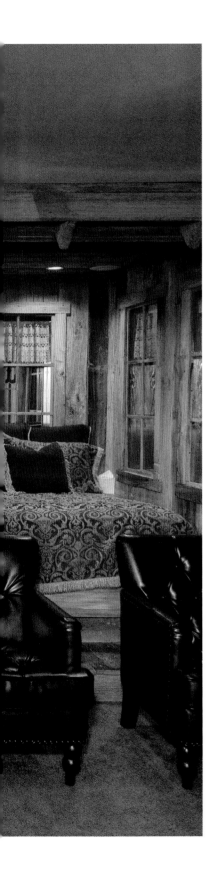

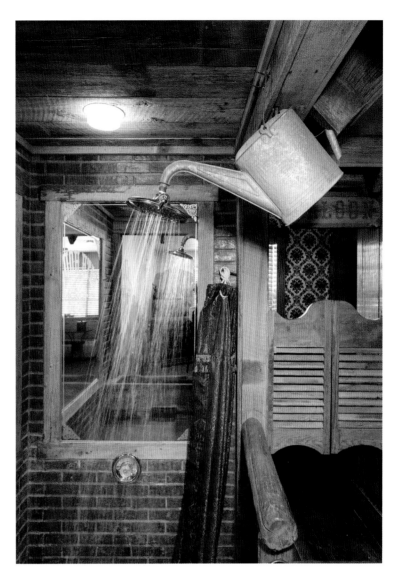

The Wild West suite features swinging saloon doors and a sunken tub with a clever watering-can showerhead.

Destinations Inn

IDAHO FALLS, IDAHO

Paris is one of the most popular travel destinations in the world, so it's no surprise that it's a favorite here at Destinations Inn.

This Idaho Falls hotel lets you travel the world within the confines of one building. With its fourteen destination-themed rooms, you can book one that promises to transport you to Egypt, Thailand, England, or Morocco. The hotel was originally opened and designed by Rob and Theresa Bishop, but in 2010, Larry and Debbie Fisher, owners of the nearby Black Swan Inn (see page 171), were thrilled to purchase the property and add it to their portfolio. Having visited many years before, the couple loved the idea of a destination-specific theme hotel and were excited to make it their own.

The rooms at Destinations Inn are elaborate, and the attention to detail is astounding. In the Paris suite, you'll shower beneath an Eiffel Tower replica. In Venice, you'll soak in a gondola-shaped Jacuzzi. In New York City, the faucet for the tub is cleverly disguised as a fire hydrant, and the Broadway-stage bed sets the scene for a night to remember. The inn's extra effort when it comes to hospitality, including breakfast delivered to your door, makes this an even more luxurious stay. It's not hard to see why locals flock to this hotel for their special celebrations, and why others travel from around the country to experience this incredibly creative and romantic getaway.

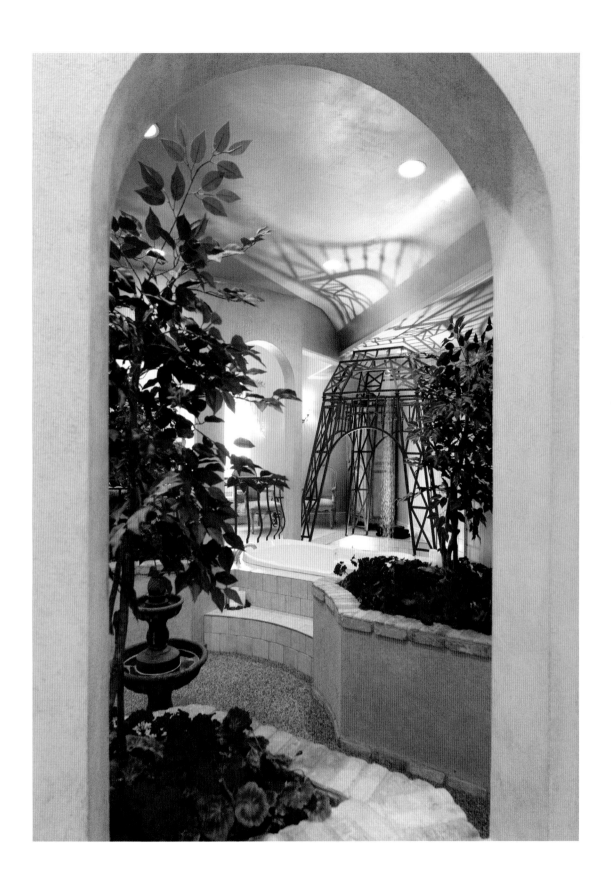

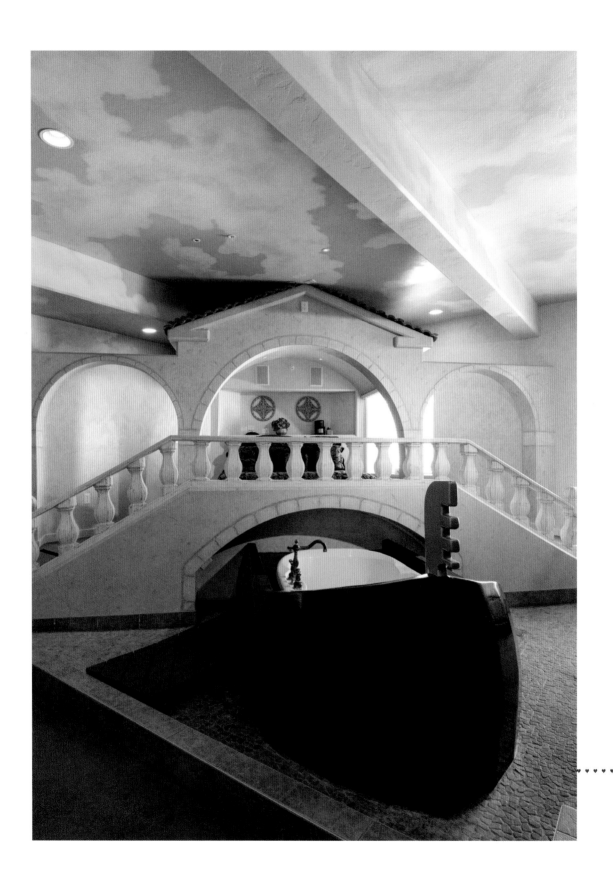

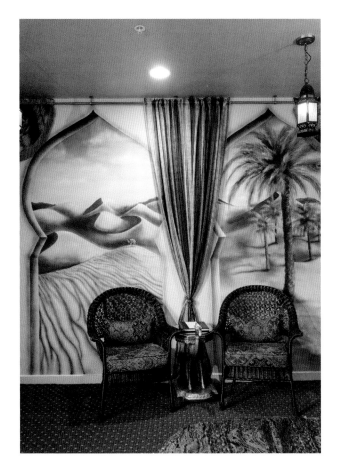

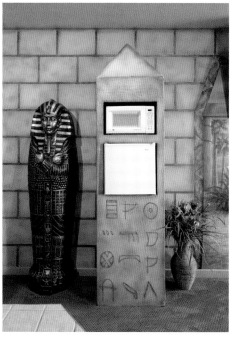

ABOVE We love to see typical hotel amenities worked into the decor of a theme room.

LEFT Murals in the Arabia room give the illusion of sweeping views and sunny skies.

Step into an iconic Venice scene and enjoy a night soaking in a fully customized gondola Jacuzzi tub beneath the Rialto Bridge.

The New York room manages to fit Broadway, the Statue of Liberty, Central Park, and Times Square all under one roof.

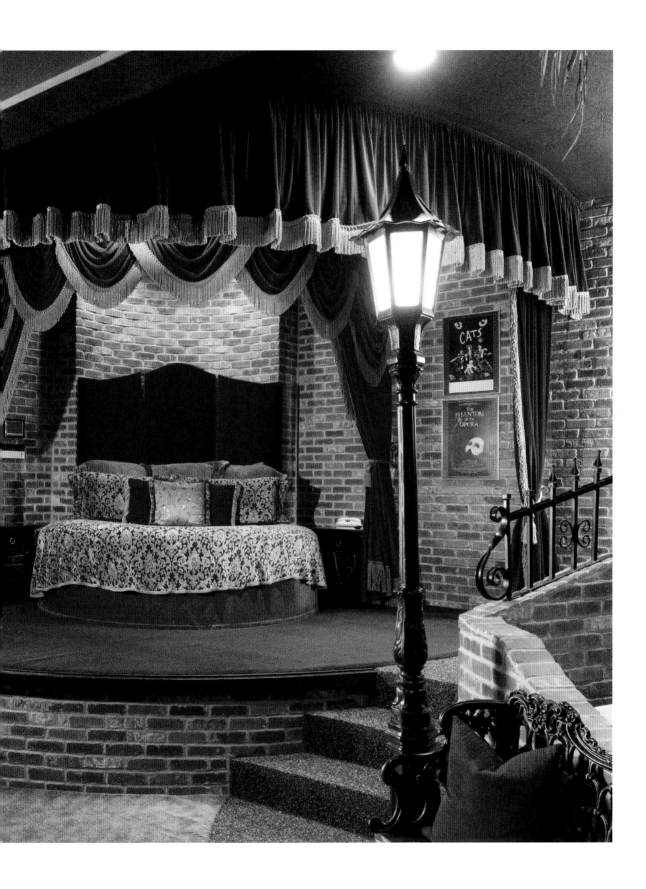

Olympic Railway Inn

SEQUIM, WASHINGTON

The bedrooms have heating and cooling, a TV, and a coffee and tea station to make the stay more comfortable.

A hunt for unique places to stay in the Pacific Northwest led us to the Olympic Railway Inn in coastal Washington, where you can sleep in a themed caboose. Pulling up to the property, you get the sense that you're entering a train station, but the tracks you cross lead to nowhere. Instead, there are train cars sprinkled across the property, each a different color, and the themes inside range from Orient Express and Polar Express to Wild West and the wine lover's Grape Escape. These cozy interiors are surprisingly spacious, offering large Jacuzzis or soaking tubs, seating areas, and even kitchenettes.

The inn, previously known as the Red Caboose Getaway, began transporting railcars to the property and redesigning them in 2000. In 2021, Pike Hospitality Group purchased the business, and they have their own renovations and updates in the works, including new themes like Underwater, Wizard, and Casino Royale.

As people who generally travel by car or plane, we found it awe-inspiring to see how massive and powerful these steel cabins are and to interact with them in such a new way. There's a certain nostalgia to train travel, and we were happy to find the same romantic feel at this unique inn.

RAILROAD CROSSING

PRIVATE

R**X**R

CROSSING

NO TRESPASSING

RIGHT TO PASS BY PERMISSION
SUBJECT TO CONTROL OF OWNER

12188

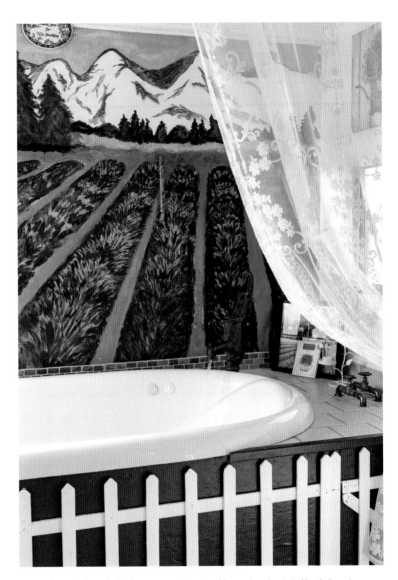

ABOVE Sequim has the highest concentration of lavender plants in North America, so staying in the lavender-themed car felt appropriate.

LEFT The colorful array of train cars you're greeted with as you enter the property.

Love Cloud

LAS VEGAS, NEVADA; LOS ANGELES, CALIFORNIA

Love Cloud sets the scene for romance as soon as guests board their unforgettable ride.

Since 2014, Love Cloud has taken the idea of a rent-by-the-hour love motel to the skies with its Mile High Club Flight. For up to ninety minutes, couples (or throuples) get a private flight in a small plane outfitted with a cozy twin-size mattress. This excursion is just as wild as it sounds: After you board, the pilot puts up a curtain that separates the cockpit from the cabin and wears noise-canceling headphones so that the experience is totally discreet. The setup includes red satin sheets, flowers, sex wedge pillows, and a Bluetooth speaker to set the mood with your preferred playlist. Toward the end of our flight, as the adrenaline was wearing off, we enjoyed a beautiful sunset along with some cheese and crackers. Just before landing, we were treated to a stunning view of the Las Vegas Strip lit up in the dark. After the flight, the pilot signed a certificate documenting that we were now Mile High Club members, and we immediately joked that we would frame it and hang it in our living room, though it may make family gatherings a little bit awkward.

Love Cloud is based in Las Vegas but expanded to Los Angeles in 2022. They want to make your experience as special as they can and will pick you up in a limo right at your hotel, have chilled champagne waiting for you onboard, and even help stage a proposal right before the flight. Beyond the Mile High Club Flight experience, they offer romantic dinners in the sky as well as weddings and vow renewals. Whichever flight path you choose, you're sure to enjoy this once-in-a-lifetime opportunity, and we would be shocked if it wasn't the most thrilling date night of your life!

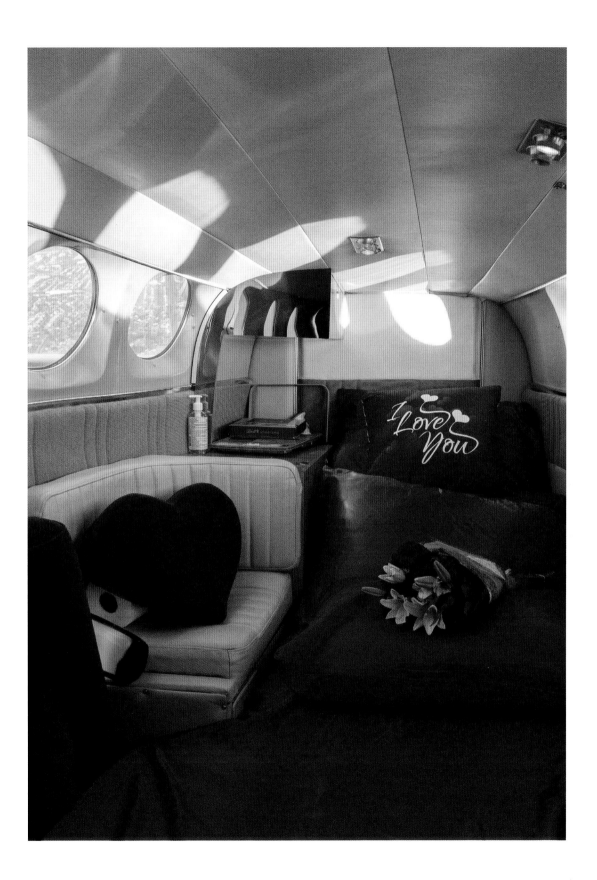

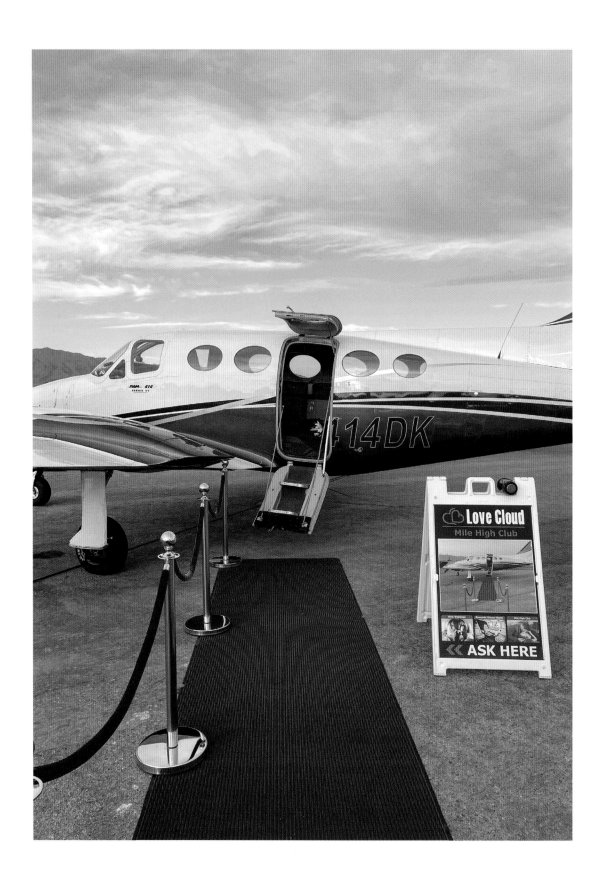

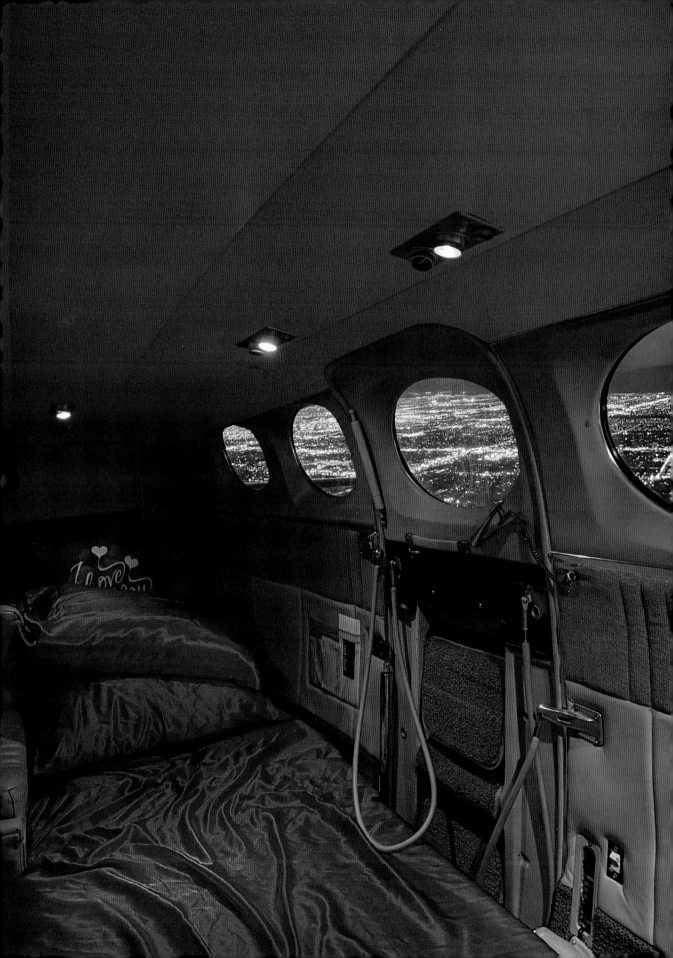

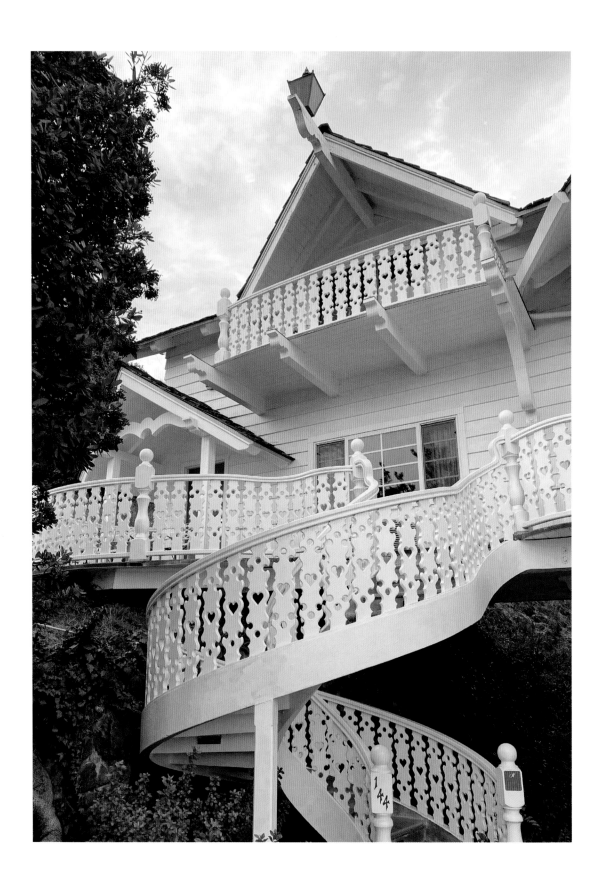

Madonna Inn

SAN LUIS OBISPO, CALIFORNIA

Winding spiral staircases are found throughout the property and give a dollhouse feel to the exteriors.

This iconic hotel, which opened in 1958 on the central coast of California, was the brainchild of Alex Madonna and his wife, Phyllis. Alex had a hard time finding architects who would execute his unconventional ideas, so he decided to take on the construction himself, creating a structure that is now famous for its curved lines and rooms built into the sides of boulders. Phyllis was responsible for the bold interiors. Even though she was not formally trained, she knew how to channel her creative spirit into a colorful fantasy escape. The exteriors are a mixture of Gothic and Swiss style, with interiors that are a wonderland of color and kitsch. The Madonnas broke the mold at a time when hotels were expected to have each room look the same: Visitors can be transported to a castle, a dollhouse, an Old Western film set, or even an episode of *The Flintstones*, depending on which room they're staying in.

Today, the inn has 110 rooms, all uniquely designed. Alex wanted people to feel inspired by their stay. It's wonderful to see that his dream is alive and well decades later, with designs that have stood the test of time and remain unique in a landscape full of copycats. Visitors from around the globe are still stopping in to see the rose-patterned carpeting, stained glass, pink tennis courts, glitter walls, and over-the-top rooms, and to experience the world created by Alex and Phyllis: the one and only Madonna Inn.

ABOVE From robes to tea towels, a variety of merchandise covered in the hotel's iconic floral carpet pattern can be found at the gift shop.

RIGHT The dining room, Alex Madonna's Gold Rush Steak House, gets decorated seasonally. It is a full winter wonderland around Christmastime.

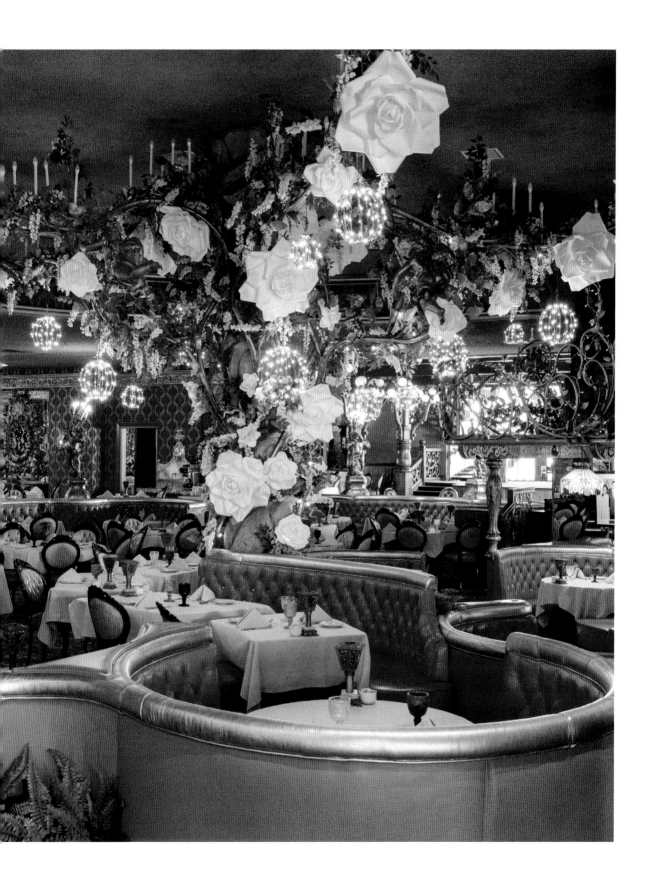

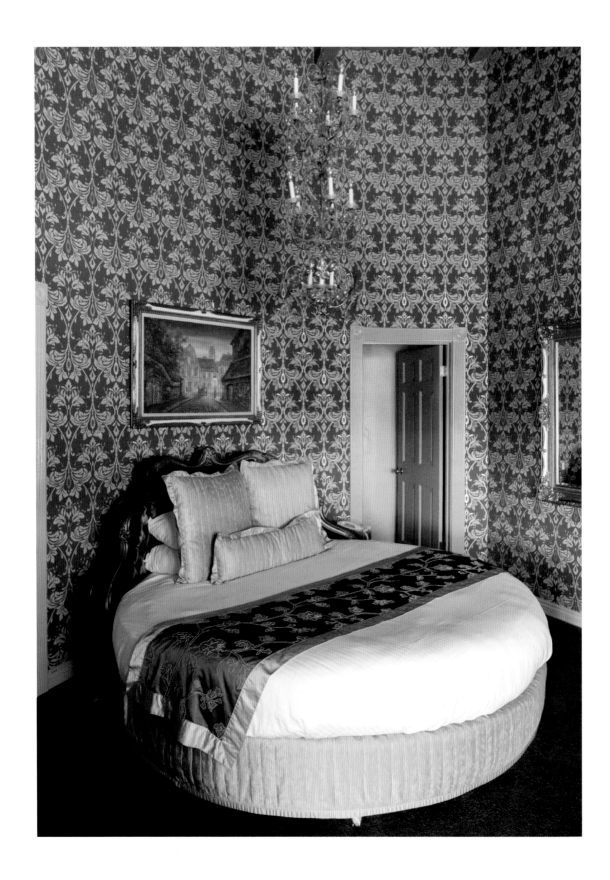

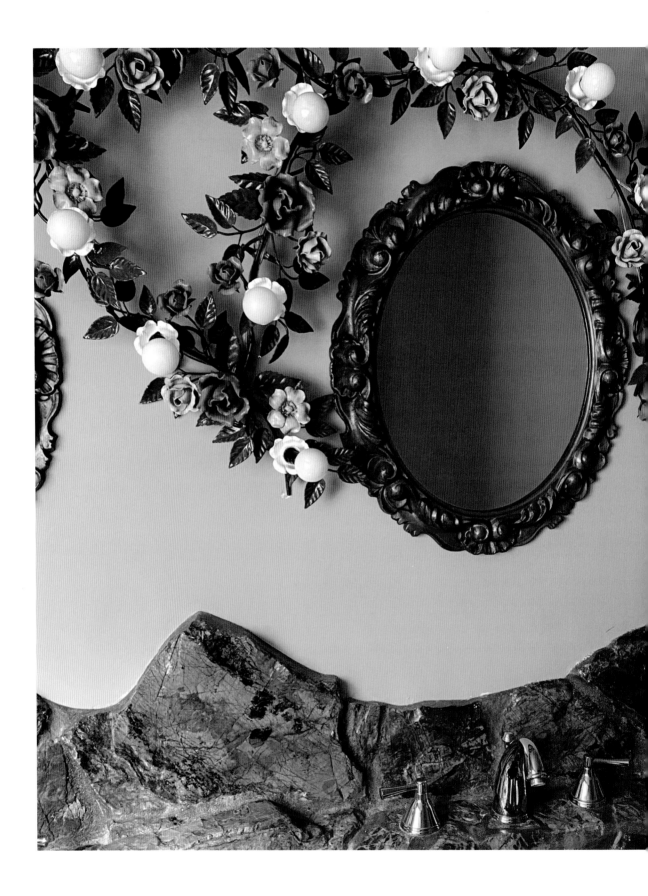

Rocks and boulders are an integral part of the architecture as well as the interiors and decor.

Victorian Mansion

LOS ALAMOS, CALIFORNIA

Extensive restoration work has been done to the mansion to maintain its intricate beauty.

A perfect detour while driving up the California coast, this quaint but stunning bed-and-breakfast is set in a mansion built in 1864. Originally constructed in Nipomo, California, by a Russian family, the house was moved to Los Alamos, in several pieces, by its new owner in 1980. There it was transformed with six themed suites, which were crafted over ten years by more than 200 artisans.

The current owner had dreams of opening a bed-and-breakfast that felt like Disneyland for adults, and when he learned that this B&B he had visited as a child was for sale, he jumped at the opportunity to restore it to its original magic. Each room is incredibly interactive: You can sleep in a 1956 Cadillac convertible, a Roman chariot, or a vardo. Bathrooms can be found behind doors that are disguised as part of the artwork, and there are camouflaged cubbies for the TVs, closets, and mini fridges. If you didn't know to look for these amenities, you might miss them entirely! In the morning, couples can have their breakfast delivered through a butler door, a system whereby the hotel staff has access to one of the hidden cubbies in the guest room from the back side. Each room is impressively detailed, and the whole experience is intimate and romantic—it will surely give you the feeling of getting a piece of Disneyland all to yourself.

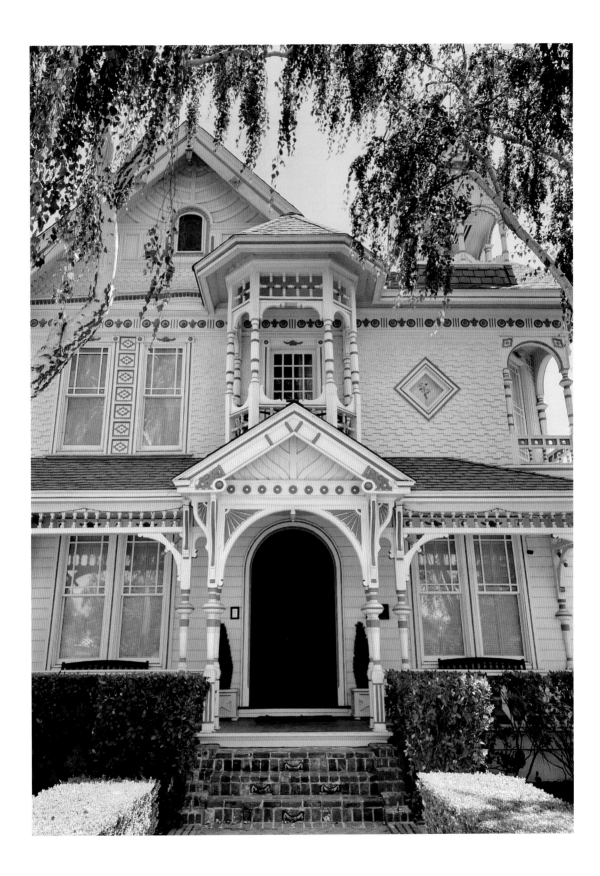

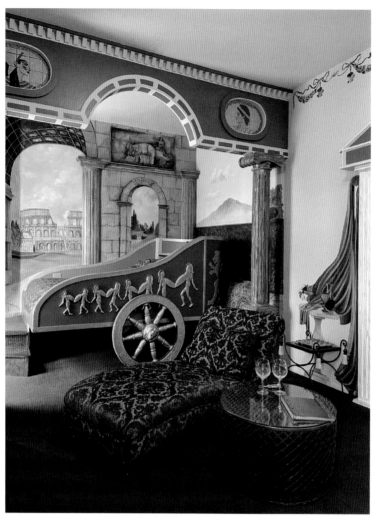

In addition to the chariot bed, the Roman suite includes a deep soaking tub surrounded by murals of Rome burning in the background.

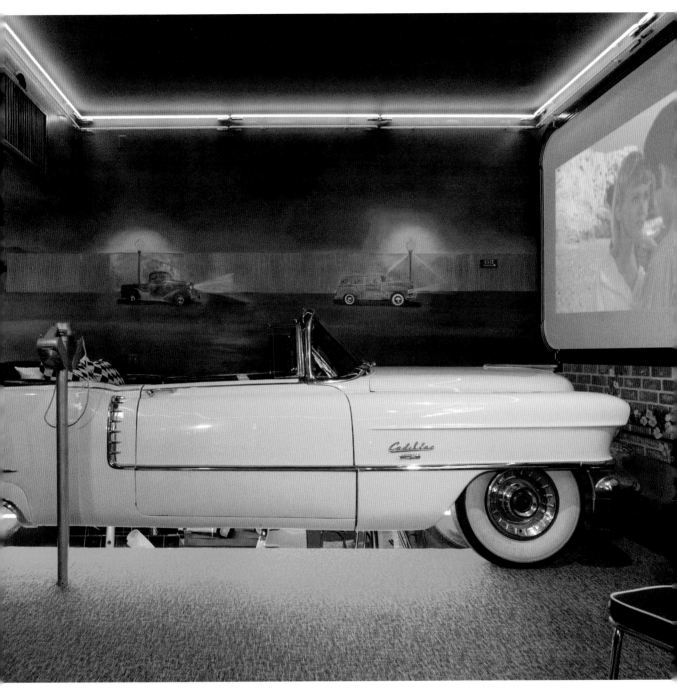

A projector screen is set up in front of the car bed in the fifties-themed suite to create the perfect drive-in movie date.

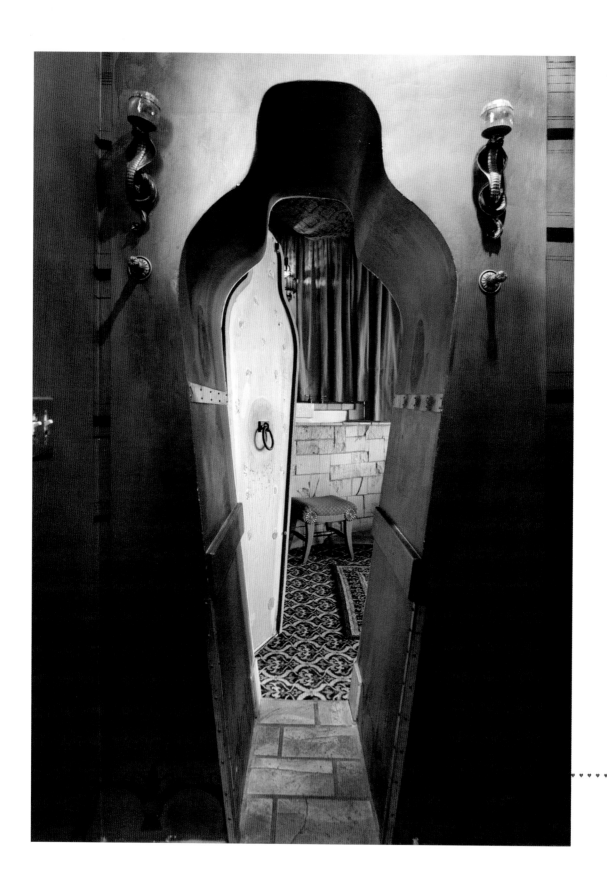

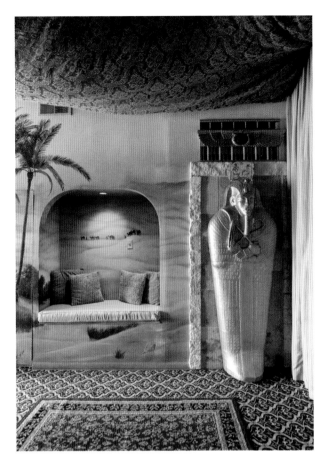

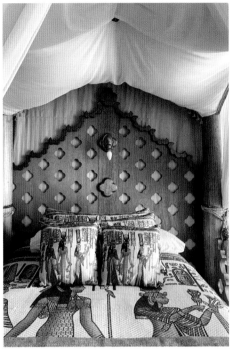

With walls and ceilings covered in colorful tapestries, the Egyptian suite is outfitted in stunning detail.

♥ ♥

The doorway to the bathroom in the Egyptian suite is carved to mimic the shape of the sarcophagus that disguises the door (shown above).

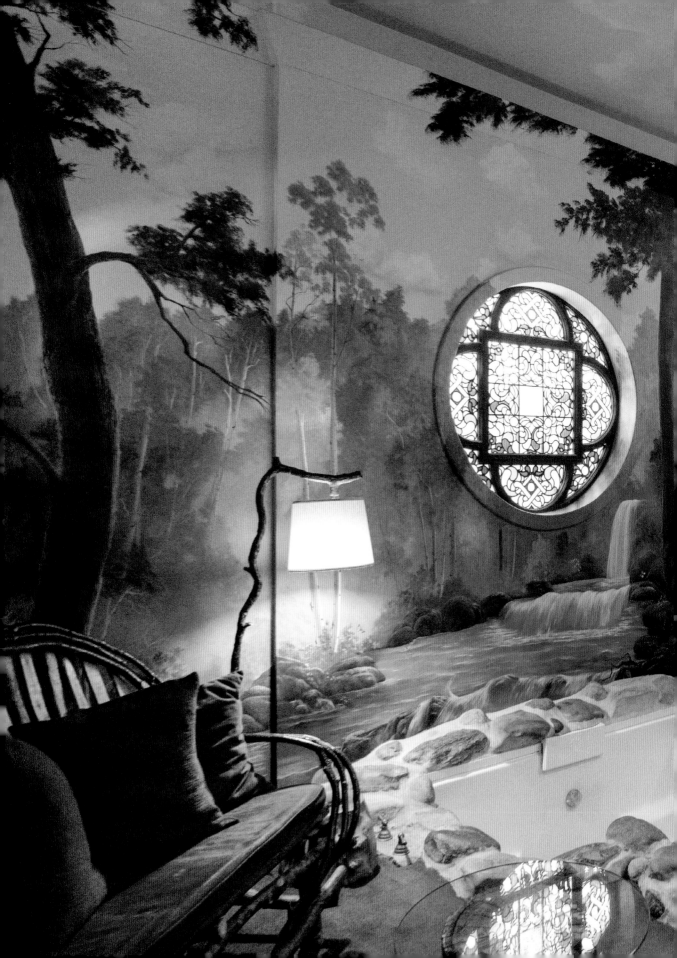

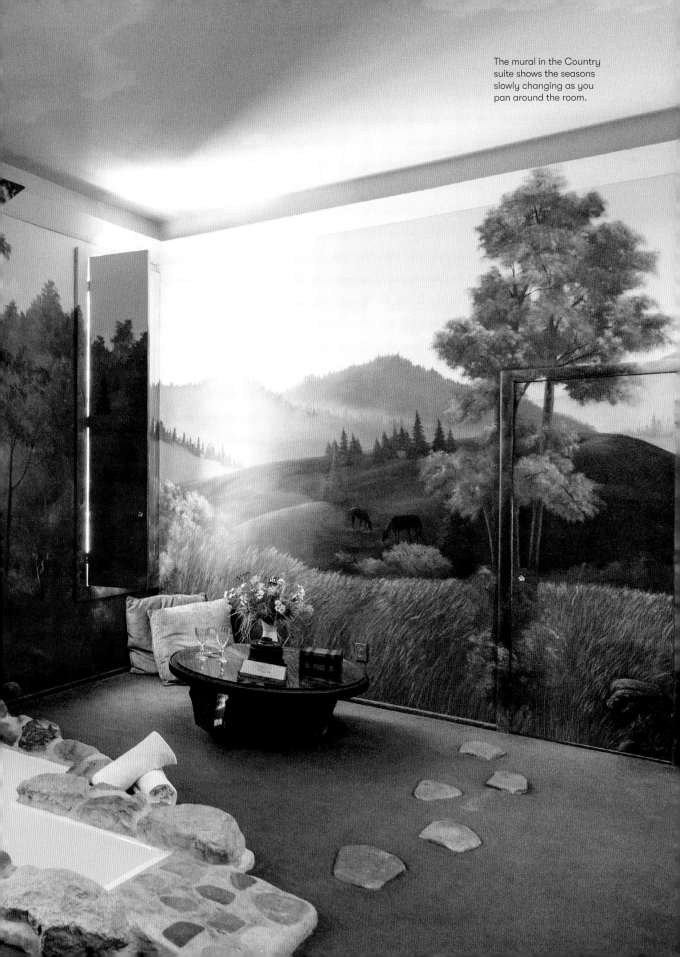

The mural in the Country suite shows the seasons slowly changing as you pan around the room.

Trixie Motel

PALM SPRINGS, CALIFORNIA

The lobby lounge is a pink daydream, with heart-shaped benches lining the walls along with artwork showing Mattel photoshopped into famous vintage photographs.

Trixie Motel is a colorful paradise created by *RuPaul's Drag Race All Stars* winner Trixie Mattel. On top of being a singer, songwriter, actor, comedian, and makeup mogul, Trixie Mattel also had a dream of opening a motel in Palm Springs with her partner, David Silver, and made that into a reality by purchasing the property in 2020. The building was built in 1952, and the previous owner, Ruby Montana, had already turned this midcentury modern motel into a themed escape. When Mattel took over, she gave it a complete face-lift and "put the motel in drag," all while filming a TV show, *Trixie Motel*, documenting the process.

Mattel picked Los Angeles–based designer Dani Dazey for the project, and her maximalist style and bold approach to patterns and colors are on display in the seven themed rooms, which include Queen of Hearts, Pink Flamingo, Atomic Bombshell, and Yeehaw Cowgirl. Although the pair looked to vintage theme hotels for inspiration, they also wanted the rooms to feel fresh, upscale, and distinctly "Trixie."

At a time when social media appeal is the best marketing money can buy, Mattel and Dazey knew there had to be photo opportunities throughout the property. There is no shortage of cute, patterned, and playful moments for guests to enjoy (and share) during their stay. This modern version of a kitschy theme hotel is sure to draw not only Trixie fans but also those looking for a colorful, over-the-top approach to a dreamy Palm Springs getaway.

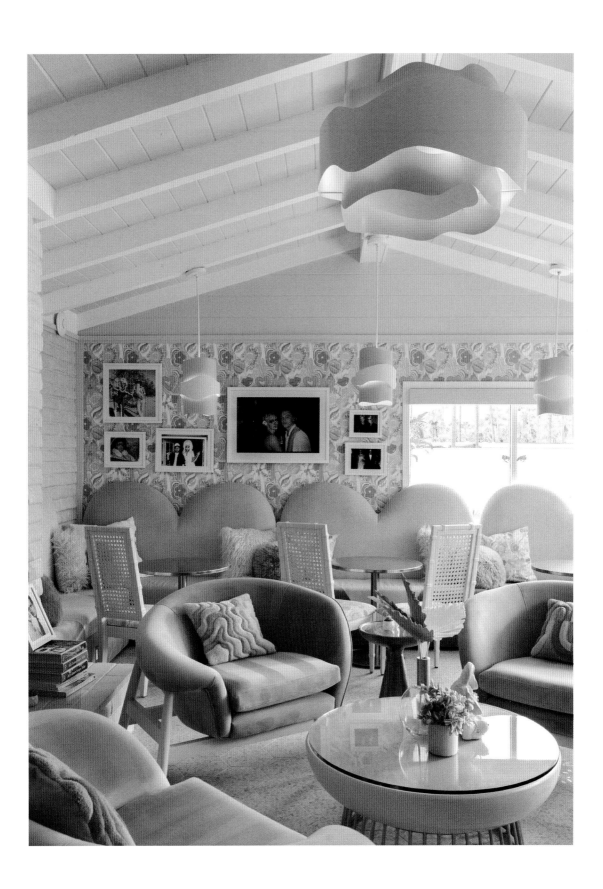

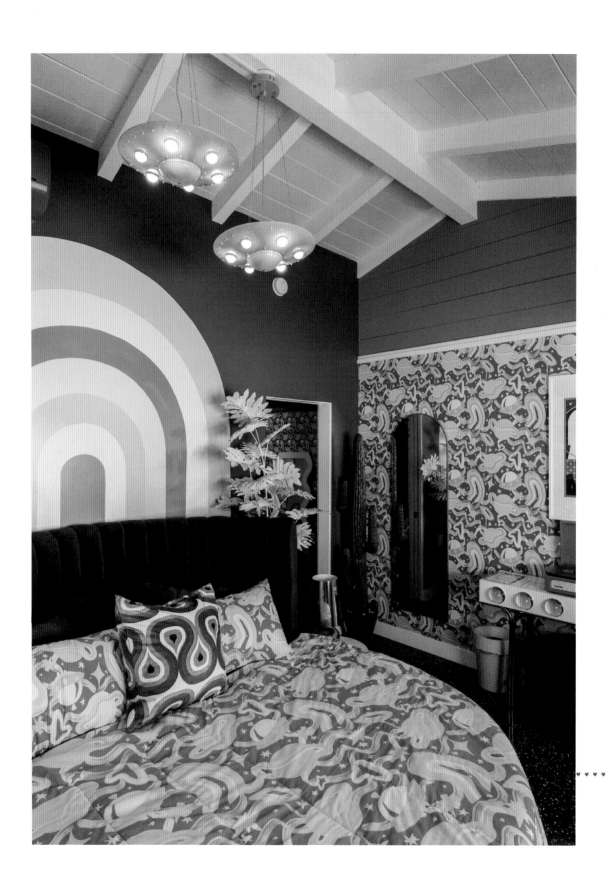

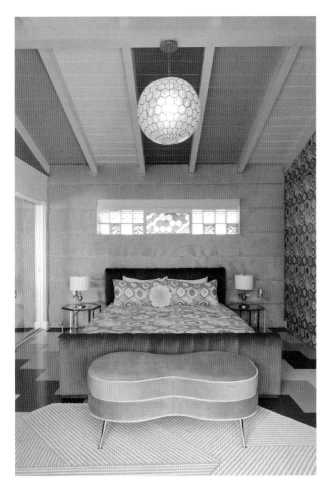

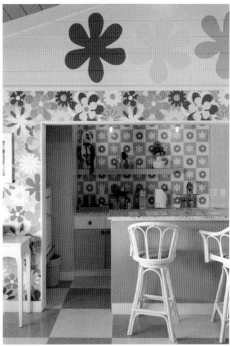

ABOVE The Flower Power suite goes full seventies groovy glam with pastel daisies and a petal-shaped headboard.

LEFT The Oh Honeymoon suite is extra spacious and has honeycomb and bee details throughout, as seen in the fixtures and in hand-drawn designs.

This custom round bed in the Atomic Bombshell was so large it had to be transported in several pieces and assembled in the room.

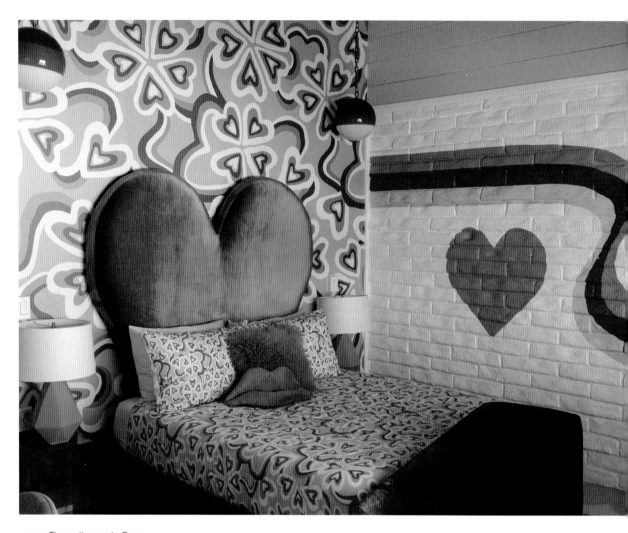

ABOVE The wallpaper in Queen of Hearts was drawn by Dazey, who turned each room theme into a pattern for custom curtains, bedding, and more.

OPPOSITE Even the floors got a makeover with a variety of colorful finishes and custom tiling.

A flock of pink flamingos and Trixie's iconic eyes are part of the decor out on the pink patio.

With temperatures regularly exceeding 100° F (38° C) in the summer, a pool is a must-have hotel amenity in Palm Springs.

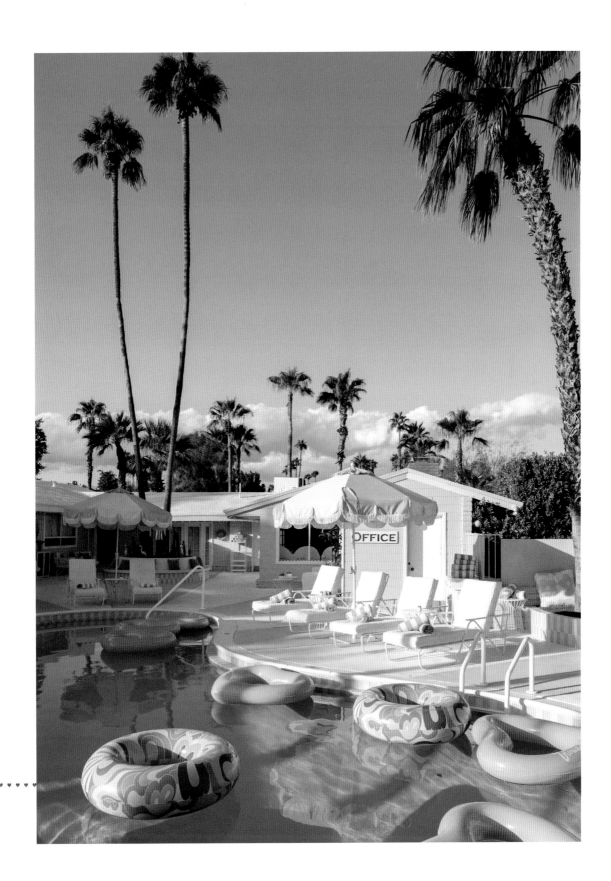

Rooms Inspired by POP CULTURE

Outer space, jungle, cave, honeymoon, and western-style rooms are all staples at vintage theme hotels. These designs were heavily influenced by old Hollywood films and gave couples a chance to feel like they were on their very own movie set. Modern hotels are following suit, with themed rooms referencing popular TV shows, films, and more. Here we feature four of our favorites, and be sure to check out the Roxbury on page 53 and Hicksville Pines on page 226 for more great pop culture–influenced designs.

Home Alone Experience

GRADUATE HOTEL
EVANSTON, ILLINOIS

• • • • • • • • • • • • • • • •

Just minutes away from the house where *Home Alone* was filmed, this Graduate Hotel suite is the perfect location for a trip down memory lane. Sleep in the iconic four-poster bed surrounded by the busy red-and-green floral wallpaper; enjoy the collection of memorabilia like photos of the McCallister family, Buzz's tarantula, a Michael Jordan cutout, and aftershave; and pop in a VHS of *Home Alone* to watch on the room's tube TV.

The Phantom's Lair Suite

LIONS GATE MANOR
LAVA HOT SPRINGS,
IDAHO

• • • • • • • • • • • • • •

This suite offers adventure right from the start, when you enter through a door hidden behind a bookcase. From there, you walk down a spiral staircase into the dark dwellings of the Phantom of the Opera and find famous decor from the show, like a chandelier, an organ, roses, a roped-off room labeled "Box 5 Reserved," and an impressive piece of art that makes you feel as though you're being watched by the Phantom through the two-way mirror.

Stranger Things Suite

**GRADUATE HOTEL
BLOOMINGTON, INDIANA**

♥ ♥ ♥ ♥ ♥ ♥ ♥ ♥ ♥ ♥ ♥ ♥ ♥ ♥ ♥ ♥ ♥

The Graduate Hotel chain opened another themed suite, in their Indiana location, for fans of the Netflix show *Stranger Things*. The room is completely decked out with references to the series, from student IDs to Eggo waffles, and it even has a game table ready to host a round of Dungeons & Dragons. Guests are provided costumes to wear so they can dress as their favorite characters while in the suite, and the hotel offers themed menu items in the café. The details are so incredibly impressive and immersive, visitors will swear they're in Hawkins, Indiana.

Tropicana Ibiza Suites

SANT JOSEP DE SA TALAIA, SPAIN

Even hotels overseas are taking inspiration from Hollywood. The Tropicana in Ibiza is themed around the movie *Cocktail*. In the rooms, you'll find a framed poster that showcases a scene from the film featuring Tom Cruise, who plays a bartender named Brian Flanagan. Each suite is named after a different classic drink, like Acapulco Gold or Margarita, with the recipe included in the decor. By the pool, you'll find more cocktail-inspired art, including a Cocktails & Dreams sign and a giant martini-glass shower.

Castle Wood Cottages

BIG BEAR LAKE, CALIFORNIA

The three-level Castle Garden includes a fireplace, dining hall, moat, and bench swing surrounded by faux florals and foliage.

Castle Wood Cottages is an adults-only fairy-tale setting in the mountain town of Big Bear Lake, California. The story goes that the original owner, Dan Payne, purchased the property in 1988 after his wife complained that he didn't take her to Disneyland often enough. In response, he decided to build her a custom Disneyland experience by converting the eleven cabins into different romantic-themed escapes. Robin Hood and Maid Marian, King Arthur, and Antony and Cleopatra are some of the characters represented, and rooms like Woodland Tree House and Enchanted Forest feature hundreds of little bunnies, squirrels, fairies, and other creatures.

In 2015, Shannon and Dave Schonland purchased the property, and they have maintained as well as added to the magic. As a self-proclaimed theater and Renaissance fair lover, Shannon knows how to celebrate losing oneself in an imaginary world. Each cabin now comes with costumes, interactive elements (like hidden doors and even a castle moat), a gigantic soaking tub, and decor that truly sets the scene for a fairy tale. Everything seems magical here, and with the added invitation of costumes, there's no excuse not to fully escape into the fantasy. The gift shop features custom scented candles and bath products that Shannon tailors to each room, as well as all sorts of fairy-inspired garments, crystals, and decor to complete the fantasy experience or bring a piece of the magic home.

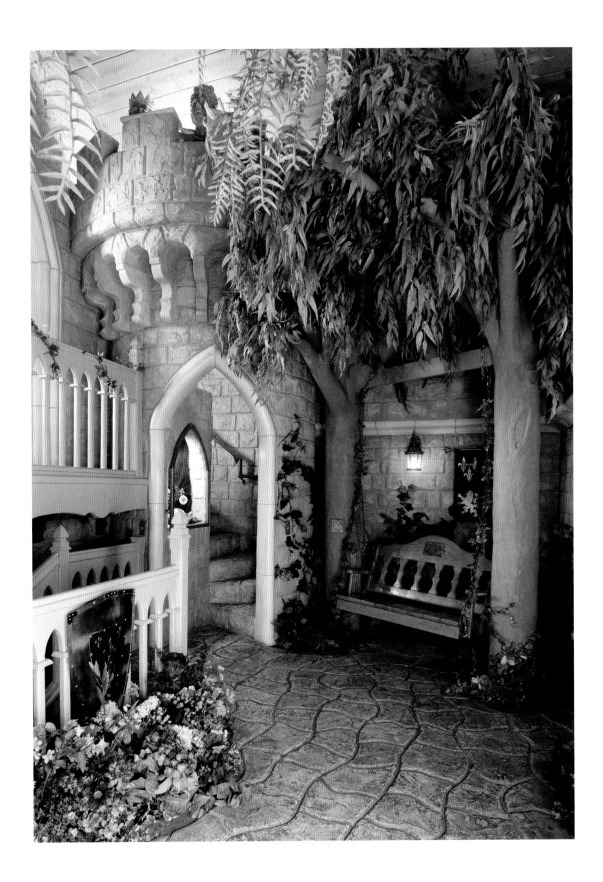

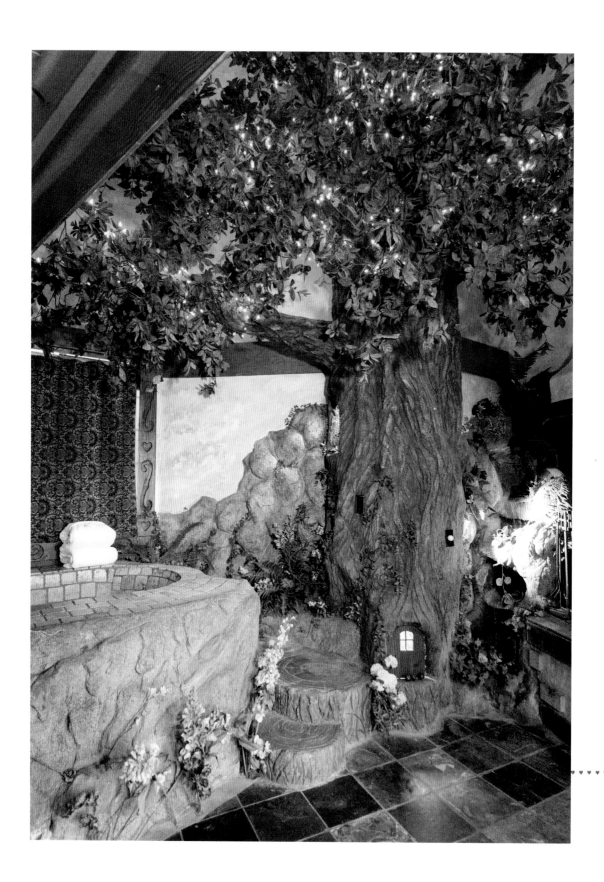

ABOVE The Haunted Manor feels like something out of a fairy tale (and is only mildly spooky).

LEFT Each room comes with costumes, like this feathered hat and overcoat found in the pirate-themed Captain's Quarters.

The Woodland Tree House cabin is built on stilts several stories high. Hidden creatures can be found throughout the decor inside.

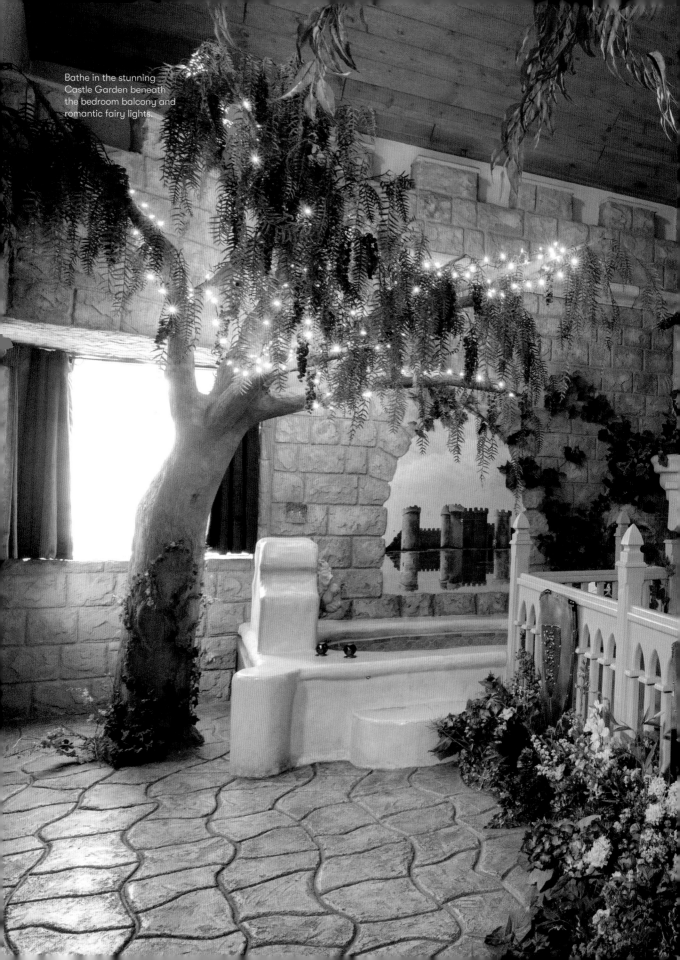

Bathe in the stunning Castle Garden beneath the bedroom balcony and romantic fairy lights.

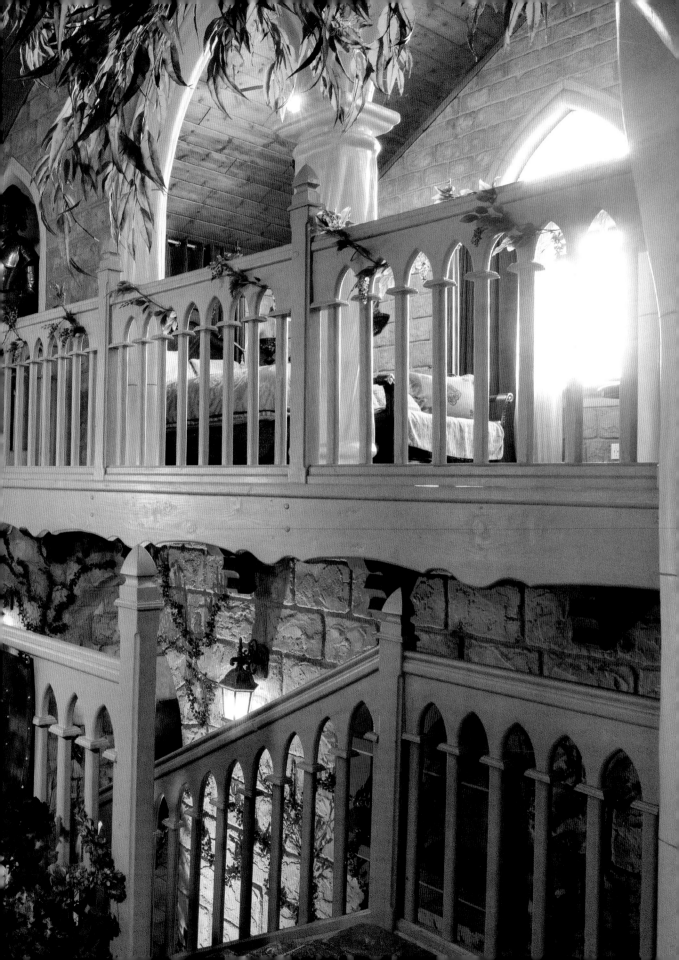

Hicksville Pines Chalets & Motel

IDYLLWILD–PINE COVE, CALIFORNIA

Black-light posters line the A-frame walls around the sunken bed of That '70s Room.

In the quirky mountain town of Idyllwild, California, where the mayor is literally a dog (a golden retriever, to be exact), sits an appropriately eccentric "bud-and-breakfast." Hicksville Pines is a twenty-one-and-over property where each room has its own porch with an ashtray, and a nugget of cannabis is gifted to guests upon arrival. No smoking is permitted in the cabins (That '70s Room being an exception), but there are plenty of areas in which to partake.

Founder Morgan Night designed each suite around one of his interests. Because he didn't take the traditional route to creating the themes, they're some of the most niche and creative you'll find. There's a John Waters–themed suite, a large cabin dedicated to *Twin Peaks*, and a bathroom featuring a wooden tub and microphone showerhead in the Dolly Parton room. In the lobby you'll find shadow boxes filled with taxidermy by artist Brooke Weston, each designed around individual cabin themes. The suites are set in different-colored vintage Sears A-frame cabin kit homes, and the whole property has a magical-forest feel to it, even before the smoke sesh.

In 2022, Erica Beers and Rebecca Slivka purchased the business, and they plan to maintain and expand on the unique universe Night created, giving it a second life that not every theme hotel is lucky enough to have.

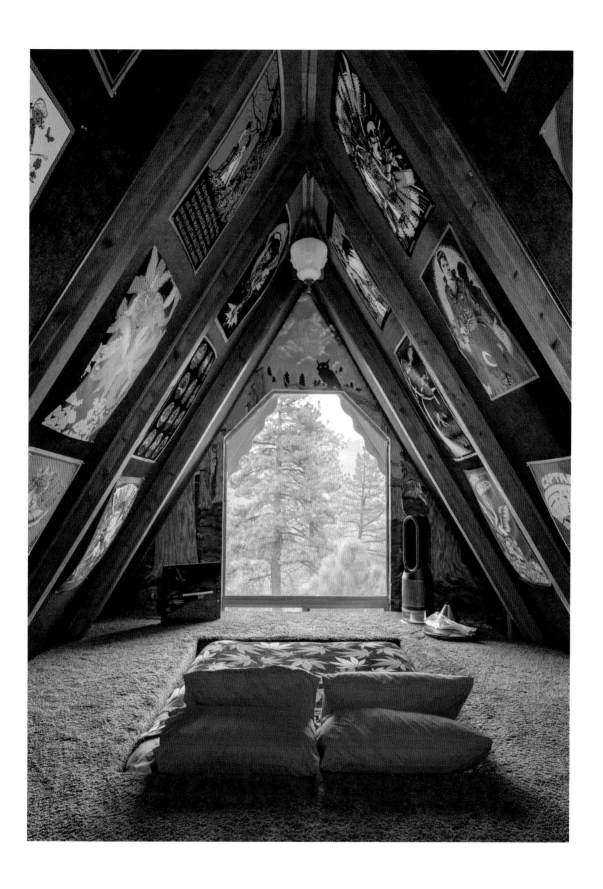

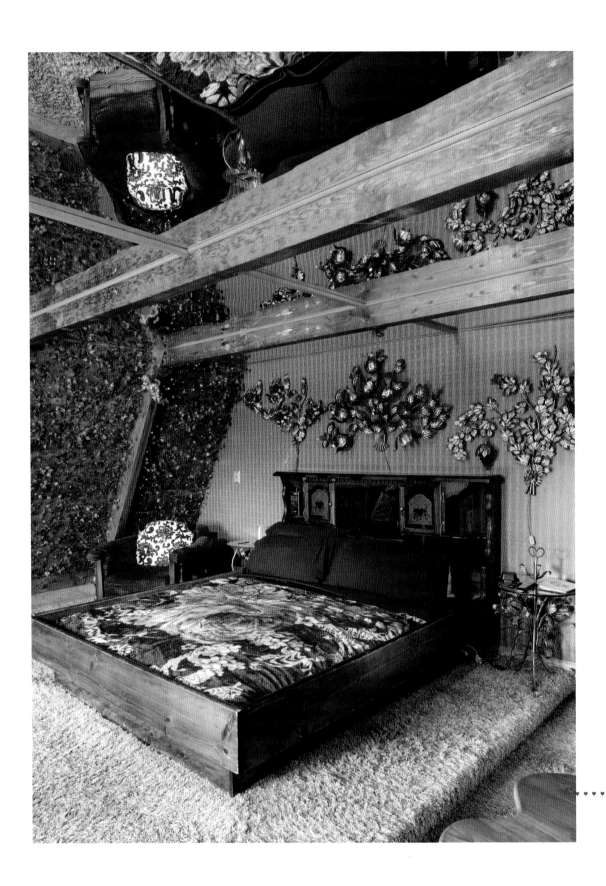

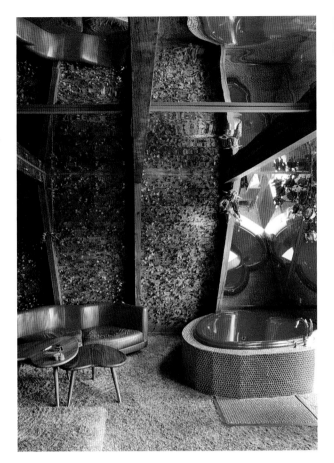

Shag carpeting, a heart-shaped tub, ceiling mirrors, and swan faucet details are among our favorite elements of the Honeymoon suite.

The Honeymoon suite has one of the only waterbeds we've found at a hotel.

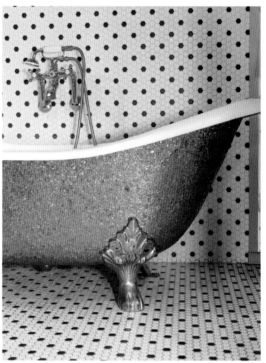

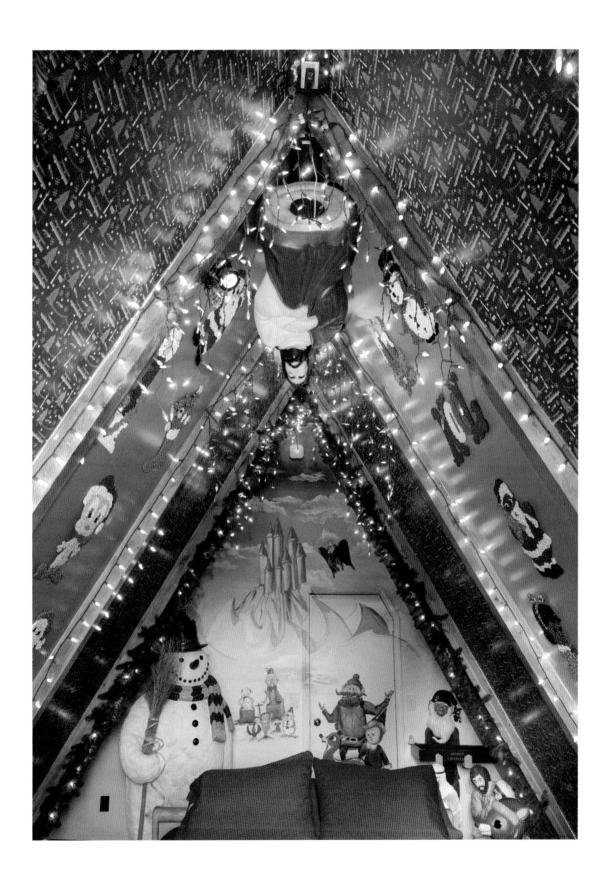

Even the facilities play a part at Hicksville. The upside-down bidet on the ceiling in the Third Man room (*left*) actually functions as a shower, and a mouth-shaped urinal (*right*) greets guests in the lobby bathroom.

Burlesque icon Dita Von Teese helped design her namesake cabin, which includes a claw-foot tub covered in pink glitter.

Best Western Fireside Inn

KINGSTON, ONTARIO, CANADA

The Flights of Fancy room hides a mounted TV in the mouth of the balloon, so you're still able to channel surf while lounging in the basket.

In the world of theme hotels, we've learned to never judge a book by its cover. This Best Western in Kingston, Ontario, is a perfect example, since driving by the hotel or even walking down its hallways would not tip you off to the elaborate fantasy lands hidden inside the rooms.

Before the Fireside Inn became part of the Best Western franchise, the owner turned a wing of the hotel into themed suites inspired by his world travels. The rooms are detailed and elaborate, built with quality materials like real stone, imported furniture, and even a Rolls-Royce converted into a bed. Some of the suites used to be racquetball courts, so the ceilings are notably high, and the rooms feel ever so spacious—which is particularly fitting for the Flights of Fantasy room (featuring a hot-air balloon) and the Tranquility Base suite (which gives guests a sense of floating through the stars).

It's a rare treat to stumble on a theme hotel that is so well cared for, especially within a larger franchise, and it's obvious that the owner takes great pride in maintaining these works of art.

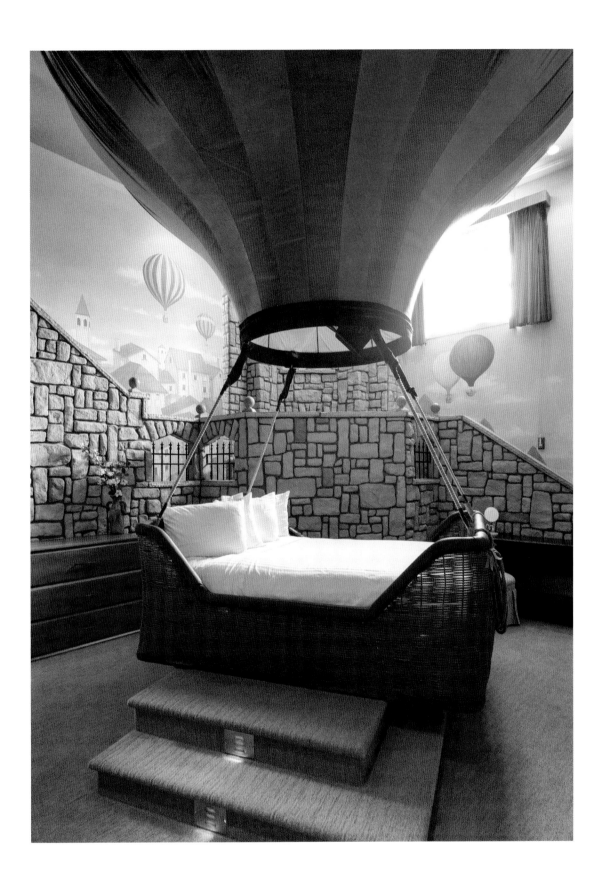

The Tranquility Base suite features massive wall murals and a lifelike floating astronaut.

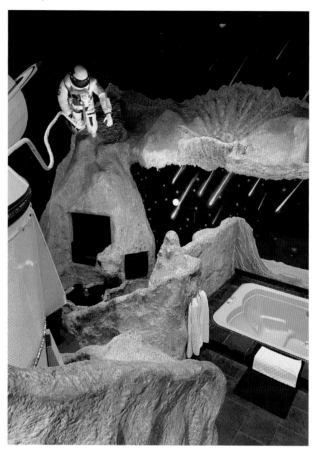

♥ ♥

Walk up the stairs carved out of moon rock to reach your bedroom inside the space capsule.

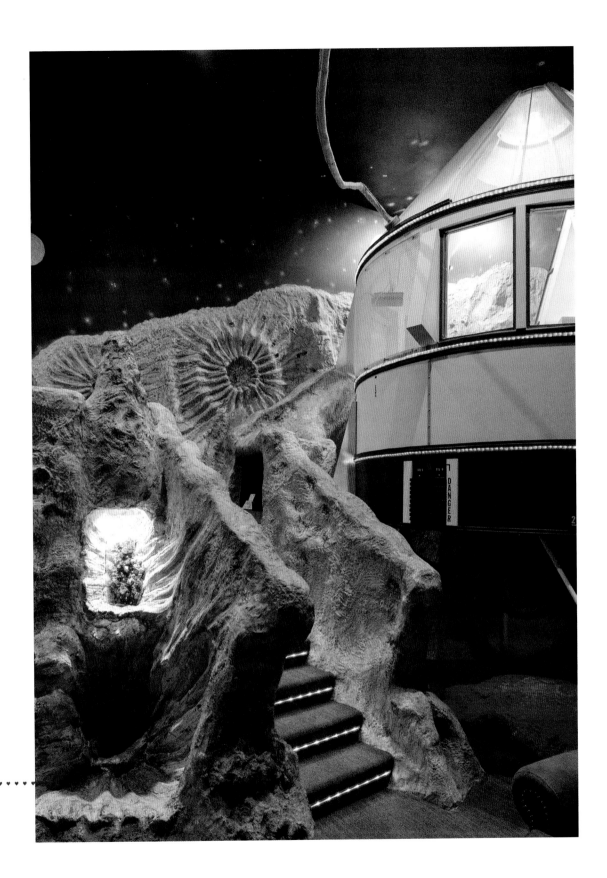

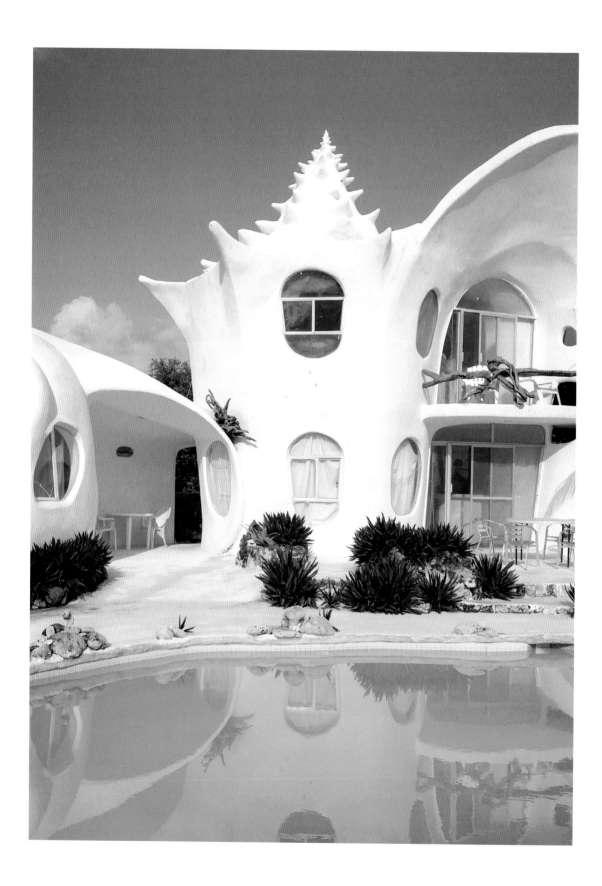

Shell House

ISLA MUJERES, MEXICO

The home's architecture is so impressive you can almost convince yourself that you're sleeping in a giant seashell that has washed ashore.

Pulling up to this giant seashell-shaped home on Isla Mujeres in Mexico, you can hardly believe your eyes. This fantasy hotel is unique in that the outside of the building is as evocative of the theme as the inside. Beginning in the mid-nineties, two brothers, architect Eduardo Ocampo and painter Octavio Ocampo, began working on the Shell House, also known as Casa Caracol. The name "Casa Caracol," which translates to "snail house," came from Eduardo's vision of building a house shaped like a shell to actually live in, like a snail.

Inspired by the beaches around them, the Ocampos wanted every detail of the space to represent ocean life. To that end, they crafted rounded rooms that appear soft and smooth, as if the building itself has been shaped by the waves over many years. Octavio decorated the interiors with murals and artwork depicting popular mermaid folklore, and fixtures like faucets, lights, and showerheads were made from seashells.

While staying at Casa Caracol, you get the sense that you're truly inside a massive seashell, and sitting out by the pool, staring up at the giant carved home, you feel like the mermaid in this fantasy. Or the snail, whichever you choose.

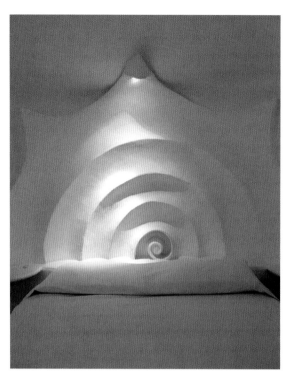

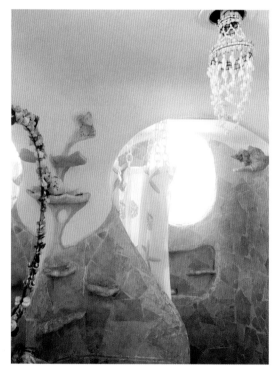

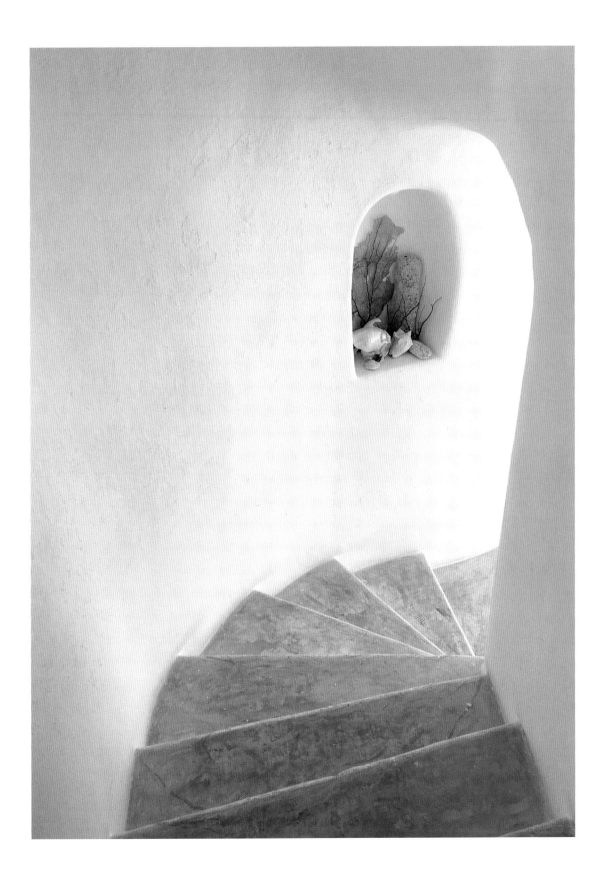

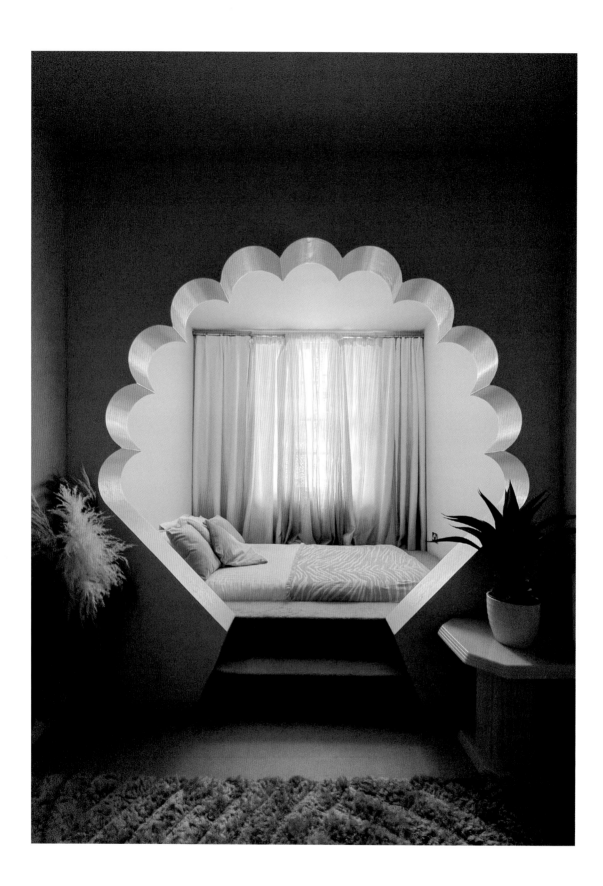

Margate Suites

MARGATE, ENGLAND

This aquatic Courtyard suite is located just steps away from the Margate seaside.

England is not known for kitschy theme hotels, but if you travel to the beachside city of Margate, you can find a rare treat. Margate Suites is a set of rental apartments that have taken their inspiration from eighties fantasy suites but with an updated look befitting the modern era.

The Courtyard suite is their most immersive design. Here you'll find a carpeted round bed frame, a tone-on-tone pastel color palette, and, best of all, a dramatic seashell wall cutout. This innovative twist on the shell-shaped headboard frames the entire bed with a custom wall. Themed suites are often larger than your average hotel room to accommodate extravagant beds or Jacuzzi tubs, but Margate Suites needed to get creative in order to bring a fantasy feel to standard two-bedroom apartments. Not only that, each one is up several flights of incredibly narrow stairs, so any set design had to be brought in piece by piece or crafted right in the room.

Interior designer Amy Exton says one night she woke up with the shell cove design in her head and knew she had cracked the code. Luckily, she was working with "carpentry genius" Elouise Farley, whose incredible precision brought the piece to life. Jessica du Preez of Poh Maluna design studio brought in the vintage feel with custom upholstery and carpeting. Together the three women created a modern take on the colorful, kitschy fantasy getaway that transports you to another world.

The peachy coral, cool blue, and seafoam green color scheme creates a dreamy glow throughout the apartment.

♥ ♥

The round bed frame had to be carried up in several pieces and assembled inside the room.

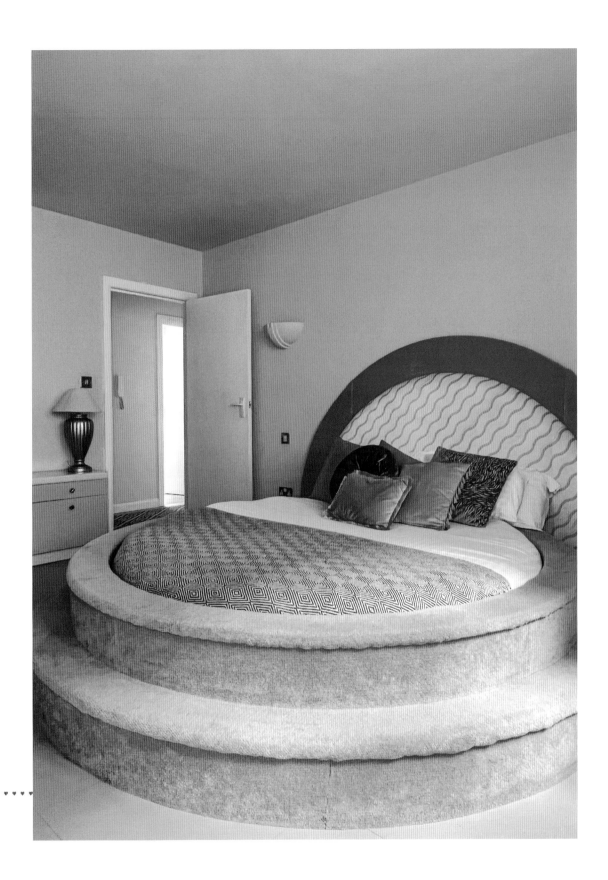

Romeo's Motel & Diner

IBIZA, SPAIN

This magnificent hotel on the Spanish island of Ibiza embodies the feel of an American love motel that might have opened along Route 66 in the fifties, sixties, or seventies. Designed by hotelier Diego Calvo with Concept Hotel Group, a company known for its well-executed, modern theme hotels, the entire property completely masks the truth of its 2020 debut with its vintage feel. Calvo is a huge fan of classic American motel design and, despite never having visited the United States, took his cues from archival photographs and old Hollywood movies to create the authentic look of the property. Unlike many American roadside motels that are no longer attracting a large number of visitors, Romeo's is a nostalgic paradise brimming with the energy of a youthful clientele, showing that style is cyclical, and what was once considered outdated by an older generation feels fresh and exciting to the next.

Romeo's brings luxury to the kitschy hotel category and features a heart-shaped hot tub inspired by the Poconos, a little white wedding chapel that gives a Vegas feel, neon signs that pay homage to the vintage motel signage along US highways, and a hidden bar called the Playroom that mimics a speakeasy, decked out with leopard-print upholstery and a light-up dance floor. The lobby doubles as a classic American diner, so guests can find a comfortable booth to sit in and enjoy a hot dog, cheese fries, and a milkshake while visiting the Mediterranean island.

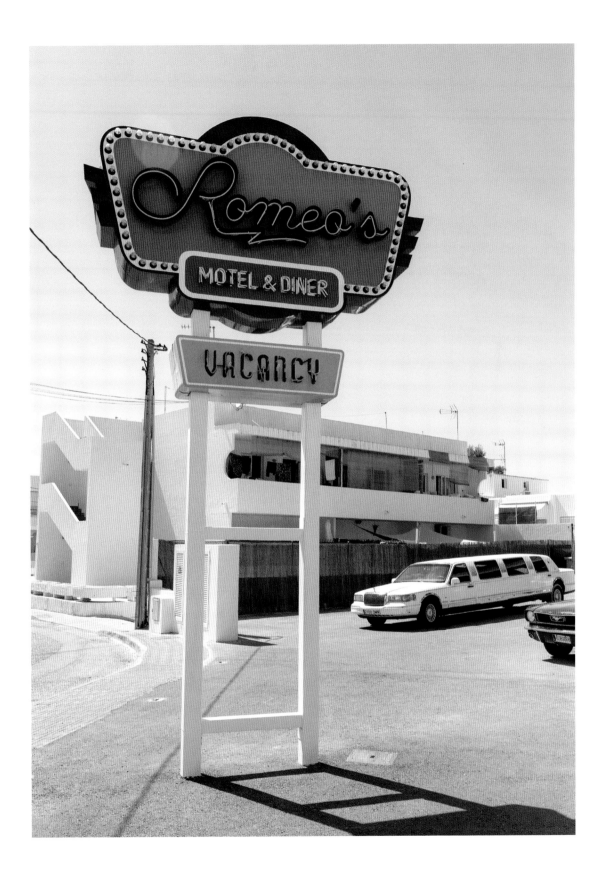

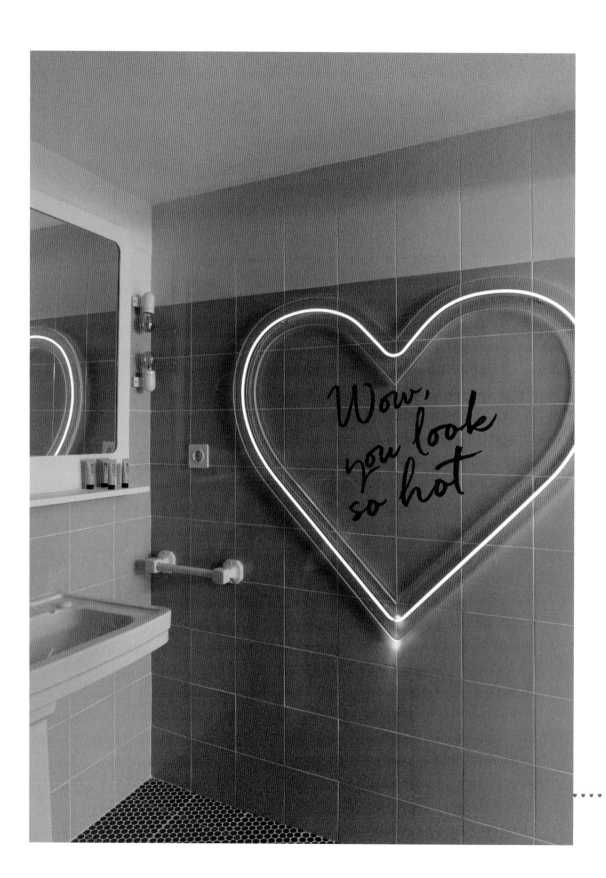

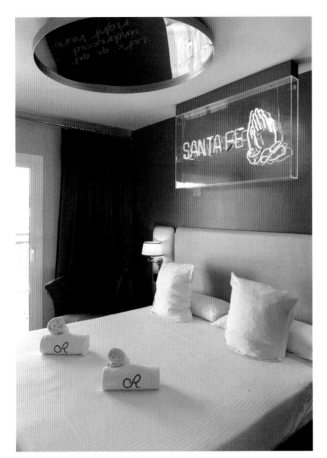

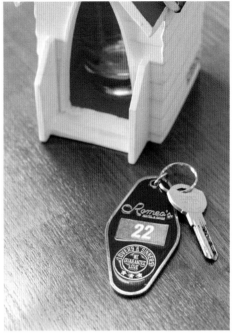

Ceiling mirrors and retro-style key chains complete the classic love motel aesthetic.

Cheeky English phrases can be found throughout the bedroom decor.

ABOVE Heart-shaped planters are sprinkled throughout the exteriors.

RIGHT The circular tiles found throughout the property are mirrored on the ceiling of the diner.

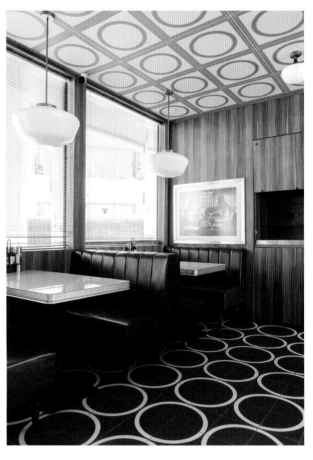

♥ ♥

The mesmerizing tile pattern continues across the spacious pool deck.

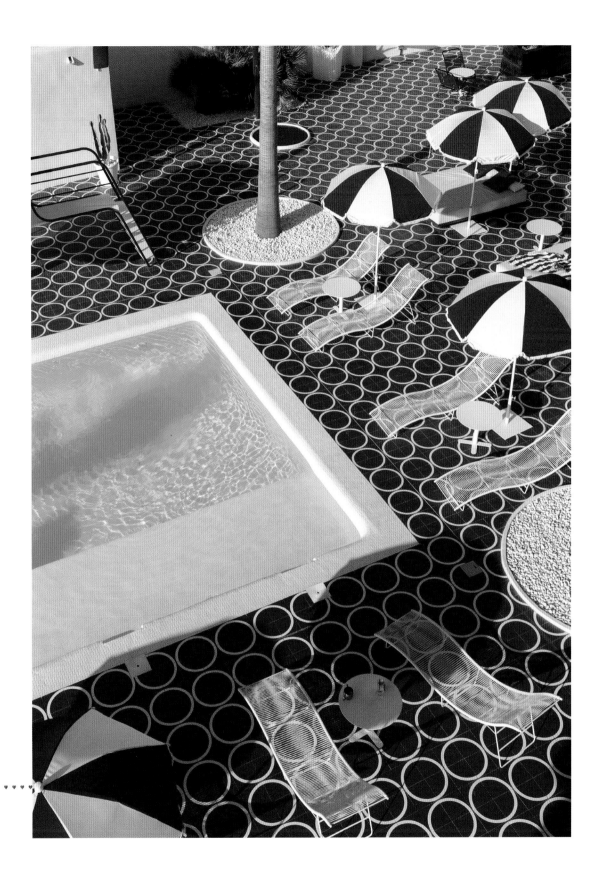

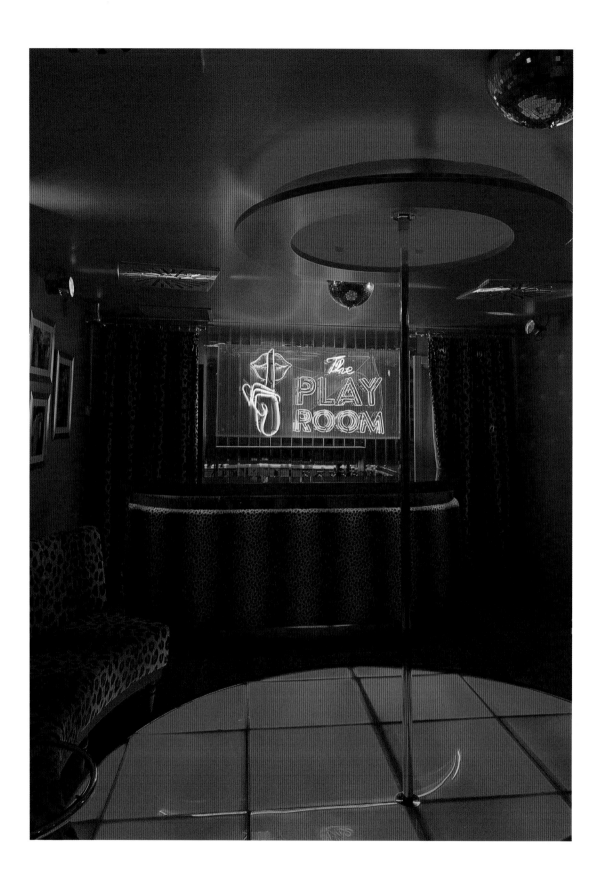

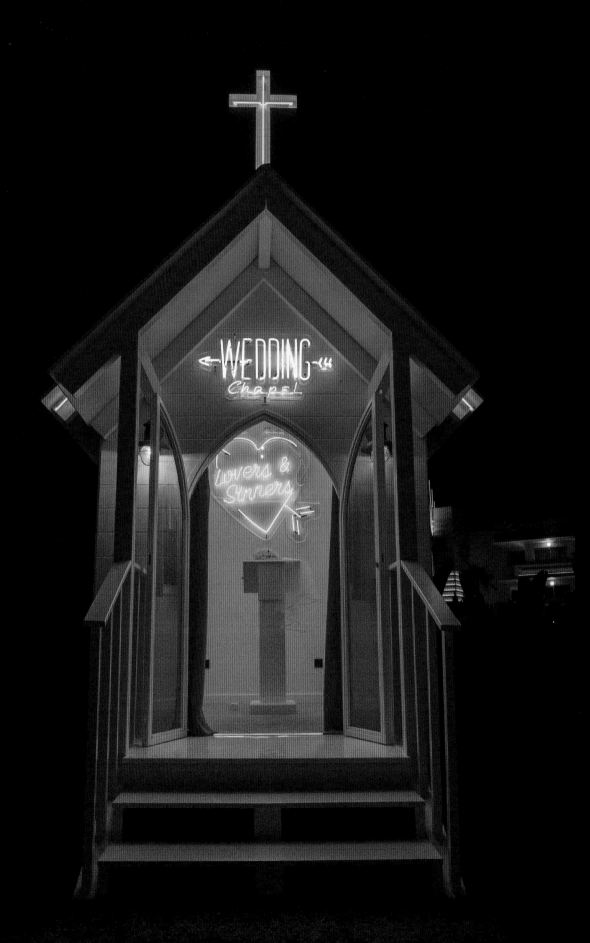

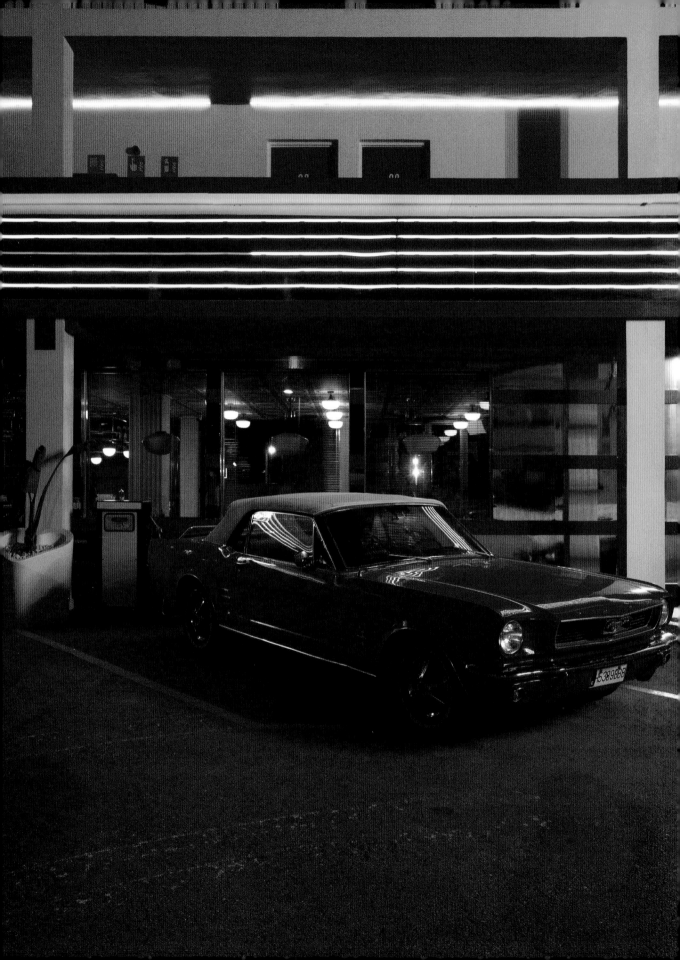

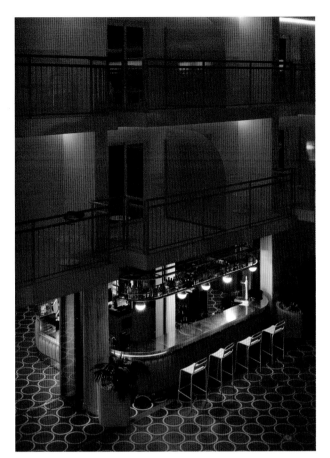

Romeo's looks equally impressive after the sun sets as the balconies, pool, and heart-shaped tub are bathed in a red glow.

All the neon lights and classic cars make the exterior feel like a perfectly curated movie set.

The Future OF THE Boutique Theme Hotel

When the FantaSuites era (see page 100) ended and many of their locations fell into disrepair, theme hotels began to garner a reputation for being old and undesirable. The hotels weren't getting the maintenance they needed, and they became decidedly unfashionable. Several iconic examples—like the Madonna Inn (page 193), Designer Inn & Suites (page 95), and Don Q Inn (page 88)—thankfully survived, due to their owners' care in keeping up the properties and loyal fan bases. Others, like the Black Swan Inn (page 171) and Adventure Suites (page 45), opened in the late nineties, even though it was a time when the genre was losing popularity, and found that one-of-a-kind rooms with handmade pieces and outstanding hospitality could still draw a crowd; their rooms remain stunning works of art today. There is a cycle to every industry, and in the last decade, a new generation has come to embrace the creativity and fun of kitschy, fantastical getaways. Theme hotels are on the rise—across the country and abroad.

TOP LEFT The Urban Cowboy in Nashville (page 117) incorporates instruments into the parlor bar, where they host live performances.

TOP RIGHT Quirky signage adds to the fun at Hicksville Pines (page 226).

BOTTOM This scenic mural is just one of the many unique designs found at the Dive Motel in Nashville (page 122).

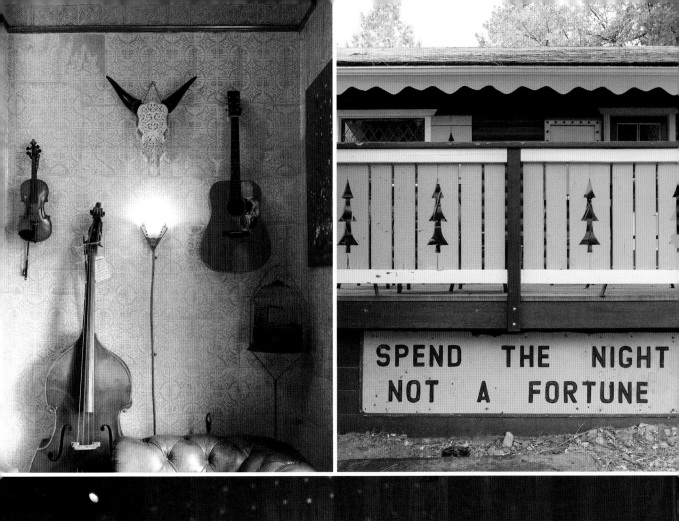

SPEND THE NIGHT
NOT A FORTUNE

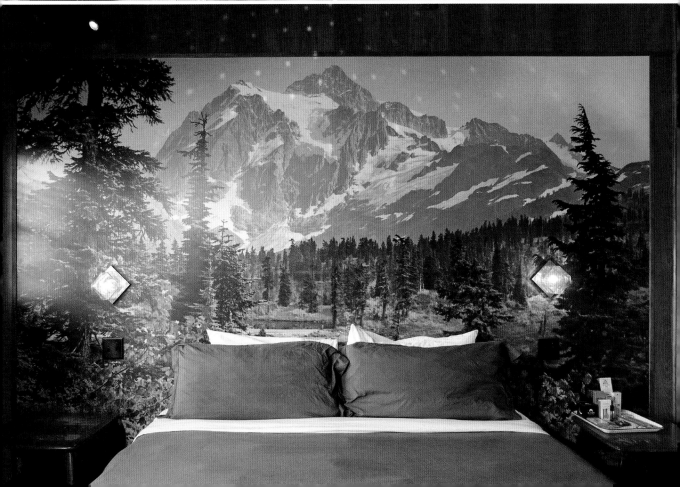

RIGHT AND OPPOSITE With a carved headboard, marble walls, and a lively ceiling mural, Terrazza of the Titans at the Roxbury Stratton Falls (page 53) makes guests feel like Greek gods for the night.

Artists are making hotel rooms their canvases once again, each taking their own personal approach to creating fantasy suites. Morgan Night opened Hicksville Pines (page 226) in 2017 to offer niche themed experiences, so instead of picking a broad and familiar scene like a beach or cave, Night drew inspiration from his own favorite pop culture icons. The Mondo Trasho room is inspired by the John Waters film of the same name, and the Third Man room is based on the design of Jack White's record label. At the Dive Motel (page 122), which opened in Nashville in 2019, instead of each room having a different theme, the whole hotel features seventies decor. Reminiscent of the bell-bottoms and shaggy hairstyles that have come back into fashion, this hotel is a perfect way to get a taste of the groovy fashions that were once all the rage without needing a time machine.

The Roxbury at Stratton Falls (page 53) opened at a particularly hard time for any business, right before the start of the 2020 pandemic lockdowns. While 2020 was an excruciating time of navigating the unknowns, Gregory Henderson and Joseph Massa had just finished creating what would become the ultimate escape from an increasingly demanding world. Six years in the making, these immersive cabins are decked out in handmade designs and custom furniture pieces that draw from classic fables and folklore. And in 2022, Trixie Motel (page 208) opened its doors after debuting on a TV series documenting the entire design process. The individual

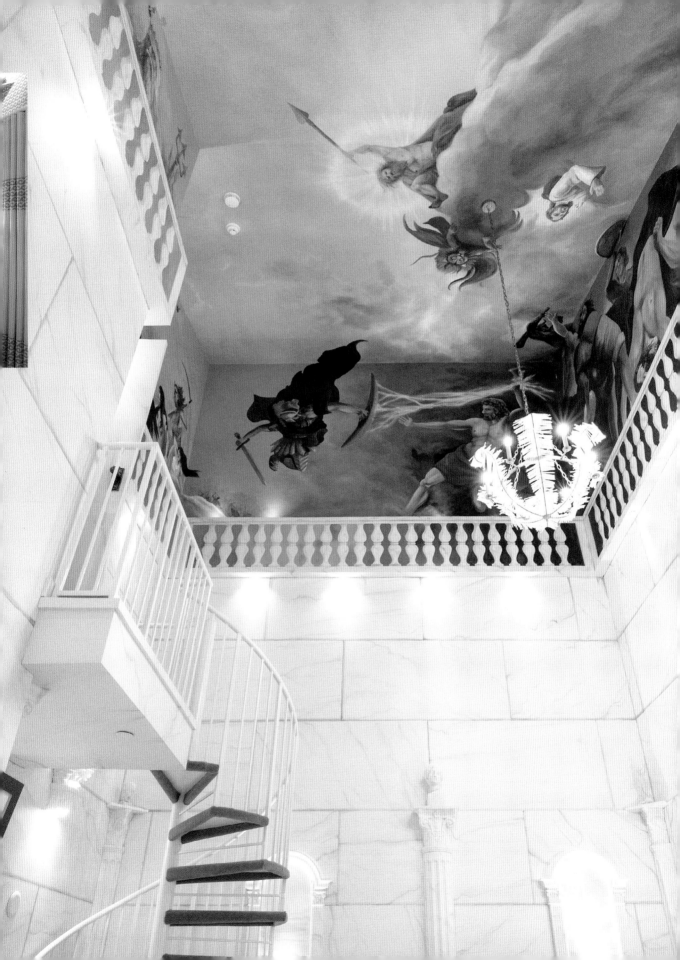

rooms are explosions of color and personality, just like the motel's owner—drag performer Trixie Mattel.

Many young people who would not have considered a theme hotel as a viable vacation destination before are checking into these amazing new locations and celebrating the vibrant wonderlands within, staging photo shoots in their rooms to show off on social media and adding to the buzz. And as these kitschy hotels make their way back into the mainstream, hotels abroad are taking notice. In 2020, Romeo's Motel & Diner (page 246) opened on the Mediterranean island of Ibiza. Inspired by features of American love motels, the neon signs, heart-shaped hot tub, and red tiles throughout are reminiscent of the roadside honeymoon suites that were popular in the seventies; there are even classic American cars permanently parked out front. Romeo's is the brainchild of hotelier and designer Diego Calvo, who specializes in hotels with themed twists—his most recent project, Grand Paradiso, is inspired by classic cinema and has suites named after filmmakers like David Lynch and Wes Anderson.

Although changing trends may continue to bring theme hotels in and out of the spotlight, this new generation of hoteliers is finding a way to take personalized and thoughtful approaches to the genre. With the high cost of creating custom rooms, it is unlikely we will see a widespread chain of theme hotels anytime soon, but thanks to the artists breathing new life into the boutique category, the future of kitschy, themed getaways looks bright once again.

The Pink Flamingo suite at the Trixie Motel has hand-painted murals and custom wallpaper drawn by designer Dani Dazey.

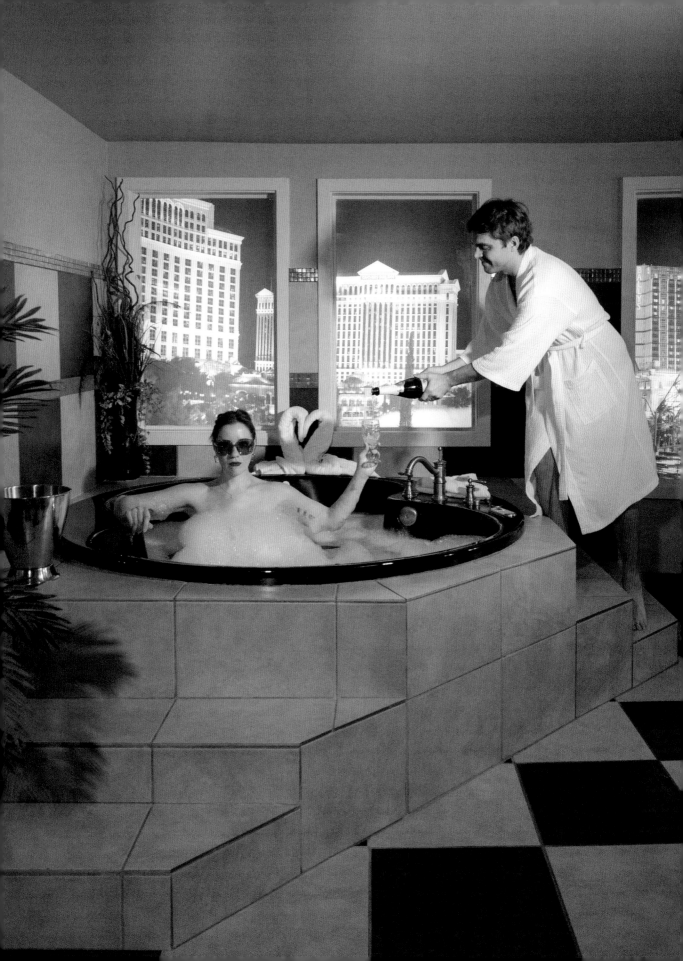

Afterword

It's time to check out and head back to reality, but we hope this book has inspired you to plan your own off-the-beaten-path adventure. Reflecting on A Pretty Cool Hotel Tour, we're reminded of how much we gained during our years on the road, learning about America, ourselves, and each other.

We were often surprised at the locations of theme hotels, since many were in small towns we hadn't heard of rather than in big cities we usually think of as vacation destinations. At first this was confusing, but it became clear that not only is it more affordable for hoteliers to take risks on building niche experiences in smaller towns, but they also offer locals an escape without having to travel far. Why go to a city like Los Angeles just to stay in your room the whole time when there is so much to explore? It makes much more sense to stage a windowless escape in a town where you've already seen all it has to offer.

Because this project brought us to locations far from the nearest airports, we traveled across the country by car and were able to witness firsthand the vastness and diversity of America. Being on the road became therapeutic for us. There's a simplicity to needing to get from point A to point B, with a couple of stops at gas stations to break up the journey and give us a chance to stretch our legs. Each area of the country is so different, but they somehow all got the memo on having gift shops full of cheeky bumper stickers.

Within each region we visited, it seemed like there was a different culture, shared language, and even way of life, but the people we met at each stop served as a reminder that you can find kind people and kindred spirits anywhere you go. We've been rescued from a snowbank on more than one occasion by strangers who saw someone in need and immediately offered a helping hand. We've had mechanics quickly diagnose mysterious car noises or flashing dashboard lights that we worried would leave us stranded in an unfamiliar place for days. We even had a hotel staff member contact us to ship us a hard drive with all the files from our recent trip that they

found before we even noticed we'd left it behind.

And we've met so many staff members and property owners who have inspired us. These people are fueled by romance. Not just the kind that involves a box of chocolates and bouquet of roses—the kind that motivates you to put thought into every action, that believes everything done with intention is meaningful. The people who build and maintain these special places have a sense of adventure, a willingness to dream big, and a love of sharing their unique world. They want to bring people joy and help them rediscover some of life's magic. We've been so lucky to witness how these people live boldly, pushing through the fears of failure or judgment to see what they can bring to life.

Traveling as a couple can put a strain on any relationship, but it can also offer endless opportunities to learn and grow together. We had to get to know ourselves well in order to be honest about what we needed in trying circumstances and enclosed spaces. We had to figure out our individual comfort levels when it came to overnight stays, and get good at recognizing which hotels might be more suited to a fun afternoon escape. Nothing gets in the way of a good time like feeling stressed, so it was important to learn these lessons and manage our expectations. Communication is key, whether it's about what types of places you like to stay in, what kinds of food you want to eat, or even how long you can handle being in a car.

Since road-tripping requires you to spend hours together in a confined space, respecting each other's needs and giving each other room to decompress is imperative. For us, this means setting a quiet time in the car or making sure we're allowing each other privacy in the bathroom, one of the only times you get a moment to yourself! (This has proven to be difficult here and there, since for some unknown reason, many adults-only fantasy rooms don't actually have bathroom doors, but you can always take turns going to grab morning coffee.) That brief time apart can keep you from feeling stuck with each other, which fosters more interest in getting closer when the time is right.

We feel lucky that after endless hours together, we still can't get enough of each other, and we like to think that one of the secrets to our enduring romance is our frequent trips to fantasy rooms. Relaxing in a Jacuzzi after a long day of driving is a great way to slow down and unwind. It's an activity that forces you to do nothing but enjoy the moment. Morris Wilkins was sure onto something!

The years we spent on the road were full of moments we'll cherish forever, with people we'll never forget. Even though we set out to find clever designs, flirtatious interiors, and unique experiences, there was so much more waiting for us that made the journey far more valuable than we'd ever imagined. Nothing could have prepared us for the adventure that would unfold, and we look forward to whatever world is waiting for us behind the next door. Thank you for coming along for the ride! May your hotel fantasies be fulfilled, your heart-shaped tubs be forever bubbly, and your late-checkout wishes always be granted.

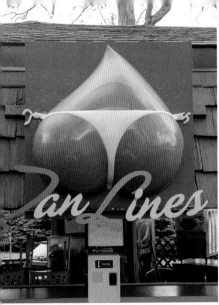

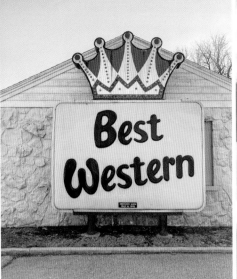

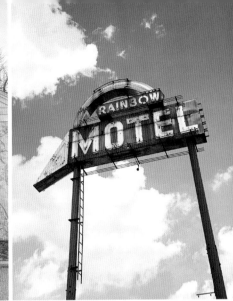

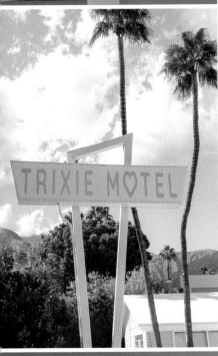

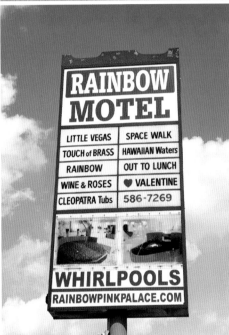

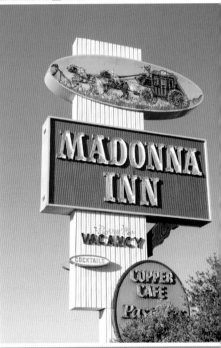

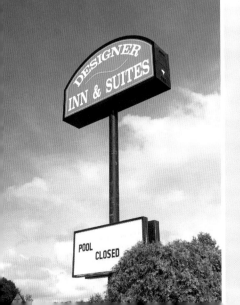

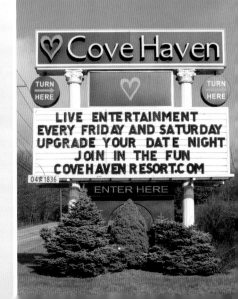

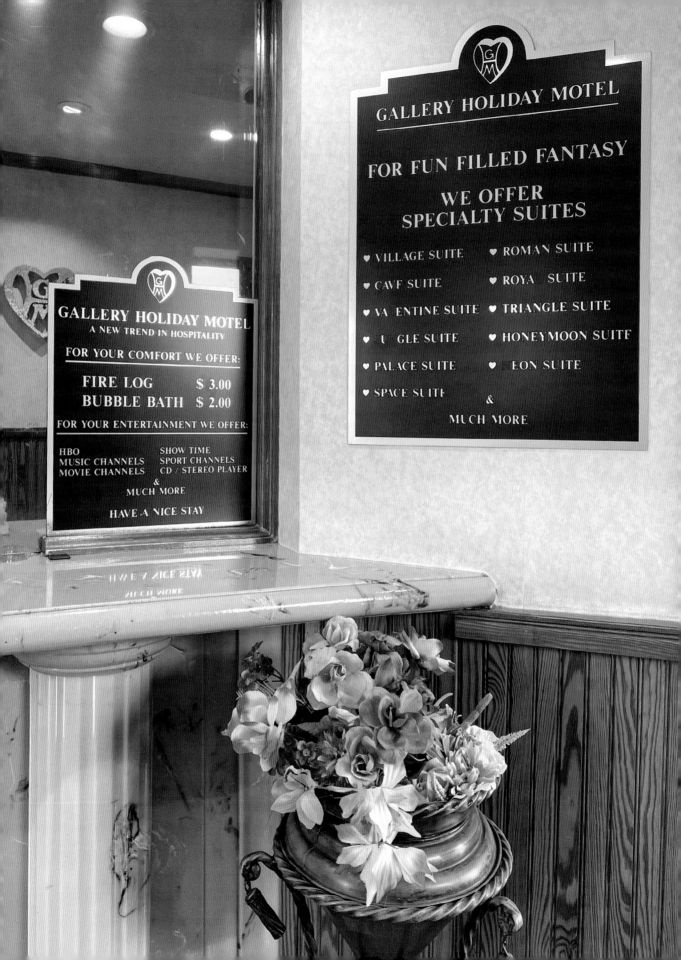

GALLERY HOLIDAY MOTEL
A NEW TREND IN HOSPITALITY

FOR YOUR COMFORT WE OFFER:

FIRE LOG	**$ 3.00**
BUBBLE BATH	**$ 2.00**

FOR YOUR ENTERTAINMENT WE OFFER:

HBO	SHOW TIME
MUSIC CHANNELS	SPORT CHANNELS
MOVIE CHANNELS	CD / STEREO PLAYER

& MUCH MORE

HAVE A NICE STAY

GALLERY HOLIDAY MOTEL

FOR FUN FILLED FANTASY

WE OFFER SPECIALTY SUITES

♥ VILLAGE SUITE	♥ ROMAN SUITE
♥ CAVE SUITE	♥ ROYA SUITE
♥ VA ENTINE SUITE	♥ TRIANGLE SUITE
♥ U GLE SUITE	♥ HONEYMOON SUITE
♥ PALACE SUITE	♥ EON SUITE
♥ SPACE SUITE	

& MUCH MORE

Hotel *Directory*

Amenities

❤	Heart-shaped tub
	Pool
🍸	Bar or restaurant
🐻	Family-friendly theme rooms
🔥	Extra-spicy touches (e.g., ceiling mirrors, erotic furniture)

ADVENTURE SUITES *page 45*
3440 White Mountain Highway
North Conway, New Hampshire
adventuresuites.com

AMERICAS BEST VALUE INN & SUITES OASIS OF EDEN *page 134*
56377 29 Palms Highway
Yucca Valley, California
oasisofeden.com

ANNIVERSARY INN *page 162*
1575 South Lusk Place
 Boise, Idaho
169 East Center Street
 Logan, Utah
678 East South Temple
 Salt Lake City, Utah
460 South 1000 East
 Salt Lake City, Utah
anniversaryinn.com

AXIS *page 77*
335 South Pulaski Road
Chicago, Illinois
verycoolrooms.com

BEST WESTERN FIRESIDE INN *page 234*
1217 Princess Street
Kingston, Ontario, Canada
bestwestern.com

BEST WESTERN IN GALENA, ILLINOIS *page 79*
9923 West US Route 20
Galena, Illinois
bestwestern.com

BEST WESTERN ROUTE 66 RAIL HAVEN *page 135*
203 South Glenstone Avenue
Springfield, Missouri
bestwestern.com

BLACK SWAN INN *page 171*
746 East Center Street
Pocatello, Idaho
blackswaninn.com

THE BLOOMHOUSE *page 145*
Austin, Texas
bloomhouse.live

CASTLE WOOD COTTAGES *page 220*
547 Main Street
Big Bear Lake, California
castlewoodcottages.com

CLIFF HOUSE LODGE *page 151*
121 Stone Street
Morrison, Colorado
cliffhouselodge.net

COVE POCONO RESORTS
page 15
206 Fantasy Road
 East Stroudsburg, Pennsylvania
194 Lakeview Drive
 Lakeville, Pennsylvania
6208 Paradise Valley Road
 Cresco, Pennsylvania
covepoconoresorts.com

DESIGNER INN & SUITES *page 95*
403 US-30 Business
Toledo, Iowa
designerinnandsuites.com

DESTINATIONS INN *page 178*
295 West Broadway Street
Idaho Falls, Idaho
destinationsinn.com

THE DIVE MOTEL *page 122*
1414 Dickerson Pike
Nashville, Tennessee
thedivemotel.com

DON Q INN *page 88*
3658 Highway 23 North
Dodgeville, Wisconsin
donqinn.net

**EXPRESS SUITES RIVERPORT
CONFERENCE & EVENT CENTER**
page 132
900 Bruski Drive
Winona, Minnesota
riverportinn.com

GALLERY HOLIDAY MOTEL
page 37
2020 US Route 35 North
South Amboy, New Jersey
gallerymotel.com

GRADUATE HOTELS
pages 217 and 218
Locations throughout the US and UK
graduatehotels.com

GRAND HOTEL *page 62*
286 Grand Avenue
Mackinac Island, Michigan
grandhotel.com

GRANDPA'S POOL HOUSE
page 107
1431 County Road 6 Northwest
Stanchfield, Minnesota
grandpaspoolhouse.com/main

**HICKSVILLE PINES CHALETS
& MOTEL** *page 226*
23481 CA-243
Idyllwild–Pine Cove, California
hicksville.com/idyllwild

JULES' UNDERSEA LODGE
page 136
51 Shoreland Drive
Key Largo, Florida
jul.com

LIONS GATE MANOR *page 217*
10376 Dempsey Creek Road
Lava Hot Springs, Idaho
lionsgatemanor.com

LOVE CLOUD *page 188*
Las Vegas, Nevada, and
Los Angeles, California
lovecloudvegas.com

MADONNA INN *page 193*
100 Madonna Road
San Luis Obispo, California
madonnainn.com

MAGNOLIA INN & SUITES
page 129
5069 Pepper Chase Drive
Southaven, Mississippi
magnoliainnsuites.com

MARGATE SUITES *page 243*
17 Marine Drive
Margate, England
margatesuites.co.uk

MIAMI PRINCESS HOTEL
page 133
4251 Northwest 11th Street
Miami, Florida
miamiprincess.net

MON CHALET *page 154*
12033 East Colfax Avenue
Aurora, Colorado
mon-chalet.com

OLYMPIC RAILWAY INN *page 184*
24 Old Coyote Way
Sequim, Washington
pikehg.com

RAINBOW MOTEL *page 74*
7050 West Archer Avenue
Chicago, Illinois
rainbowpinkpalace.com

ROMEO'S MOTEL & DINER
page 246
Carrer de Lleó, 3
Sant Josep de sa Talaia
Ibiza, Spain
romeosibiza.com

THE ROXBURY *page 53*
2258 County Highway 41 and
48 County Highway 41
Roxbury, New York
theroxburyexperience.com

7F LODGE *page 141*
16611 Royder Road
College Station, Texas
7flodge.com

SHELL HOUSE *page 239*
Carretera Garafon KM 5
Punta Sur Mar Turquesa
Isla Mujeres, Mexico
casacaracol.com.mx

SUNSET INN & SUITES *page 84*
1251 Kleeman Road
Clinton, Illinois
sunsetinnandsuites.com

SYBARIS POOL SUITES *page 70*
600 Ogden Avenue
 Downers Grove, Illinois
7500 West Lincoln Highway
 Frankfort, Illinois
3350 Milwaukee Avenue
 Northbrook, Illinois
5466 West 86th Street
 Indianapolis, Indiana
10240 North Cedarburg Road
 Mequon, Wisconsin
sybaris.com

TRIXIE MOTEL *page 208*
210 West Stevens Road
Palm Springs, California
trixiemotel.com

TROPICANA IBIZA SUITES
page 219
Carrer de la Deessa Tanit, 10
Sant Josep de sa Talaia
Ibiza, Spain
tropicanaibizacoastsuites.com

URBAN COWBOY HOTELS
page 117
37 Alpine Road
 Big Indian, New York
1603 Woodland Street
 Nashville, Tennessee
urbancowboy.com

VICTORIAN MANSION
page 200
326 Bell Street
Los Alamos, California
thevick.com

WILDWOOD INN *page 111*
7809 US 42
Florence, Kentucky
wildwoodinnky.com

Acknowledgments

Thank you to the people who have supported *A Pretty Cool Hotel Tour* by liking, subscribing, and commenting. As silly as it sounds, you gave this project some serious momentum. And to those who have supported us financially by buying a piece of merch or a subscription to our Patreon, you are the reason we have been able to continue making this series. We quite literally could not have kept going without your help.

To Kyle Kuczma. Thank you from the bottom of our hearts for believing in us before we had a single follower. You saw our vision and opened many doors for us (literally and figuratively) so that we could start digging into the world of fantasy and romance. Also, to Lindsay Williams and the rest of the team at Cove Pocono Resorts for access and materials that shed light on the history of your wonderland of resorts.

To E. Hussa of Dead Motels USA for sharing so much of your expertise about Romantic Kitsch in the Poconos. Learning from what you put online is always a pleasure and getting to interview you for this book was so enlightening and completely laid the groundwork for the historical deep dive.

To Debbie and Larry Fisher, Gregory Henderson, Diego Calvo (and Laura Boyd!), Shannon Schonland, Lyon Porter, and many other hoteliers, front desk managers, housekeepers, and staff members who went out of their way to show us kindness and share their stories. It has been an honor to experience and capture your beautiful creations.

To Michael Isabella, Roger Dehring, Gary Strobusch, Kathy Scholl, and Dorothy Heers for sharing your history of the early days of theme hotels across America. We were thrilled to uncover your stories and share a piece of them with the world.

To Jacob Boll for lending your photography skills and making us look much cooler and more put together than we really are.

To the fantastic team at Artisan: Zach Greenwald, thank you for reaching out to us and guiding us through this completely new experience. Your belief in us and our shared vision brought this book to life. Bridget Monroe Itkin, thank you for lending your thoughtful and meticulous skills. You elevated this book in so many ways, and we're so grateful for your patience. To Nina Simoneaux, for your design, which helps celebrate these photos we feel so close to. And to the whole team—Lia Ronnen, Hillary Leary, Sibylle Kazeroid, Suet Chong, Meghan Day Healey, Nancy Murray, Donna Brown, Erica Huang, Allison McGeehon, Brittany Dennison, Amy Michelson, and Fiona Winch—working with you has been a dream come true!

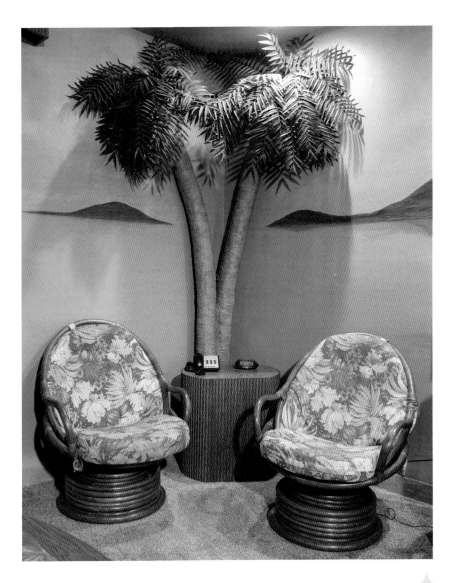

MARGARET AND COREY BIENERT are the couple behind A Pretty
Cool Hotel Tour, a viral travel series exploring themed rooms
and adults-only hotels in the United States and abroad. Since
starting the project in 2018, they have gained millions of social
media followers and have been featured in major media outlets
including *Condé Nast Traveler*, *Architectural Digest*, *Elle*, the *New
York Post*, *Vogue Australia*, *VICE*, *House Beautiful*, *Refinery29*,
GQ, and *HuffPost*. Through their production company, Marginal
Creative, they have worked with high-profile brands such as Marc
Jacobs, Fred Segal, Warby Parker, and Twitter. When they're not
on the road, the Bienerts split their time between Los Angeles and
southwest Michigan. Find them online at @aprettycoolhoteltour.